The Rev. Mary Beth Wells
1183 Canoe Pt.
Delray Beach, FL 33444

Remembering Piero

A Novel of the Early Renaissance Artist, Piero della Francesca

By

Alice Heard Williams

Alice Heard Williams

authorHOUSE™

1663 LIBERTY DRIVE, SUITE 200
BLOOMINGTON, INDIANA 47403
(800) 839-8640
WWW.AUTHORHOUSE.COM

First published by AuthorHouse 12/04/04

ISBN: 1-4208-0596-7 (sc)

Library of Congress Control Number: 2004097855

Printed in the United States of America
Bloomington, Indiana

This book is printed on acid-free paper.

FOR

Challey, Tyler, Leah, Anna, Adam and Arrien

IN MEMORIAM

Daisy Huffman Heard, 1896-1992

Joseph Richard Heard, 1885-1969

San Sepolcro

ONE

1492

It is the morning after her first sight of Piero in more than thirty years. She walks down the once familiar streets of San Sepolcro, toward the Priory of San Giovanni Battista, a place she knew well long ago. Is the neighborhood more derelict now? She looks with dismay at overflowing detritus edging the street. Some of the houses seem ready to tumble down. There is little evidence of order and caring anywhere.

A tall woman, she moves firmly without halting step or cane, although from the abundant gray streaking the wheat-colored hair and the lines etched on her face, it is apparent she is well past middle age. Maddalena Castellani struggles with her feelings as she walks.

Is this the turning? No, another distance to go. Ahead she makes out the outline of the old gate house at the Priory entrance. She steps inside, hurrying toward the sanctuary, blinking in the darkened interior, hesitating while her eyes grow accustomed to the dim light. At once she is assailed by memories brought on by the smell of burning candles, a hint of stale incense, the sight of clear glass windows letting through pale sunlight.

Will someone she recognizes step out of the shadows into her line of vision? Father Bruno perhaps, or Mother Scholastica? But no, they are gone, long gone. Only she and Piero are left from her past, remaining actors in the ongoing pageant that is life.

She lets memory guide her toward the Graziani chapel. It is on the left of the high altar, if she recalls rightly. Scenes from the dedication ceremony that bitter cold January day long ago come stealing back into her mind. The unveiling of Piero's great painting, *The Baptism*, the communal gasp of admiration from the people gathered, the babble of whispered praise for its beauty. And *her* face, *her* figure in the painting.

1

The ominous fluttering in her chest starts up, and she quells it by force of will, breathing deeply, focusing her eyes toward the chapel at the end of the aisle. There it is, the Graziani chapel, she is sure of it! There she will find Piero's painting, unveiled all those years ago.

At last she stands in front of the altarpiece and with trembling fingers, empties coins from her purse into the votive box and lights half a dozen candles. She sees it clearly, the painting that is the symbol of their brief period of closeness, hers and Piero's. Many times in later years he has painted her face in his pictures, painted her from memory. But this one was painted from *life*.

Now that she looks at it critically, bolstered by the wisdom of age, she realizes it is a portrait painted by a man in love. *Her* portrait. Or is she just being foolish? Her faded blue eyes take in the rich crimson of the angel's drapery, the waterfall of yellow hair trailing down her back, skin fairer than the snowy white of the altar cloth.

Did I really look like that? What does it matter? That is how he saw you. This business of conversing with herself is derivative of living alone. Her son Gino is always chiding her about it. But she has been alone too many years, too many. And she is tired now, so very tired.

She stands transfixed at the spill of sunlight over the surface of the painting. Even in the darkened, candle-lit interior, she can see it looks real, that sunlight. And the precision of the perspective! The diminution of the figures merging into the distance is as scientific as the formula an alchemist might concoct to produce precious metal. In the background the town of San Sepolcro rises out of green Tuscan hills dotted with cedars. Oh yes, she reassures herself, Piero is a genius. No doubt about that. But as a man? Has she misjudged him all these years? Perhaps she is to blame as much as he for all the heartache and misunderstanding. The passage of time has altered her views.

At the meeting with him yesterday, her first in thirty years, she could not help but feel remorse that *she* also wronged *him* all those years ago. And *his* guilt! She shivers, recalling his torment. She must do something about that. She will go again to visit, yes, she will go and tell him, this very afternoon. Tell him he must not shoulder the burden of guilt any longer. She was as much to blame as he!

Slowly she turns away and begins the long walk back to Palazzo Castellani. Back to her son who is the master there now. Yes, it is Gino, whom she still calls by his childhood name, Maddalena has come down from Florence to visit, but it is Piero who occupies her thoughts. Gino arranged the meeting with Piero, setting off the soul-searching.

Bless you for taking me to see him, Gino. And forgive me for slipping away alone to make this final pilgrimage of old age, to pay homage one last time to a young Maddalena, and a young Piero.

Memories take over as she makes her way back to Palazzo Castellani. The fete of *Befana*, Epiphany, Piero singing to her the poem by Dante as though they were the only people in the ballroom, the glow of a hundred candles, the dress of rose velvet which she knew made her look beautiful, even though Bianca had the dressmaker fashion it from an old curtain. Remembering the good things is one of the few pleasures left to us, the ancient ones, she thinks, slowly approaching the massive doorway of the house where she grew up, which is now Gino's home.

TWO

1450

The dream finishes as the sun breaks through the tiny glass window of the little room under the eaves. Always the young Maddalena awakens at the same moment. In the dream her parents blow kisses to her as she sits playing with a kitten.

In this perfect dream, Bianca, her widowed mother, is not alone. Maddalena's father Giovanni, who died when she was a young child, a soldier fighting with the army of Florence, stands tall, golden-haired, beside Bianca, wearing the dei Medici insignia on his scarlet uniform. The worry lines on Bianca's brow have vanished, her pearl-like skin is smooth, her hair a lustrous braid of dark, shining strands, winds around a well-shaped head, her smile is carefree. In the dream, the family circle is complete: Giovanni, Bianca, Maddalena.

Sixteen is an age for dreaming, but now reality asserts itself. Why are we little better than servants for the Castellani, mired in the backwater of the little Tuscan town of San Sepolcro? Why are we not in Florence, which Bianca says is the center of the civilized world? Why will Bianca never talk of her family? Who are they? Where are they? Couldn't they help us? And if my father's surname is dei Crespi, why, in the dream, does he wear the emblem of the dei Medici on his uniform? Why, Maddalena thinks. Why?

Bianca is housekeeper and companion to La Signora Castellani. In return she is paid a modest salary and given a place for herself and her child to live. It is not an unhappy life for them, but Bianca works very hard, and there are so many unanswered questions.

Maddalena sits up in the bed, almost touching the foot board with her long legs and feet. Throwing back the covers, she pads on cool, tile floors to the window. Even if San Sepolcro is a backwater, the Castellani did not skimp when they built the palazzo, putting in a little *occhio* of round glass in the outside wall. Most unimportant rooms have only shutters which can be thrown open in summer, but oh the dark and gloom of winter when they are closed.

When the sun rises to the proper angle, she can see her reflection in the clear glass, and she knows her coloring is becoming. Blue eyes and blond hair are in short supply in San Sepolcro, where most of the women are dark-skinned, dark haired. But she despairs of her brows. No matter how often she moistens them with the tips of her fingers wet on her tongue, they remain blonde like buttercups. Never will she have brows dark as a raven's wing like those the minstrels sing about in their ballads. It is a hopeless flaw, like a wart on the nose, a limping walk. She sighs.

THREE

The kitchen of the palazzo is a fine big room, not a poor, detached lean-to like many of the kitchens in San Sepolcro. Fire is still greatly feared in Italy of the *quattrocento*. Even houses with walls of stucco or stone are constructed with wooden posts and beams, huge doors and shutters of wood, kitchens outfitted with enormous fireplaces, all tinder for disastrous fires.

Warm bread baking. The smooth, velvety aroma of hot milk spiked with cinnamon and honey. Fire in one of the room's two fireplaces, overhung with cranes and spits, a cauldron on iron legs warming over the flames, another nearby, for dipping, big enough to hold a barrel of water. And a cook whose ruddy complexion attests to long hours bending over those fires with the basting ladle.

Dressed in a plain gray dress with a long, full skirt, bound in black ribbon at the neck and waist, Maddalena rushes into the kitchen. She is hungry.

"*Buon Giorno,* Maria*.*"

"*Buon Giorno,* Maddalena." The cook's ample figure barely comes to Maddalena's shoulder, but her smile is as broad as one of her saucepans. She is dipping into the huge flour chest, preparing to make more bread.

Oil jars stand on the floor, and locked away in a pantry are precious salt, wine, cheeses, spices, salted meats and olives swimming in brine. From a large iron wheel above the table hang ladles, spoons and saucepans. There is a wooden sink, a big table in the center of the room. The kitchen has little else in the way of conveniences.

"Your *Mamina* has a slight indisposition and wishes a tray in her room. She asks me to tell you she will be down later. If you will go to your dining room, I will bring your tray, Maddalena."

Maddalena longs to be asked to sit at the old scrubbed pine table where Maria works, but she knows it will not happen. She and Bianca, in the strict protocol of Palazzo Castellani following custom in *quattrocento* Tuscany, are not invited to dine at the Castellani table in the great *sala da pranzo,* the dining room. Neither are they invited to share the servant's table in the cozy kitchen. They exist in a kind of limbo.

Sniffing the delicious cinnamon-laced aroma of the milk, she walks slowly into the little cabinet, the room where she and her mother take their meals. From her chair she hears the sound of the massive kitchen door opening, a quick slamming, then a mighty wail.

"Mamina, Mamina! Tina closed the door on my fingers!" It is Giuseppe, Maria's six year old boy, spoiled darling of the household.

"Tina, you witch! How can you be so careless?" Seated in the little room, Maddalena hears the cook's anger boil over, then her cooing reassurances to the child, the sobbing of the little boy as Maria envelops him in her ample arms. A subdued, sullen reply from the serving girl, Tina, is muffled, indistinct.

Then Maria again, sharply, "Take Maddalena's tray to her quickly, Tina, while I calm Giuseppe. She has been waiting."

Maddalena watches as Tina appears bearing the tray, setting it down abruptly so that the hot milk splashes over into the saucer. The serving girl has the grace of a cat in her movements; this spill could not have been an accident, Maddalena thinks, her level gaze taking in the pretty, pouting face, the dark, resentful eyes, the developed figure. Why does Tina dislike the world so? Maddalena is more puzzled than angry.

"No harm done." Maddalena calmly pours the liquid from the saucer back into the cup, swallowing her irritation. "May I have a clean saucer please, Tina?"

Without a word Tina swans out and returns quickly with a saucer, her face a thundercloud of frowns, her eyes blazing like coals. The saucer thuds on the table.

"What is wrong, Tina?"

"Nothing, Signorina," she replies, her voice sarcastic, dripping irony. She turns her back and is gone in an instant.

Tina is inefficient, insolent, sometimes cruel, yet she has a spirit that makes her unique among the army of servants who keep the household running. Maddalena thinks she is untamed, proud, as if she doesn't deserve to be working. *What is Tina's secret? I'll have to ask Bianca.* It is not a major offense, how she acts with me, but hurting Giuseppe, that's another thing entirely.

A small window looks out to the garden. She watches sunlight weaving a pattern of light and shadow as she sips the milk, mindful not to make sucking noises. Carefully, she breaks off a bit of the roll and dips it into her cup. Why should dipping bread into the cup be permissible and the sucking noises not? *Because the sucking noise is vulgar and unpleasant.* Bianca's remembered instructions cover every aspect of a young lady's behavior. Sometimes Maddalena grows sick of it.

Maria comes in with more milk and warm bread, drizzled with honey. Giuseppe peeps shyly behind her wide skirts, looking intently at Maddalena. "Giuseppe is growing like an elder shoot," Maddalena smiles, giving the boy a big wink. Maria beams proudly.

"Growing so fast I cannot keep him in decent hose and buskins. Every night I am busy sewing soles back onto his hose." Pride is etched into every feature of her plain face.

"Be assured, he is a joy in the household," Maddalena murmurs.

FOUR

father Bruno arranges his desk in preparation for the arrival of his pupil.

The Priory of San Giovanni Battista is an old and venerated institution in San Sepolcro, presided over by the formidable abbess, Mother Scholastica. Father Bruno, also old and venerated, has been chosen by Bianca to instruct her daughter in the history of the saints of the church and in other scholarly pursuits. He is caretaker of a collection of remarkably beautiful old missals and prayer books, many dating from the Middle Ages, the most sumptuous painstakingly decorated by monks of long ago.

He also has the task of preaching daily to the nuns of San Giovanni Battista, but his real passion is the *bibliotecca*, the library. He delights in keeping the precious volumes in pristine condition, and in sharing their contents with Maddalena.

The small, gentle priest passes a hand over his bushy brows as he waits for Maddalena. He thinks of his star pupil who will be arriving soon. Sadly he shakes his head. What will become of Maddalena? She is of gentle birth, descended in some obscure way from the dei Medici, he knows not how exactly, and Bianca, her mother, undoubtedly of noble birth, but not in the least forthcoming about her family.

No, not a word there. But Bianca is tireless, never sparing herself in the Castellani household. What dark secrets that family hides. He shakes his head and sighs, the faded blue eyes registering compassion.

Why will Bianca never speak of her own people? Why have they abandoned her? Just who was her husband, Maddalena's father? The mysteries layer like a Christmas cake, one puzzle atop the other.

And how, Father Bruno wonders, can I be of help when I know so little? He sighs again, knowing God will send instructions on how to proceed. His faith is unconditional and absolute. He knows all can be safely entrusted to God.

Lovingly he fingers a Book of Hours dated from the *trecento*. Opening the page he sees the Blessed Christ in the desert, a frail, vulnerable young man, being tempted by Satan, a loathsome red creature with dark, evil eyes and a forked tail which switches in anticipation of pent-up deeds of darkness. Or so Father Bruno imagines it.

Here, he thinks, in a book like this, faith is pure and genuine. No fancy, elegant poses, no artifice. Simply the words of the Good Book put into pictures of tremendous strength and power. He must show this to Maddalena when she arrives. There is a soft knock at the door.

But it is not Maddalena. It is the rising young artist of San Sepolcro, Piero della Francesca, recently returned from apprenticeships in Florence, perhaps even Rome it has been rumored. Piero has come to talk with him about the new altarpiece commissioned for the Priory by the Graziani family. Together Father Bruno and Piero make their way to the sanctuary of the church where the new work will hang.

Maddalena, meanwhile, walks through the noisy streets of San Sepolcro toward the Priory, observing the morning rituals of the town. Housewives gossiping from window to window in buildings whose upper stories overhang the street. Shutters thrown open, bedding hung out to air, peddlers' carts clattering on the cobbles, melding with the musical sounds of their deep-throated cries lauding their wares.

The peddlers scurry from door to door, selling fresh milk, plump capons and chickens, late melons. Tiny dogs bark ferociously at the carts from the safe haven of doorways. Small children chase each other round and round until they drop dizzily to doorsteps, while old women, swathed in shawls and caps, nod in the sunshine at open windows. Maddalena relishes the sights, wishing she could be a painter to record life.

As the carts bearing fresh produce from the outlying farms hurry toward the city market, she is surrounded by cries of the vendors, mingling with the clink of coins. Beggars plead for alms as she draws near the Priory.

She reaches the gate, the old porter tells her Father Bruno is in the Sanctuary and requests she meet him there. Her heart sinks. Is today a Saint's Day she has forgotten? Only last week the kindly Dominican chided her mildly for not attending weekday masses more often. The interior is dim. She looks for him in the gloom.

"Maddalena! Over here! This way!" The familiar, kind voice. She sees him beckon from a side chapel and goes to him at once. He is standing next to a stocky, dark-complexioned man with curly black hair framing a red *berretto*, a hat much more substantial than a commonplace beret. The man possesses the blackest, most searching, heavy-lidded eyes she has ever seen. She judges him to be about thirty five years old, not very tall. They seem to stand eye to eye. He wears a tunic trimmed in lambs' wool and tight fitting *calze*, hose, of a superior quality. He is not handsome, and the overly long tunic on his stocky figure creates

a faintly comic effect, but the eyes are commanding. He has a certain presence, Maddalena admits, covertly sizing him up.

"Maddalena, this is Signore Piero della Francesca, the artist. He has come to discuss the altarpiece he will paint for the chapel of the Graziani family." She dips slightly and bows her head in the direction of the man.

"Maddalena and her mother came to San Sepolcro from *Firenze*," Father Bruno explains. "Signora dei Crespi serves as companion to La Signora Castellani. Maddalena studies here with me in the library; a most intelligent pupil she is." The priest smiles warmly at her, eyes twinkling.

Maddalena's cheeks burn as hot as coals. Why does Father Bruno embarrass me so? But the artist hardly notices.

"Do you paint?" Piero asks abruptly, solemn dark eyes trained on her face.

"No, Signore." She shakes her head regretfully, clasping her hands.

He seems to lose interest. Turning to Father Bruno he asks, "So it is a Baptism of Christ which is wanted?"

"Yes, my son," answers the priest. "And you are free to place the figures in a landscape setting as you have requested. The Graziani are enlightened collectors and patrons of art. They do not insist on an old-fashioned background of solid gold leaf. Truly they are the most agreeable patrons an artist could hope to have, wanting nothing in their altarpiece to appear out-dated. It will be a marvelous tribute to the Priory's patron saint, Saint Giovanni, as he baptizes the Christ."

"Excellent! Excellent!" answers Piero. He has apparently forgotten Maddalena. "And you are sure, Father, that the concept will be mine and mine alone? No interference of that sort from the Graziani?"

"I can guarantee it," Father Bruno answers happily. "Mother Scholastica tells me you are absolutely to have your wishes. We are so proud to have San Sepolcro's most famous son, indeed, Tuscany's pride, working at our Priory." Piero waves a hand of dismissal. Such praise seems to embarrass him.

"Then I shall sign the contract at once and begin work. It is good to return to the place of my birth. Nowhere is more appealing than San Sepolcro, eh, Father?"

Maddalena listens in silence, ignored, like an altar rail, a kneeling cushion, her opinion neither asked for nor given. She takes an instant dislike to Piero-of-the-Long-Tunic.

"And will you not be sorry to leave *Firenze*?" she asks boldly, determined to exercise her voice, if only as an afterthought.

"I won't be leaving it," he answers smugly. "Citizens of San Sepolcro are automatically citizens of Florence. It is the new law. Did you not know?"

Such an impudent rooster. And rude into the bargain. Maddalena hopes she will not be seeing him again, and she begins to inspect with absorbing interest the enormous brass candlesticks in front of the altar.

As she walks toward home her mind is filled with doubts. Why had she and the artist disliked each other so much? Had she been overly bold in her talk? No, she had kept her eyes lowered, her lips silent for most of the time. Or perhaps she had failed to act respectful?

A review in her mind of the meeting with the artist Piero della Francesca reveals nothing he could have found objectionable. Except of course the admission that she does not paint pictures. And who of all her acquaintances in the whole world can paint? He is the first painter she has ever encountered. It is to be hoped they are all not unpleasant like him, she thinks, turning into the forecourt of Palazzo Castellani. To seek rest from her walk, she turns into the garden.

FIVE

uigi Castellani walks into the garden and falls in love.

The Castellani heir is resplendent in the uniform of Florence. Grey hose under the tunic reveal shapely (but powerful) legs. Long, golden hair falls in a page boy just above the shoulders. His features are well-formed, pleasing. Since the age of eight, he has lived away from home, at his uncle's villa in Fiesole.

Disaster befell him on a day of great tragedy many years ago. His older brother Paolo had been allowed to go hunting with his father and some friends. A charging wild boar frightened Paolo's horse and he was unseated. The maddened boar trampled the boy to death before the hunters could reach him. When Paolo's body was brought back to Palazzo Castellani, La Signora Margherita collapsed on the floor in a heap, suffering a breakdown. She would not look at her youngest son, Luigi, after that. Paolo had been her favorite. Poor Signore Castellani decided it would be best for both his wife and his surviving son to send the boy to his brother-in-law in Fiesole to live.

Signore Castellani visited Luigi whenever he deemed it safe to leave his ailing wife, showing his son great affection, but La Signora's fragile state persists, even today. Until this moment, Luigi has not set foot on the property of Palazzo Castellani, nor has he seen his mother. He has hurried into the quiet of the garden for a few moments alone to prepare himself for the meeting with his mother for the first time in fourteen years.

He enters the little *giardino segreto*, the secret garden he remembers from childhood. In a circular space, protected by tall cedars, rose bushes encircle a path and a bench. The space is small, secluded. He inhales the scent of the roses, even before seeing them. Closing his eyes a moment in anticipation, he takes a few steps and opens them to discover a pretty girl wearing a modest gray dress bound in black ribbon at the neck and waist, sitting on the bench, looking directly into his eyes.

"Your eyes are as blue as asters," he says, the first thought that pops into his head. *"Scusi, Signorina,* I do not wish to disturb you!*"* But his heart tells him as he gazes at the beautiful girl that he is very glad to interrupt her solitude. "I am Luigi Castellani."

She expresses surprise. Is he a son of the household whom she has never seen? Nor has she heard of him. Why Palazzo Castellani is her home! How can this be?

He begins to tell her the sad story, glad to have her attention and wondering how he can press his suit with this adorable creature when he has already half-promised a distant relation in Fiesole that his heart, more or less, belongs to her.

In a few minutes Maddalena and Luigi are pacing the path together as they tell each other about themselves. They have much in common, Luigi growing up without a mother to love and comfort him, Maddalena without a father.

Her cheeks match the color of the rose blossoms. Both pairs of blue eyes look earnestly at each other. Had there been anyone watching, it would be plain as could be that the two of them found much to talk about.

SIX

A head of fair hair streaming loose; dark, shining braids wound around a second well-shaped head. The pair bend closer together as Maddalena and her mother Bianca snatch a few minutes from the busy routine at Palazzo Castellani . They are holding a private conversation in the secret garden while La Signora is resting in her chamber. Luigi and his father have left to inspect the family estates outside San Sepolcro. From all indications, the reunion of La Signora with her son has been a happy one. Bianca realizes the time has come to confide in her daughter of the family's history.

"We arrived in San Sepolcro so that I could become a companion to La Signora shortly after their son Paolo's death, Maddalena. You were too small to understand such sadness, so I said nothing to you about it. If you could only have realized how distraught poor Signora Margherita became! She could barely drag herself about the house and anything, any tiny reminder of Paolo, set her off weeping uncontrollably. She is much better now. But to send the other son away! That must have broken Il Signore's heart, even though he acted for the best interest of all concerned."

Bianca looks carefully at her daughter. She does not fail to see the sparkle of those blue eyes--so like Giovanni, her dead husband, she remembers with a little stab at her heart. She sees the enthusiasm on Maddalena's face, hears the music in her voice as she speaks of Luigi. Bianca frowns. How can I crush her hopes, drive the light from her eyes? But she knows she must speak, to protect her daughter from a greater, future unhappiness.

"Listen, Cara, we should have had this talk sooner. You have grown so quickly! It seems only yesterday you were a little girl, chasing butterflies here in the garden. I want to tell you a little about your father. Maddalena, Giovanni was the natural son of Cosimo dei Medici, the ruler of Florence, yes, Cosimo, and a peasant girl on one of the family estates. His mother died soon after Giovanni was born, but he told me people said she was beautiful. When he was born, Cosimo refused to give him a home in the dei Medici palace. Instead he was sent to an honorable family, the dei Crespi, who raised Giovanni as their own son." Bianca pauses to let Maddalena absorb the shock of her words.

15

"Because of his wife's jealousy, Cosimo did not recognize Giovanni's kinship to the dei Medici , although he allowed your father to wear their emblem on his uniform when he became a soldier of Florence. It was thought by everyone that Cosimo's wife, Alessandra, poisoned his mind against Giovanni, his own son."

Again Bianca pauses, warily watching her daughter. Maddalena's face is pale. She does not speak. In her hands she holds a single red rose whose petals she slowly crushes, one by one. Her eyes are fixed on a small insect diving repeatedly into the perfect center of a tightly closed bud on the rosebush in front of her.

"And then there is my family, the Albizzi," Bianca continues, "Respected in Florence for many generations. You wonder why I never speak of them? For decades the Albizzi were the rulers of Florence, merchants and bankers, until they were thrown out of power by the dei Medici family, long before you were born. The Albizzi were banished, many put to death. Our fortunes were taken away. We were left homeless. Only through the help of a kind family were we given shelter, and this was at great personal risk to them. Sometimes I was even glad my mother and father were dead---so they did not have to face the wretchedness, the shame we were made to feel." Bianca sighs.

"So that is why I do not speak of my family, Cara. In a country like Italy where the family means everything, I cannot bring up the name of Albizzi. Nor can I mention that my child has the blood of the ruling dei Medici in her veins."

Maddalena perches on the bench as though carved in stone, trying to register all that Bianca is telling her. My father a dei Medici, my mother an Albizzi! And the Albizzi and the dei Medici sworn enemies, everyone knew that!

"Do the Castellani know?" she asks in a whisper.

"Yes," Bianca nods, her voice low. "I had to explain all to Il Signore when we came here." She looks fixedly at her daughter. "And they have been kind." Maddalena studies her hands, despair written on her face.

"The thing to remember, Maddalena, is that we are still hated by the dei Medici, even though Giovanni is no longer alive and Cosimo is dead. And it is going to make finding a suitable husband even more difficult for you, Maddalena, since you have neither a family name to fall back on nor a dowry to bring to a marriage." Maddalena nods miserably.

"As for the Castellani," Bianca continues in a low voice, her thoughts turning to Luigi and the present, "I happen to know they are desperately trying to stay solvent. It takes a lot of florins to run the palazzo, and the estates do not produce much in the way of income. The land has not been well-managed; the soil is exhausted." She sighs.

"The appearance of wealth is all a facade. Il Signore is desperate, counting on Luigi to marry a suitable girl, one who will bring wealth or land, preferably both, to the marriage. So Luigi, for all his freshness and charm, is not likely to be a candidate for your hand, Cara. I wish it weren't true, but there it is. But you must not be discouraged, Maddalena. There will be a proper husband for you someday. I am sure of it!" Her voice is almost too hopeful, Maddalena thinks, in her despondent mood.

Her mouth dry and a lump in her throat, Maddalena nods woodenly, trying to keep her countenance calm. *But it is Luigi I want,* an inner voice cries out. Her heart feels as if it is imprisoned in chains. Meeting Luigi had made her so happy! With a tremendous act of will, she shifts her thoughts, shakes the petals from her skirts and begins to tell her mother of her meeting with the artist who will paint the new altarpiece for the Priory.

SEVEN

Piero holds the old orange cat Giotto as he sits before a small fire in his studio in the Via della Chiesa. He has finished a light supper of fresh bread made by his housekeeper Lucia, along with a dish of olives, all washed down with a carafe of sparkling *Carmignano,* as good as any wine in Tuscany, from grapes grown at the foot of the San Sepolcro hills.

Lucia has left for evening mass at the Priory of San Giovanni Battista. The house is silent except for the purring of the magnificent cat and an occasional sigh and upheaval of the burning logs in the fireplace. Piero passes a hand over his eyes. How lonely he is. He notices a run in the hose on his right leg with annoyance. Lucia tries, but her mending is impossible! Her poor, weak eyes. A child could do a better job, he thinks.

A wife sitting in the gloaming of twilight near him would be a comfort. Someone he could talk to about his work, someone who would listen and understand, who would sympathize when he tells of the apothecary who sells him the lapis lazuli and the gold leaf, cheats him by not giving full measure. He is sure of it! Or that sly Domenico Veneziano, his former master, who is copying his style, his color, his compositions all over Florence. Yes, someone to confide in would be pleasant.

With a wife sitting beside him, he might even bestir himself to play his lute for her. Anything to have and to enjoy the company of a fellow creature. No good going to visit at his brother's house, shouting children running to and fro and a mother-in-law at his hearth expressing a contrary opinion (usually wrong) on every subject brought up. He might walk over to the Priory for a visit with Father Bruno, but on reflection, Piero realizes the holy man will already be at his prayers. The thought that he needs a wife persists in his consciousness.

The young girl he met at the Priory, the one who is Father Bruno's pupil. She is comely, well brought up. What was her name? Maria? Margherita? Maddalena? Yes, Maddalena. How he would like to paint that face. The golden hair trailing down her back, matched by the wonderful golden brows and eyelashes. Such splendid coloring, and skin like a lily petal. But as usual, he was unable to speak pleasantly and with ease in her presence. Fears, fears,

always the nameless fears bubble up, afraid to venture, afraid he will be rebuffed. It is the curse of my miserable childhood, he thinks to himself, staring into the dying embers of the fire.

EIGHT

I wonder what Maddalena is really thinking, Bianca muses as she counts cloths, napkins, sheets and towels in the linen cupboard and sees that they are neatly stacked. Such a supply of table linens, and many seldom used. *What this house needs is life!*

Is Maddalena pining over the Castellani youth? He is handsome enough, she admits. Or is Maddalena trying to force him from her thoughts? Bianca's heart turns over, remembering the shine in her daughter's eyes as she speaks of him. That happiness, that exuberance, Bianca remembers. *Oh, yes, I know what it is like when the heart takes flight on wings of its own. Giovanni, my love, I miss you!*

Since rising this morning Bianca has doled out the daily supplies to Maria, the cook, posted the household expenses for the previous day in the ledger, wound skeins of silk for La Signora's embroidery while listening to her chatter about the advantages of one cushion-cover pattern over another and supervised the gardener in the pruning of the roses in the *giardino segreto*.

Her back aches, but most of all she is anxious about her daughter. Oh, how she longs for her to be happy, to be settled with a devoted husband, to have children to love and care for, a proper house to manage. But without a dowry, where will she find a suitable husband? *Oh, Giovanni, I need your strength. Too long I've shouldered these burdens. Help me!*

She leans a throbbing brow on the door of the linen cupboard, knowing she is due in the kitchen to assist Maria in trying a new recipe for orange preserves. It is called marmalade (funny name), and La Signora received the receipt from a Castellani cousin visiting in England. She wants Maria to make it, and of course Bianca will have to lead the willing but unlettered cook step by step. The day hardly contains enough hours for all her tasks, she thinks with a sigh. At the same time, she realizes she is indeed lucky to have such a post.

But it is her daughter, Maddalena, on whom Bianca's thoughts engage. Maddalena must have a husband; she must not be enticed into any attachment other than one leading down

the aisle to a priest who will administer the marriage vows. But more to the point, where is her daughter going to find a husband, when she will have no dowry settlement to bring to the marriage? Bianca sighs, feeling the weight of the world on her small shoulders.

NINE

*L*uigi stands at the window in his chamber waiting to go down for dinner. He has asked his father to include Signora dei Crespi and Maddalena at dinner tonight since he will leave in the morning to rejoin his regiment in Florence. At least he will have a chance to see her, he thinks glumly, looking in the concave mirror, checking to see if he is presentable. That one encounter in the garden is all they have had together.

He's guessed the reason why she's avoided him, after his father told him about her parents. Mother an Albizzi! Whew! And the father a dei Medici! With a pedigree like that anywhere but Tuscany she'd be at the top of a dozen suitors' lists. That's the difference between the older generations and the younger, he thinks. I don't care a whit whether she has unspeakable ancestors or not. The matter of a dowry, though, that's serious, certainly to my father.

He recalls his father's not-so-veiled hints about getting on with the wedding plans, his and Julietta's. His father murmuring he saw no reason for delay. And his observation, moreover, that he did not for one moment think Luigi would consider a liaison with someone so unsuitable as Maddalena. Luigi had gone to his father after meeting her in the garden, his heart overflowing, as he poured out his feelings for Maddalena.

"She is of aristocratic birth, not to be toyed with," his father had firmly replied. "Of course the girl has poor prospects, no dowry at all. It is a pity, for she is comely and sweet-natured. Perhaps the church will offer the best possible life for her?" Luigi recalls his father's unacceptable speculations rendered in his measured, thoughtful manner.

"Nothing dishonorable *she* has done, you understand," his father had put it, referring to her ancestry. "But rather unfortunate," he added, meaning the dowry of course.

I'd hate to break with my family and strike out on my own, but if I am pushed to marry for money, I'll do it, Luigi thinks, rather than be bound for life to someone I don't love. As soon as I can, I'll untangle things with Julietta. It was only a silly promise we made to each other when we were twelve, he reminds himself somewhat self-righteously. I'll ride over

to Impruneta to see her and explain the first chance I get when I visit Uncle Baldassare in Fiesole. Better yet I'll write her. And I won't give Maddalena up, that is if she'll have me.

"We are counting on you to revive the family's assets with your sensible marriage, Luigi," his father had droned on in that even voice of his. " To bring the name of Castellani back to its former glory. Remember, you are my sole hope now."

Another reminder of his dead brother. Well, he hadn't gotten a lot of consideration from his family, being sent off for fourteen years for a tragedy he did not cause. With a pang he regrets that last thought. His mother's fragile nerves couldn't be helped. And his father, well his father has been a loving support for him. His uncle is a kind man too. He hasn't suffered. All the same, Luigi promises himself, he must talk with his father again in a serious way about his future, and he knows his father will be livid with rage if he insists he will marry Maddalena dei Crespi. Ah, that wonderful hair, those eyes deep as mountain lakes reflecting the blue of the sky. She is a vision, a dream, and he vows again to wed her, dowry or no dowry.

As he looks at his reflection one last time he wonders, will I be able to slip away with her for a brief turn in the garden after dinner?

TEN

The afternoon sun slips behind the hills as time for the festive dinner approaches. In her room, Maddalena puts up her hair into one long braid with a pale ribbon wound through it and binds it around her head. It looks like a halo. She loves the velvet dress with its ordered folds as it slips over her head. The old rose color, *rosato*, the aristocratic color of Tuscany, like the purple of the Romans, suits her coloring.

Bianca discovered a wonderful little seamstress who sometimes comes to the palazzo to help with the sewing. Bianca designed the dress and the seamstress made it from an old castaway curtain once hanging in the downstairs reception room. But nobody would have guessed.

She wears no jewels, she has none, but it does not matter with her shining gold hair, the sparkling blue eyes, the rose-tinted cheeks which advertise a heightened sense of being alive, not something out of a paint pot.

Candles light the wall sconces and the tables in the dining room, the *sala da pranzo*. A loggia of archways leads onto the terrace on this unusually warm night, and torches gleam along the garden paths, turning the yews and cedars silver.

Once Father Bruno told Maddalena, when their scholarly studies wandered slightly off the path of the most venerated saints, that of all the countries of the civilized world, in Italy, dress is of supreme importance. Looking at the assembled guests, Maddalena silently agrees.

La Signora wears cream damask with slashed sleeves inset with gold embroidered lace. Bianca looks regal in black brocade of the utmost simplicity while Signora Mazzetti, wife of Il Signore's business partner, resembles a peacock in deep blue silk paired with magnificent insets of bottle green and blue in the sleeves.

The gentlemen wear equally colorful tunics of quilted wool or damask, embroidered with crests or similar emblems. Except for Luigi, of course, who looks commanding in the

crimson uniform of the Florentine officer. He steps forward to bend over Maddalena's hand as his father introduces her and Bianca to the guests.

Luigi and Maddalena eye each other covertly over the *minestre*, a clear broth in which float the tiniest pillows of ravioli stuffed with ground pork. There is a saddle of tender veal, eels shipped in from the lagoons of Comacchio, a fish pie with spices and saffron, dates, raisins, pine seeds and marjoram, pounded into a paste, then placed around the fish and encased in a rich pastry. Even though Tuscan sumptuary laws of the period limit the number of courses which can be served at banquets, ingenious cooks quickly adapt to their menus huge pies, containing multiple ingredients, thus circumventing the troublesome laws.

Maria's triumph for the evening, a platter of poached pears, swimming in a honey and spiced wine sauce, is greeted with applause. She places the dish before Il Signore with a flourish.

"Your favorite, Signore," she says, beaming like one of her shining copper pots.

The evening passes with no hope of Luigi and Maddalena stealing a private moment. Maddalena has to be content with admiring glances from Luigi from across the table. She half listens to a long dissertation on the dangers of foreign trade by Signore Mazzetti as the candles burn low, and the servants, standing mute in the shadowy background, can hardly conceal their yawns. Luigi has been unable to propose a stroll during the lengthy talk at the table after dinner.

Tucked away in her tiny room under the eaves after the evening has finished, Maddalena looks out at the autumn moon and wonders what her future will be. She knows what her mother has told her is reality. For her, there can be no way to her heart except through marriage. But oh, how she feels her equilibrium vanish when Luigi draws near.

*

Later that night, when the palazzo is quiet, a lithe, shadowy figure pauses at Maddalena's door and tucks a small scroll of paper under it.

In the early light of dawn, when the palazzo is quietly humming with the bustle of servants at their morning duties, another figure, somewhat obscured by the pale shadows, a figure with the quick grace of a cat, sees the tip of the paper protruding under the door and pouncing upon it, bears it away in triumph.

ELEVEN

Maddalena tries earnestly to apply herself to her studies with Father Bruno. In studying obscure saints she is able to prohibit Luigi from constantly entering her thoughts. She delves into her assignments with renewed vigor.

Father Bruno, unaware of the tumult in her heart, thinks this enhanced thirst for knowledge is something of a minor miracle. Could she be the one God has chosen to carry on his studies in the *bibliotecca*? Stranger things have happened. History records several women who have taken up such work. He must consult Mother Scholastica about this matter. He pauses in his inspection of a new gift to the collection, a *trecento* missal with exquisite illustrations in colors of the rainbow, sent to the Priory as a gift by a merchant of Siena.

Work on Piero's altarpiece is progressing nicely. As often as not, Piero joins the pair in their studies, not speaking much but sketching, always sketching. He gives them daily bulletins on his progress. Between Piero's visits, the gentle priest tries to bring Maddalena around to a more charitable view of the artist. Father Bruno believes, in his unworldly way, that Piero is paying court to Maddalena. And he views Piero as an admirable candidate for her hand.

Father Bruno tells her that Piero is an official, a city councilor of San Sepolcro. "You see, Maddalena," he says, dancing on his little feet as he always does when he is excited, his long nose twitching, "He was born here. His father worked as a humble leather worker. To rise to such eminence to be named a councilor is indeed a great honor!"

Maddalena nods politely. In her mind San Sepolcro is only a backwater compared to the blinding cosmos that is Florence. Bianca has told her this truth many times. She is not impressed with San Sepolcro...or Piero, for that matter. Nor does she feel very comfortable around him. To her he seems so remote, withdrawn. She doubts he even considers her as a real person.

"But Maddalena," the priest continues, "You should understand how much Piero has suffered."

"Suffered?" she replies. "I cannot really imagine someone so proud, so arrogant, being overcome with suffering. It just does not fit."

"Oh yes, Maddalena. He has struggled with a life of great hardship. His father died suddenly, and Piero's mother had to work long, hard hours in a variety of menial jobs, just to feed and clothe her family. Piero was the oldest child so his burden was heaviest. He toiled to bring in a few lira doing whatever odd jobs he could find. The mother recognized early that he had a talent for drawing, and she pinned all her hopes on him." The priest bestows on Maddalena his sweet, guileless smile.

"She encouraged him to become an artist. And he idolized her. When she died before he received recognition, Piero was devastated. He wanted fame for *her*, you see. It made him more determined than ever to succeed." Her icy regard of Piero melts a little after this revelation. But she still finds him cold and unapproachable.

"Be patient, Maddalena. In time you will understand," Father Bruno says.

Piero continues to pay visits to the Priory. "Why does he waste his time?" Maddalena exclaims on one occasion when he has departed. And Father Bruno decides it is time to confide. Blushing, he tells her that Piero comes because he wants to see her.

"See me?" She can hardly believe her ears. "That is very strange, as he never addresses any remarks to me when he is here."

"You will see, you will see," is all Father Bruno will say.

When Piero speaks at all, it is about his painting. He might declare something like, "Most of all, I want my painting to be true to nature. In the altarpiece, John the Baptist will be a wild figure, a head of tangled hair, wearing animal skins to cover his body because he lived in the wild. I have a tanner who is posing for me, a man with such rugged features, such bushy brows! He will be a credit to the altarpiece."

Maddalena notices that when Piero is speaking of painting, his face changes. It loses the bland, mask-like appearance he normally wears and becomes radiant, as though lit from within. She quite enjoys his dissertations on art. She is learning more about him; he does not seem quite so formidable.

"Of course, my son, of course." Father Bruno's replies are meant to soothe. "We have every confidence in your God-given abilities to create a noble work for the Priory. Will there be a Graziani portrait in the painting?"

"Yes, Father, in the face of Christ. But it will take nothing away from the intensely spiritual moment of Baptism when John pours water over Christ's head and the Holy Spirit appears in the form of a dove. The Graziani have lent me a small portrait of their ancestor. It is a face

full of strength and character, yet having a sense of sweet determination in the eyes." Piero's voice is husky with emotion.

"I want to make the light moving and natural, like the true light at that wonderful moment of Baptism long ago. The sunlight of midday is what I am aiming for, even though to my knowledge, it has never yet been portrayed in a painting."

"And the background?" Maddalena ventures timidly.

"Cedars and pines of the hills around San Sepolcro and the town itself seen in the distance." The silence after this pronouncement lengthens as Maddalena, Father Bruno and Piero imagine just how it will look. This man, this artist, sees in a new way, Maddalena thinks.

During the same morning, Piero discusses painting techniques with Father Bruno while Maddalena listens. How he prefers mixing oil with the egg and water-based tempera to form a more lustrous, lasting surface.

"Domenico Veneziano taught me that," he admits, one of the few times he gives his former master grudging praise. "If you paint with pure tempera, the result will be quite flat. Mixing in the oil adds a sheen. It is the Venetian way."

Later during the visit, Father Bruno receives a summons from Mother Scholastica, and Piero and Maddalena are left alone for a few moments.

"Do you enjoy looking at paintings?" he asks her suddenly. She jumps at the urgent tone of his voice.

"Why yes, although I know very little about it." His manner is so intimidating, Maddalena feels like a trapped deer when she is alone with him.

"And your mother, does she too enjoy it?"

"Yes, certainly. I know she loves paintings, although the Castellani collection is very old and in great need of restoration. But she tells me of the fine paintings she has seen in *Firenze*." Maddalena is puzzled. What is he thinking, behind those heavy, half-closed lids? But he says no more and soon Father Bruno returns, a little breathless in his hurry to resume his role as chaperone. He needn't have rushed, Maddalena thinks.

TWELVE

Piero walks home from the Priory, elated over the Graziani commission he is working to complete. A fitting painting for a church whose patron saint is John the Baptist. It will have realism, the fall of sunlight over the canvas, solid, substantial figures who might be expected to live and breathe, and as a background the glorious landscape of Tuscany. John, dressed in furry animal skins, will gracefully anoint Christ, a figure as explicit as a Greek sculpture, with the Jordan waters shimmering beneath him, while the dove of the Holy Spirit spreads sheltering wings above. Satisfied, his thoughts turn to the stunning young woman he has recently met.

*

The serving girl Tina moves stealthily along the corridor of the cellar below Palazzo Castellani, unnoticed in the din of raised voices, the cries of children sounding through closed doors. The pungent smell of olive oil burning in little brass lamps used for lighting overlays the stale odor of dinners long eaten and the sour hint of perspiring bodies in the airless corridor. The lamps are an enduring design of lighting equipment in poor households surviving since Roman times.

Here the servants live; Maria the cook and her husband Antonio with little Giuseppe; the other married couples and the single women. Single men live alongside the stables. Tina hurries past her own door. It is evening and she has not much time. At the end of the narrow passageway she knocks on the last door.

"*Avanti,*" sounds the voice of the old crone. Tina quickly goes inside.

Old Palma can no longer walk more than a few steps on her rheumatic legs, but she is one of the few servants at Palazzo Castellani who can read. She sits out her days dreaming of her childhood in Spain, before she came to Italy as a household slave, one of many arriving after plague decimated the population of Tuscany years ago and there was a desperate need for laborers. Palma fixes clouded eyes on Tina.

"Palma, I want you to read something for me. Look here, I've brought you a bowl of ravioli and some nice fresh bread." Tina's voice is coaxing. Tina hates admitting she cannot read, but she has concluded Palma is less likely to reveal her secret than anyone else. She hands over the small scroll of paper.

Palma, gray strands of hair half-covering her weathered, lined face, reaches greedily for the bowl with one hand and grasps the scroll in the other. She begins to read:

Carissima,

It breaks my heart to leave here without the chance to speak to you alone. You have made my heart soar like a falcon, my spirit rise as high as the meadowlark at dawn. Do not, my love, forget me. I must think of a plan for us so we can be together forever. Soon I will return to you. I kiss your cheeks, your lips, your eyes, my dearest. Do not forget me. I will return to you as swiftly as the eagle flies and until I see you, you are each minute in my thoughts. Yours, Luigi

The old crone's cackle can be heard in the corridor, Tina fears, as she reaches angrily for the scroll.

"Where did you steal that note, my girl? That note was written by a gentleman, oh yes. From a gentleman to a lady. Not for the likes of you." She cackles again before tearing into the bread with her few remaining teeth.

"Hush, you silly old cow, or I'll take back the food I brought." Tina smarts at the truth of Palma's guess as she backs out of the door clutching her paper.

THIRTEEN

A month after Luigi leaves, La Signora Castellani suffers another breakdown. Still grieving for her long-dead firstborn son, she takes to her bed and the household walks around on tiptoe. Gradually she improves, and Maddalena is able to relieve Bianca in the sick room by spending time with La Signora Margherita, winding her embroidery silks, listening to her rambling chatter.

On better days, she is able to coax the ailing woman into talking about her childhood and how she spent those happy, carefree days. She is propped up on a plethora of pillows in a comfortable chair in front of a small-paned window overlooking the garden below. Maddalena looks at the still-tiny hands and feet, not keeping up with the increasing girth of middle age, which has spoiled La Signora's once fragile good looks. The years have done cruel things to a skin that was once compared to porcelain. Now her skin's pallor shows grayish tinges; the once beautiful fawn-colored eyes and hair have dimmed and faded.

But when she talks of the balls and fetes she enjoyed as a young girl, her face lights up and worry lines disappear. She seems less remote. She talks of her family's country estate in the hills outside Florence, near Impruneta, where she spent the summers of her childhood.

Every summer she and her sister ran barefoot over the green lawns, their white dresses flowing out behind them. She talks of bathing her face in the cooling waters of the fountains, of Roberto, the gardener, who surprised them by turning on the water jets in secret, the *giocca del aqua*, the water joke, so they were drenched with the spray. La Signora actually laughs with pleasure as she recalls this fond memory.

Impulsively, Maddalena reaches out to her and takes her hand. "You will be happy again, Signora. Why, already you are improving and growing stronger every day."

"Oh, Cara," she sighs, "I hope so. Every night I pray to Our Blessed Lady that I may recover."

Maddalena, while somewhat in awe of Il Signore with his cool, distant demeanor, has always felt drawn to La Signora. In her fluttery, vague way, she has shown a real affection for Maddalena, often giving her small presents of sweetmeats and marzipan when she was young, showering her with ribbons for her hair as she grew older. Maddalena prays each night that La Signora may find calm and peace.

FOURTEEN

At the Priory, Father Bruno and Maddalena are reading Virgil when Piero rushes into the room in a state of great excitement.

"The most wonderful thing has happened! I've found the figure for the middle ground of the altarpiece, the figure directly behind John the Baptist and Christ."

He explains that he had gone to a small lake outside San Sepolcro on a fishing expedition with his brother Marco and his family. Piero planned to sketch some sky studies as the party fished from the bank of the lake..

"Suddenly I looked toward the lake and there I saw Pietro, the twelve-year old son of my brother, getting ready to go into the water to untangle his line. He was pulling the shirt over his head. He will be the young man in the painting preparing to be baptized next. It will add a wonderful bit of realism to my picture."

It is plain to see Piero is delighted at this discovery, as though he has found the missing piece in a particularly difficult puzzle. He reaches proudly into his folio and produces sketches, wonderful drawings of a slim, adolescent boy with bare torso, his head completely covered by the shirt he is removing. A little stream curves past him and the two principal figures of John the Baptist and Christ are summarily sketched in front.

The boy's body, confidently drawn, suggests both faith and innocence. It is clear that Piero is indeed a gifted artist possessing great powers of observation. Maddalena recalls that when he talks about painting, Piero's voice and his face are transformed. She envies Piero for caring so much and she wishes more than anything else to find a cause in her life to care deeply for, something or someone to waken her to real life.

*

Piero watches Maddalena, wishing he could read her thoughts. Her beauty is pure, untainted by vanity. The creaminess of her skin demands hints of rose madder, lapis, ochre to bring it to life on canvas. The symmetry of her form he can only guess, modesty demands she wear simple, dignified clothing. Marveling at her regal yet unassuming bearing, he feels a compelling attraction. What a suitable, decorous wife she would make! In a flash he hears the words of his long dead mother, Romana: *My son, with the power in your hands and your intellect, you will become the greatest artist in all Italy.* Why, Piero muses, should he not have such a wife as Maddalena? The seed is planted.

FIFTEEN

uigi has been assigned to border patrol duty near Pisa.

Away from the comfort of the barracks in Florence, away from the dining room for officers which the young men enjoy, he finds himself instead in frost-etched marshes, on windy, barren hillsides, leading cold, sullen men. He had planned to ask for leave to visit his ailing mother, but now it is impossible.

All right, he admits, he would like to go to San Sepolcro so he could see Maddalena again. Perhaps it is just as well to wait a little. He has not yet been able to visit his Uncle Baldassare in Fiesole. Guiltily, he thinks he should have written to Julietta by now, telling her their earlier, unofficial betrothal is over. He blows on his freezing hands and startles his palfrey. The creature whinnies, a pitiful, lonely sound.

Under Luigi's tunic, next to his breast, he carries several half-finished letters to Maddalena, love notes. He is disgusted with himself that he has not yet written to his father of his intention to marry her and strike out on his own, but he knows his father will be angry with him. The family finances are in crisis. Luigi is due for a promotion soon, but the money he earns as an officer would hardly keep a roof over their heads. No help there!

Surely he can secure something better. But what? Managing his uncle's estates? Perhaps those of some of his neighbors? What else can he do? No, he dare not propose to Maddalena until he has found his way. And he realizes as a particularly frigid blast of mist envelops him in the saddle, he'd better have a plan of action in mind before he discusses the matter a second time with his father. Writing to Maddalena will have to wait. At least, he reflects, she will have his farewell note left under her door the morning he departed.

*

In San Sepolcro, Piero sits in the studio atop his house, holding the purring cat on his lap as he gazes out into the night. Absently he strokes the cat as he imagines what it would be

like, painting Maddalena. He recalls the Contessa who sat for him, fingers and arms ablaze with jewels. No, much too gaudy. Maddalena should have pearls, ropes and ropes of pearls, with perhaps one stone, rare and precious, on her finger. Amber? Certainly not rubies or emeralds. Yes, she would make a perfect wife, he thinks. But could she come to terms with the demands of my art? *You will succeed in your art, My Son. I am certain that you will.* His mother's voice rises as though from the grave, inspiring him.

SIXTEEN

Father Bruno enters the *bibliotecca* with a spring in his step. He can hardly keep his tiny feet from dancing. He has just heard important news from Mother Scholastica. He finds Maddalena is waiting for him, ready to begin her lessons.

"First, my child, I want to bring you up to date on Piero's painting. The work is nearing completion and the exciting news is that he has been offered a second commission for an altarpiece for the Confraternity of the Misericordia in San Sepolcro. Maddalena, this altarpiece will contain a total of twenty-three panels! It is a huge commission. *The Baptism* and this new work will be the making of Piero."

Maddalena understands this new commission will be a splendid advancement for Piero. Some of the leading men of San Sepolcro are members of the Confraternity. Signore Castellani belongs to it. It does seem as though Piero's star is on the rise.

"And when will we be able to congratulate Piero in person?" she asks.

Father Bruno can hardly contain himself. His feet begin to dance and his black robes sway. Excitement takes over in his voice. "That is the other important news, Maddalena. Piero has invited us, your dear mother Bianca as well, to visit his *studiolo* tomorrow and view *The Baptism*. He wants us to be the first to see it."

Maddalena is pleased at the prospect of visiting the studio. It is the best thing that has happened to her since Luigi Castellani walked into the *giardino segreto* and found her all those weeks ago. In waiting for a letter from Luigi, she has been disappointed. Perhaps she should forget all about him, enjoy the visit to Piero's studio.

SEVENTEEN

Father Bruno and Maddalena walk toward Piero's house battling autumnal gusts of cooling air. Bianca, occupied with La Signora, is not able to join them, but she gives her approval of the outing, hoping it will divert Maddalena from her preoccupation with Luigi Castellani. Maddalena has not yet told her mother what her true feelings are; she is hardly sure she knows. She is still dreaming of receiving a letter from Luigi, but nothing as yet has arrived.

Piero's house, on the Via della Chiesa, is in a section of San Sepolcro Maddalena does not know. The poorer neighborhood showcases crumbling plaster and sagging shutters, roofs with broken tiles. A few tired flowers have given up in window boxes, their blackened stems and leaves a reminder of winter's imminent arrival. Still, some old carved doors from an earlier time and the occasional window of small-paned glass give the area a certain austere charm.

Father Bruno stops in front of a solid, carved doorway and pulls at the bell. The house is well-maintained, more imposing than its neighbors on either side, Maddalena notices. From within the depths of the house they hear footsteps approaching. In a matter of seconds, Piero himself opens the door. His welcome is especially cordial.

They enter a warm courtyard with carefully tended geraniums blooming in pots. An enormous orange cat sits in the courtyard washing in the sunlight. Seeing the visitors, the cat pauses, one white paw still raised, fixing an unblinking gaze on Maddalena as she passes. She cannot resist rubbing his head.

"My cat, Giotto," Piero explains. "He is spoiled beyond measure."

Entering a passageway at the rear of the courtyard, they climb a staircase taking them to the *studiolo.* As they enter, Maddalena is struck by the wonderful light high above the surrounding rooftops. There are half a dozen windows. Painted panels are stacked around

the lower walls. Several easels stand in corners. The largest easel in the center of the room holds a huge panel covered by a curtain.

Maddalena sees several paintings of mythological figures, destined, she supposes, for some villa library. There is a fine Hercules, a beautiful Diana the Huntress. The room holds four comfortable chairs grouped on a Persian carpet with a small table in the center. Her eyes stray to the large curtained panel on the easel. This must be *The Baptism*, she decides, as she launches her speech to Piero, voicing Bianca's regret at being unable to be present because of Signora Castellani's indisposition. Her eyes return to the large easel and the drawn curtain and she waits for Piero to speak.

Without fanfare, Piero steps up and draws aside the curtain. Father Bruno clasps his hands to his chest. Maddalena gasps in astonishment.

"My Son, you have created a masterpiece! Look at the light!" Father Bruno's voice is hushed.

They drink in the fall of light, real sunlight, in the painting. There are so many things to see! The town of San Sepolcro rising in the background, the hills, the young acolyte ready to be baptized, the figures of Saint John and Christ, the Holy Dove. But Maddalena's eyes are frozen on the left side of the painting, where three angels, beautiful young girls, watch the scene which is taking place. Two of the girls are looking outward, the third angel, painted a little aloof from the others, is seen in profile. She wears contemporary clothing, unlike the other two, who are draped in robes of a classical style.

She recognizes herself immediately, the high forehead, flowing blond hair hanging smoothly, even her old gray dress bound in black ribbon, which Piero has transformed into a beautiful crimson gown, adding blue drapery around the skirt. She is aware of those dark, hooded eyes of Piero boring into hers, speculating on her reaction. Father Bruno too, has seen Maddalena's figure in the picture. Puzzled, he awaits an explanation.

"Why did you put me in your picture without asking me?" Maddalena's shrill voice explodes in the quiet air. Her face glowers with a mixture of anger and resentment. In her heart however there is a tiny flicker of pride, a feeling of happiness that she has become a part of such a beautiful work of art.

Piero speaks up, his voice matter-of-fact. "Only recently, two nights ago in fact, I realized something was lacking on the left side of the painting. Another figure was needed. I had made some sketches when I visited the *bibliotecca* to visit with you and Father Bruno. My two nieces, Angelina and Fiona, were models for the two outward facing angels. At the last moment, I decided to add a third figure and you, Maddalena, were the obvious choice. I confess I hoped you would be pleased." He has the grace to lower his eyes, awaiting her tongue-lashing.

"You might have told me," Maddalena falters. "Surely. . . ," she leaves the words unsaid. Her head is pounding and her hands feel like wet clams. Of course she is annoyed, but a feeling of the greatest pleasure is seeping over her.

"My dear child," Father Bruno begins, pouring oil on troubled waters. "I am sure Piero meant you no disrespect."

"Indeed no," Piero says quickly. "I showed the sketch I had made of you to Mother Scholastica, Maddalena. She thought you would make a perfect angel figure." Unhappily, Piero looks at Giotto the cat who has sidled in, waving his plume of a tail.

"Truly I was so overcome by your beauty, I simply could not resist painting you," he mutters sadly. He stands there looking miserable, staring down at his paint-stained hands. He seems unaware of the priest's presence. He is speaking as though he is alone with Maddalena.

Pleased at his words, the tensions slowly dissolve within her and Maddalena feels calmer. But why can Piero not express himself more easily? If only he would strip away the mask which hides what he is feeling and speak up.

"I find it hard to say the words when I am with people," Piero speaks up surprisingly, as though privy to her thoughts. Father Bruno has tactfully withdrawn to the kitchen to have a few words with Lucia, the housekeeper, a faithful communicant at the Priory church.

"I, I find it easier to say as few words as possible," he admits. "Things seem to go better when I do that."

"Surely not, Piero, for how can people become closer, become friends, if we do not give of ourselves?" Maddalena's sincerity touches him, her eyes lock with his, pleading for understanding.

"Maddalena, I promise I will try. No more surprises, all right?" Piero looks hopeful.

The moment is interrupted by the reappearance of Father Bruno and Lucia bearing small goblets of watered wine and a plate of tiny almond cakes on a tray. Giotto keeps close to Lucia, hiding himself behind her skirts as she serves them. Lucia, a small woman with a face deeply lined like a walnut, is whippet thin, hair scraped back in a bun. Her movements are quick and efficient.

Maddalena notices the beautiful silver salver, the chased goblets. Everything in plain, unadorned style but of the highest quality. It is true, she thinks, so much is admirable about this man, in spite of his inability to relax.

The three settle comfortably in the chairs, the cat rubbing against Piero's ankles. Maddalena casts furtive glances at the glorified Maddalena in the painting. She is growing accustomed

to the idea of being in such an important work of art. Perhaps she has misunderstood Piero's remoteness in the past. It must be explained by his shy nature, she reflects.

They discuss the figure of Piero's nephew, the acolyte in the painting. Piero reveals he was aided in drawing the finished figure by a recently-unearthed fragment of an antique sculpture of a torso found in Florence.

"There have also been several such fragments uncovered in the old burying ground of Santa Croce I believe," Piero adds. "It is thought to be the site of the old Roman Forum." Father Bruno nods happily, pleased that at last, harmony has been restored.

"I know," Maddalena adds quickly. "Pliny speaks of such." Piero looks intently at her while Father Bruno beams. Piero is thinking *she is certainly not empty-headed, like some women.*

All the way back to the palazzo Maddalena hugs the words of Piero to her heart. *He thinks I am beautiful! Even with my light lashes and brows! He placed me in his painting!* The wonder of it sends her feet flying over the cobblestones, thinking of the vision in the painting. Father Bruno is hard-pressed to keep up.

When Maddalena tells her mother of the visit, Bianca is pleased. She must meet this artist, this Piero della Francesca, if he thinks enough of Maddalena to place her in his painting. And of course, with Mother Scholastica's approval, he is above reproach. She wonders to herself if he might possibly be a candidate for her daughter's hand.

EIGHTEEN

a Signora Castellani has recovered.

With three doctors in attendance, prescribing everything from chewing sage leaves, drinking a draught made from rhubarb, to a tonic of unknown ingredients boiled for three days in a cauldron (supposedly a panacea for all ills), most of the credit for her restoration belongs to Father Lorenzo, her priest, who is only concerned with her state of mind and spirit. He writes to her:

Let me speak to you of your well-being. Do not allow yourself to be grieved and taking matters so much to your heart. For it is these things the doctors try to teach us which destroy our bodies more than they heal us. Signora, I beseech you, restrain yourself from grief above all things and you will be healthy in your body and in your mind.

Remember your most important duty in the world is to be fit to give thanks to God. To this end you must strive with your whole mind and heart.

NINETEEN

Piero is having second thoughts. Angrily he paces the floor of his studio. Why did he open himself to vulnerability by revealing his innermost thoughts to Maddalena when she visited the studio with Father Bruno? This very minute she could be laughing at him. Joking at the Palazzo Castellani about how unlike a man of importance he has behaved. Why, oh why, did he have to blurt out the words to the girl of her beauty? She must think him a fool.

Every nerve end is on alert. The very act of showing one's feelings is dangerous. Does he not, in every painting, show the figures calm, thoughtful, devoid of any emotion? Layer by layer, like the second skin of some lowly creature, he has built an impenetrable wall of protection around his innermost thoughts.

The mask of his face, the inscrutable eyes---all are a piece of it. The invisible wall festered and expanded during the horrible years of privation when no one but his mother and his brother Marco could be trusted not to turn on him. Now he knows he cannot exist without that invisible wall.

All night he tosses and turns, but by morning he has a plan. He will make an impromptu visit to Maddalena and meet her mother. Then he will judge their reaction to his intemperate words, words of his admiration for Maddalena, to see what harm has been done.

Calm at last, he works for an hour at his easel. This always promotes serenity. Painting is the one constant in life which never fails him. As he paints the folds of the gown of the Madonna of the Misericordia, in the pose of a towering icon, he feels strength of purpose surge through him. The new altarpiece will show God's grace and compassion toward all mankind, and this time, the figure of the Madonna, if all goes according to plan, will have the face of Maddalena.

TWENTY

A cloudless, sunny autumn morning, with air pure like crystal.

Piero arrives at Palazzo Castellani after a brisk walk and pulls on the bell rope. A sullen, smoldering-eyed serving girl in a rumpled apron opens the door and sulkily admits him. He asks for Signora dei Crespi.

When summoned by Valentina, Bianca smoothes at her hair, straightens her back and shoulders. She has been showing Maria the proper way to stuff a goose with a dressing made of stale bread, eggs, ground nuts and spices. Who can it be? She hurries down the corridor and opens the door to the *salone*.

Piero introduces himself at once, begging her pardon for a surprise visit. Bianca replies with great warmth, telling him that Maddalena is with Father Bruno at the Priory.

"How disappointing," Piero murmurs. " I wanted to secure permission from the two of you to paint her as the Madonna in my new commission for the Confraternity of the Misericordia." His eyes study Bianca's face, gauging her reaction.

Bianca, who has been taking in his appearance from his good quality tunic and *berretto* to the small, poorly mended run in his hose, suddenly jerks to attention. Her look of radiance is instant. Surely he cannot be mistaken at that. She seems to approve of him in every way. How fortunate that he made the call. Perhaps it is just as well Maddalena is away.

"What an honor! I am sure Maddalena will be beside herself with joy. Indeed, we are grateful to you, Signore. She told me of what a rare privilege it was to visit your studio, and to find that she had been placed as a figure in *The Baptism*. And now, you choose to paint her again in the Misericordia altarpiece. You must pay another visit when she is here. Indeed, I would like to present you to Signore Castellani and his wife. He is a member of the Confraternity of the Misericordia. I am sure he will be delighted to meet you. Will you call again?"

*

Piero leaves the palazzo well satisfied that his declarations to Maddalena and his impromptu visit to her mother have been well-received. His fears have been proved groundless.

TWENTY ONE

It is decided that the ideal place for Piero to begin the sketches of Maddalena will be at the Priory after the daily lessons are finished. He has already begun painting the large oak panel of the Madonna in his *studiolo*. When Bianca tells Maddalena of his visit and the news of her part in the painting she is speechless, hardly able to believe her good fortune. In this work, *The Misericordia Altarpiece*, she will be the primary figure.

Father Bruno and Piero keep up a lively discourse as Piero sketches Maddalena at the Priory, once the altarpiece is underway. Bianca, who sometimes is present as an onlooker, is delighted at the arrangement. She and Piero seem to get on very well. It again occurs to Bianca that Piero might be a possible suitor for Maddalena. Of course, she realizes, the lack of a dowry may be an insurmountable obstacle.

At the appointed hour Piero arrives at the palazzo for an evening visit and to be presented to the Castellani, just as Bianca promised. Sitting in the *salone*, listening to the conversation between the two men, Maddalena is struck by the ease with which Piero fields questions tossed by Signore Castellani concerning *The Misericordia Altarpiece*.

Yes, he will be using his own mixture of tempera and oil for all of the panels. No, he does not prefer the use of gold leaf as a background, but the Confraternity wishes it, and he will gladly comply. Why does he not like the gold leaf? It is simply a matter of preference, Piero replies smoothly. Both are in good taste, he simply prefers a natural background, such as landscape.

Watching Piero approvingly, it seems to Maddalena that an artist needs to possess a pleasant manner, not just painting skills, if he wishes to make his way in the world. She feels with a hint of pride that Piero has acquitted himself extremely well. Both of the Castellani are drawn to Piero's forthright and intelligent manner. Maddalena sees Piero for the first time in the role of confident artist, speaking fluidly and with authority to patrons. She likes this image.

No longer does she feel shy around him. On the contrary, she feels comfortable, as one's feet grow accustomed to worn, soft slippers. No bells go off when she is in his presence, but the atmosphere is pleasant, peaceful. She is beginning to appreciate his worth. Piero can be compelling when he bends low to pass her a glass of wine when she is seated, or when he appears with a winter bouquet of bright blue juniper berries nestled in their silver green foliage and offers it to her.

The *Misericordia Altarpiece* is an enormous undertaking for one artist. Unlike so many painters who employ assistants, Piero works alone. He keeps no apprentices to paint the routine passages of a work. The altarpiece includes a Crucifixion panel, seven *predellae*, the small panels at the foot of the principal panel which will depict scenes, legends, if you will, in the life of the Madonna. In the center panel containing the Madonna of the Misericordia standing in long red robe and holding out the sides of her blue cloak, tiny figures shelter, four on each side, looking up at the Madonna in adoration. The remaining panels will contain large figures of saints.

Il Signore clears his throat and speaks to the little gathering in the *salone*. He is a tall man, slightly stooped, more jovial than usual, obviously relieved at his wife's recovery. He is a paler, more faded version of Luigi, Maddalena thinks. Lines heavily etch his brow.

He tells them of the Confraternity of the Misericordia in San Sepolcro, an organization of laymen who dedicate a portion of their time to works of mercy, especially the bringing of the sick to hospitals and preparing the dead for burial.

By the end of the visit, after sipping the obligatory wine and tasting tiny almond cakes, both Signore Castellani and his wife have come under Piero's spell. Certainly Bianca is a convert. And I, what do I think? Maddalena realizes that she now regards Piero as appealing. Her initial impression of him must have been wrong, she reasons.

TWENTY TWO

*N*atale, Christmas, filled with solemn observances of a religious nature, is past.

Tuscany is caught up in a flurry of winter snowstorms, but inside the palazzo there is warmth and good feeling, as preparations for the traditional fete of Epiphany begin. The holiday is dedicated to *Befana*, the jolly, good witch who brings presents to all children.

Il Signore's fete for the servants and their children is always held in the ballroom at the top of Palazzo Castellani on this day, when the Three Kings brought their gifts to the Christ Child. Music, singing and dancing furnish entertainment. Long tables pushed against the walls groan under the weight of hams, roasts, pies and pastries, sweetmeats and honeyed fruits.

Again, in deference to the sumptuary laws of the time which control the lavishness of banquets, Bianca has specified to the cook that many items on the menu be combined into huge pies, so as not to exceed the lawful number of courses allowed.

Bianca and La Signora have embroidered caps for each child and the children will receive a basket of oranges and sweetmeats from La Signora and Il Signore Castellani. Maria and her helpers are setting aside trays of marzipan angels, bells and stars in the pantry. Traditions of many years give added meaning to the feast. Bianca suggests Piero should be invited to sing and play his lute.

"Mother Scholastica tells me he plays for his own enjoyment. Last year he played for the children of the Ospedale degli Innocenti in *Firenze* and he was the highlight of the evening. Mother Scholastica's sister Marta is a nun there," Bianca explains. Maddalena agrees with her mother, and she offers to ask Piero to come and bring his lute.

Thoughts of Luigi, like tender seedlings deprived of water, languish in Maddalena's heart. She has heard nothing since his departure. Will he come to the fete? To see him just once more, cries her yearning heart. She can then put him out of her mind forever. Piero, she reminds herself, Piero is steady, a man who grows on one.

By the evening of the fete, all of the servants should by rights be confined to their beds, too exhausted from their labors to attend. Such scrubbing, brushing, polishing! Every surface shines. The ballroom, neglected for many years during La Signora's illness, glows tonight like the Christmas star. A room of magnificent proportions, it boasts a polished marble floor laid out in a geometric pattern of squares and circles. Wine-colored damask draperies add to the richness, while pier mirrors hang between windows, echoing the light of many tapers.

Great, sweet-smelling boughs of cedar festoon the top of each window cornice and the large mantel piece. A life-sized *presepe*, a creche, stands at one end of the room with carved, brightly painted figures of Maria, Giuseppe and the *Bambino*. Cedar branches serve as a roof. The tables, laden with the banquet fare, are decorated with wreaths of pine and yew, criss-crossed with scarlet ribbons. All is in readiness. Only the guests are lacking for the Epiphany fete.

*

Piero puts the new tunic over his head and pulls on new hose in preparation for the fete. He will be playing his lute in the grandest house in San Sepolcro, the Castellani palazzo. The Graziani family is well-pleased with *The Baptism*. The Confraternity of the Misericordia has commissioned an altarpiece of twenty-three panels from him. As his star seems to be rising, surely it is time to take a wife. Carefully he combs the dark curls surrounding his face before putting on the *berretto*. He looks in the mirror declaring, *Maddalena is the one*.

TWENTY THREE

few hours before the fete will begin, a particularly foggy, disagreeable day outside, a letter arrives for Il Signore. He accepts it and retires to his study to read it in private.

26 December, From the Florentine Border near Pisa

Dear Father,

My heart is full of joy to learn of Mamina's recovery. I pray for her daily. It pains me greatly that I am unable to leave here for home. I would wish with all my heart to be there for the fete. The enemy however, is growing bolder. There have been no real battles yet, but last night, one of our best scouts was killed when he ventured too far behind enemy lines.

This bivouac on the borders has been good for me in some ways, however. Out here alone with my men, spending long hours on patrol and even more time in my tent before I fall asleep, I have had time to give thought to my future.

I shall always strive to be a credit to you and Mamina. I want to bring honor to my family, just as you have done. But Father, I cannot give up Maddalena. I am truly in love with her, and I am determined to marry her. You were right when you said she was not an object for dalliance.

Whatever I can find in the way of honorable employment, I will seek. It may take some time, but I am determined on a course to make my own way---to support a wife and at the same time bring wealth into the family. At present I do not know what awaits me, but I am set on this course.

I am writing a second letter to you both, mentioning none of this. I do not wish to upset Mamina. The time is not ripe to give her my news until she is stronger. Nor am I writing to Maddalena yet. I must await your reply, Father.

It looks as though there may be war with Pisa very soon. I am hopeful you and I can talk things over calmly with some perspective, and that you will understand how I feel. I have written to Julietta, breaking things off. Your loving son, Luigi

Giuliano Castellani lets the letter fall from his hand to the desk of his study. The young fool! Does he think he is the only man in the universe who ever fell in love with someone unsuitable? Does he? He passes a weary hand over his brow. Never will he forget his own mistakes. Indeed. he is daily reminded of them. In his very own house. *Luigi, Luigi, with Paolo gone, my only hope for salvation lies with you. Do not forsake me.* Wearily he climbs the stairway to prepare himself for the fete.

<div align="center">*</div>

Children, dressed in their best, frolic in the simple games and raise their voices in song. La Signora, who possesses a sweet, lilting soprano, sings several carols for the company. A trio of musicians, playing violin, cello and flute, strike up music for dancing. But Piero and his lute are the undisputed favorites of the evening. Time and again he is begged for "just one more song." Servants sing and dance in harmony with their masters. It is a happy celebration of their lives together, honoring the religious tradition they share.

Nearing midnight, many of the little ones are falling asleep in the arms of their mothers. Piero picks up his lute and begins to sing some verses of Dante Alighieri as a finale..

"So gentle and virtuous she appears,

My lady, when greeting other people

That every tongue tremblingly grows silent,

And eyes do not dare gaze upon her.

She passes by, hearing herself praised,

Graciously clothed with humility

And she appears to be a creature who has come

From heaven to earth to show forth a miracle.

She shows herself so pleasing to her beholders,

That she gives through the eyes a sweetness to the heart

Which no one can understand who does not feel it,

And it appears that from her lip moves

A tender spirit full of love,

Which again says to the soul, "Sigh".

Piero sings the familiar words with feeling, and his eyes are trained on Maddalena. A hush when he finishes, then *"Bella! Bella! Bellisima!"* The fete is over. As the guests depart, Giuseppe is carried off to bed with a stomach ache, having eaten too many sweetmeats. Her cheeks flushed from the excitement of the evening, Maddalena bids Piero a warm farewell as he makes his way into the night.

Entering her room, she suddenly realizes: *Luigi did not come!* In her heart, she had hoped he might appear. Until this moment she has forgotten him. All her thoughts have been on Piero, who can be very pleasing if he puts his mind to it. She is thrilled by the tribute he sang to her through the words of the immortal Dante.

Is not Piero a man towering above all men? Will not he be remembered as the greatest artist of the age? Am I mistaken, or does he not prefer me above all others? Her head is spinning with the remembered song he sang to her at the Epiphany celebration at which Piero was undoubtedly the star.

*

Piero walks homeward, the new fallen snow softly grinding underfoot. Maddalena seemed moved by his singing of Dante's love song. A good sign? His thoughts slide over the secret sketches he already has made of her, a kneeling Magdalene figure, hair streaming down her back; a Diana, not at her bath, he blushes furiously in the dark at the thought, rather Diana ready for the hunt, modestly clothed in Tuscan riding dress, her hunting hounds beside her; and finally the towering Madonna figure in an enveloping blue cloak under which shelter tiny figures, the Maddalena of the new altarpiece.

TWENTY FOUR

*B*ianca is hurrying toward the *giardino segreto* with purposeful concentration, unmindful of the pungent scents of yew and juniper lining the paths. There is a fine mist falling which foretells colder weather. She is on a mission to find the serving girl Valentina, who has disappeared from her post in the kitchen where she should be helping Maria fill the oil jars.

She rounds a turn in the path and sees the missing girl standing with her back to the entrance of the secret garden. Valentina stretches out her hand in front of her and peers intently at it.

"Tina! What on earth are you doing here?" Bianca's voice is sharp, her patience with the girl at an end.

Tina whirls around, thrusting her hand behind her, but not before Bianca's watchful eyes catch the glint of a stone. She quickly steps forward and grasps Tina's arm. A square cut emerald set in heavy gold winks up at her from Tina's finger.

"Tina! La Signora's emerald ring! What can you be thinking of? Take it off at once." Bianca is deeply shocked. Sullenly glaring at Bianca, Tina removes the ring and places it in her hand.

"Tina, how could you do such a thing? Poor La Signora will be beside herself if she finds her ring is missing! Il Signore will have to be told. You will be flogged. How could you be so foolish?" Bianca's voice is agitated in spite of herself. Tina is exasperating..

"I only meant to keep it a little while," Tina stammers, choking on the words as her tears begin to flow. Bianca is struck by how vulnerable and tender the usually frowning face now looks. Then, "Go ahead, Signora Bianca. Tell Il Signore. I don't care." Defiance.

"Go to Maria in the kitchen, at once, Valentina," Bianca replies, her voice now under control. She puzzles over Tina's reaction, watching her leave. It seems almost as if she wants Il

Signore to learn of her misdeed. Valentina has been a problem since she arrived. Never fitting in, always contentious, her demeanor more like that of a spoiled princess than a servant.

Bianca shakes her head as she walks toward La Signora's quarters. With luck she can return the jewel to its casket, and La Signora will be spared the trauma. But with a lump like lead in her throat, she knows she must speak to Il Signore about Valentina's behavior.

*

Bianca has replaced the ring and is now on her way to Signore Castellani's study. She approaches nervously, for he always seems reserved and remote to her. Cool, impersonal, correct. No more. She dreads the gaze of the icy blue eyes appraising her. She taps timidly at the door.

"Enter." He is standing at his desk by the window, looking out at the threatening sky. Bushy gray brows fly upward. He does not ask her to be seated. Without preamble Bianca launches into details of the incident with Valentina. As she finishes she finds herself wishing she had kept her silence. But no, she tells herself, he must be told, so that it will not happen again.

"Well, this is an unpleasant surprise." His response is slow, measured. " I would not have expected it of her. She comes from Fiesole, you know." His voice sounds detached, he might be discussing a burnt pudding or an underdone piece of meat, Bianca thinks. Bianca waits silently for instructions. The room is quiet except for the sound of hissing coals in the small brazier at his feet.

"She seems to be terribly unhappy," Bianca says softly, watching as his hands form a pyramid of long, tapering fingers. "The unhappiness erupts into anger most of the time. I never know what her mood will be."

Another long pause before Signore Castellani speaks. The wind whistles, rattling the glass of the window. Bianca feels the cold seeping through her heavy skirts. Only a little warmth from the small brazier reaches her. The wind flickers the candle on the desk. Giuliano Castellani studies Bianca's face carefully, his eyes calculating.

"No, let me correct myself," he says at last.. "Her behavior is *not really* surprising to me. I have known for some time she is unhappy here. You see, her mother Ginevra, who was a servant in the household of my brother, died. It was decided it would be best for her to come here."

But why? Why would they send her away from everything she has ever known? Bianca puzzles silently, keeping her eyes lowered, waiting for him to continue. Finally she summons her courage and speaks.

"Perhaps it would be best to dismiss her, if her work here is not satisfactory," Bianca murmurs. "Give her a chance to find a more agreeable place."

"Ah, but it is not so simple, Signora. You see, Valentina is my natural daughter."

His voice is so low Bianca thinks she has misheard. "*Pardone*, Signore?" Her heart begins to race. Suddenly the temperature in the little room rises to that of the tropics.

"Yes. It is true." He sighs heavily. "She was born four years after my son Paolo died. My wife, as you know, has been in a terrible mental state since that death, sickly and preoccupied with her own health to the exclusion of everything else. My surviving son, Luigi, was living with my brother-in-law in his household in Fiesole. I went to visit Luigi whenever I could. He was only a little boy and he missed his mother. He was lonely. I, I was lonely too." He focuses his gaze directly on Bianca. She gives a slight nod, lowers her eyes. Loneliness she understands.

"I, I, Signore, I did not know." Bianca keeps her eyes on her feet. In a matter of seconds she has altered her opinion of the man. In his burden of sorrow he now seems more human to her. Giuliano Castellani swats at the air impatiently, as though waving away a troublesome insect. Clearly pride rejects pity.

"I know I was wrong, Signora. It happened and I realized how irresponsibly I had behaved. I ended my contact with Ginevra long before the child was born. But I paid for the care of both the mother and the daughter. And I am still paying the price of remorse. It is heavy on my conscience."

"Tina seems to feel the world owes her something," Bianca says, nodding her head in understanding. "But money is not always the solution to every problem," she adds, surprised at her boldness.

"That may well be true," he agrees ruefully. "I had hoped one day to reveal the secret to my wife so that Valentina might become a daughter to us both, but, as you see, Signora, my wife's health is still very delicate. She is not strong, either mentally or physically."

"No Signore, you are quite right. La Signora is not yet strong enough to receive this revelation. Why, she has only just recovered from another breakdown."

"So what now? I cannot have my own daughter flogged, nor can I turn her out. What am I to do?" He passes a hand over his eyes. Bianca can hardly believe that he has unexpectedly revealed this secret to her. But in her mind a glimmer of an idea is taking root, a way out.

"And your brother-in-law cannot take her back?" she asks, seeking confirmation rather than in hope.

"He would like to help me, but he took on an entire family when Ginevra died. The woman is the cook and the man is the gardener. They have five children. His quarters for servants are filled to bursting. That is why Valentina was sent here. There was simply no room in Fiesole for her." Bianca nods.

"Then you must make a settlement on her and find her a husband," Bianca says promptly, gathering her courage about her like a cloak. "She is a woman, fully developed and ready for marriage. Some artisan will be glad of such a pretty wife, especially if she brings a good dowry to the marriage."

Giuliano Castellani purses his lips and flexes the slim fingers. Signora dei Crespi has a head on her shoulders. She will be able to guide him through this, tactfully, discreetly, with no danger of upsetting his poor wife with the shock. Of course the cost of the dowry he can ill afford, now that Luigi is being so foolish. Still, he must not delay. Resigned, he agrees. Valentina must have a husband.

TWENTY FIVE

Maddalena and Bianca are seated in the decidedly cold, draughty sanctuary of the Priory, awaiting the dedication ceremonies to begin. It is January 20, Saint Sebastian's Day, and the day of dedication for the new altarpiece of *The Baptism*. Maddalena is wearing the same dress (transformed into crimson by Piero in the painting) and her hair hangs in riverine strands down her back, just it appears in the altarpiece. For once she has forgotten the shame of her blond brows and lashes.

She and Bianca draw their cloaks more tightly each time the wide sanctuary doors are opened to admit guests for the dedication, and a frigid rush of cold air numbs their feet. Surely all of San Sepolcro is gathered in attendance. Maddalena admires the rich, fur-lined cloaks and hats made of *bevero*, beaver, the elaborate, gold-embroidered *cioppe*, coats, the women wear, many edged in miniver fur. The embroidery of the heavy gowns glints in the glow of flickering candles lighting the interior of the church.

They listen to the high, sweet voices of the nuns singing behind a screen, hidden from view. Bianca and Maddalena are seated in a row behind the Castellani and other local dignitaries. As the pure voices fill the cavernous sanctuary with sound, excitement builds. The altarpiece, covered by a large drapery, awaits the unveiling at the altar of the Graziani chapel, the chapel of the donors.

Bianca whispers she has heard that six of the singers behind the screen have come from the Ospedale degli Innocenti, the foundling hospital in Florence. They have been issued a special invitation by Mother Scholastica, and escorted to San Sepolcro by her sister, a nun there.

"It is very clever of Mother Scholastica," says Bianca, "the idea of inviting the girls from the Ospedale. It will give them an opportunity to visit the Priory. They will be leaving there soon, and perhaps they will decide to take the vows here at San Giovanni Battista."

What better opportunity indeed, thinks Maddalena. Still, it seems sad somehow, to send them from the sheltered life of the Ospedale directly into the Priory. When will they be able to sample real life, its joys and sorrows? But where else can they go?

A sudden blast of trumpets sounding from the rear of the sanctuary marks the approach of the procession. First, banners of the Priory of San Giovanni Battista are borne in. Next, a young priest bearing the cross, followed by Mother Scholastica, impressive in her black robes and white headdress. Father Bruno follows. The family of the Graziani files in, mother and father with five sons ranging in age from fifteen to thirty years, followed by officials of the town of San Sepolcro, resplendent in robes of their office. Finally Piero enters, plainly dressed in a rich brown wool of superior quality, moving slowly yet purposefully toward the platform. He looks neither right nor left, displaying a fitting solemnity, appropriate for such an occasion.

After the prayers, Mother Scholastica approaches the draped painting. She makes an imposing figure, tall, thin, an open face, hooked nose and clear blue eyes over a mouth of strength and determination, features handed down by generations of good Tuscan farmers, her ancestors. Maddalena is always in awe of her, thinking she looks a little like a huge, powerful bird in all-enveloping robes and stark headdress. She begins to speak, the resonant voice ringing out over the sanctuary.

"Many of you here today have worked hard and have prayed that we might some day arrive at this particular moment, the dedication of an altarpiece to the glory of God of the saint for whom this Priory is named, San Giovanni Battista." She pauses.

"Today God has answered those prayers. Today we give thanks. No one has worked harder than the artist, Piero della Francesca. He has painted an altarpiece worthy of the Baptism, that most holy moment in the history of the Church. He has given us the actual sunlight of God's green earth. He has painted portraits of persons who live here among us, in our town. In the face of Christ he has painted a portrait of the revered ancestor of the donors, the Graziani family." She nods to the family members seated below her.

"You will see this altarpiece in a moment, but first let me tell you one more thing. In the background of this wonderful work are the towers of San Sepolcro portrayed in all of their splendor. Our town is immortalized in this painting. Now, let us give thanks for the hands and the eyes and the mind of a gifted painter, one of our own, Piero della Francesca."

At a signal from Father Bruno the curtain falls and the altarpiece is revealed. There is a communal gasp followed by the thunder of applause and cries of *Piero! Piero!* Mother Scholastica beckons Piero forward. Slowly he rises to his feet and holds out his strong, slender artist's hands, begging for silence.

"Friends, you do me great honor, but I cannot claim it. The altarpiece came into being because of the prayers of many, because of the generosity of the Graziani family who first approached me with their dream of a Baptismal painting for the Priory. Then Mother Scholastica, who

supported the hope with her prayers, Father Bruno, whose prayers and guidance never failed me, even on difficult days." He looks down on Maddalena.

"There were others, many others. Without their help, I would have failed." He sits down quickly as many nod their approval of his ringing voice, his eloquence, his humility. With renewed applause, the ceremony ends, and Mother Scholastica invites the guests to inspect the altarpiece, then proceed to the refectory to partake of a small collation.

As Maddalena and Bianca stand at the fringe of the gathering in the refectory, they are joined by Piero who has managed to disentangle himself without giving offense from well-wishers who have dogged his heels.

"I would have a word with you, Maddalena," he whispers in her ear as Bianca moves to greet someone across the room. He guides her toward the deserted corridor leading to the sanctuary.

Piero turns to her and begins, "This morning I received a letter of great importance from the Duke of Urbino, Federigo da Montefeltro. He has written asking me to come to Urbino to serve as his court painter. He will pay me handsomely, and I shall be free to paint what I wish after I have done his bidding. To be his court painter is the chance of a lifetime, Maddalena." He looks into her eyes to measure her reaction.

"What a wonderful preferment, a wonderful opportunity, Piero, to be sure. But it means, of course, you will be leaving San Sepolcro?" Maddalena's eyes are lowered as she struggles to hide feelings of dismay.

"That is the crux of the matter," he nods solemnly. "I, we, I had hoped we were getting to know each other better. I dared to hope..."

Quickly she looks at him, willing him to go on. "Yes, Piero?"

"You surely know that I care deeply for you, Maddalena. I need someone to share my life, a wife." He blurts out the words and they quickly look right and left, but the corridor is deserted. He has not been overheard.

"A wife?" Maddalena gasps. "Piero," she takes his hand. "I must tell you, I want no misunderstanding between us. I have no dowry settlement, not even one florin. My mother is honorable, but poor. My father died before I was born. Her family, the Albizzi, were banished, some even killed, long before I was born. So you see. . . "

He breaks in impatiently. "Do you think I care about a dowry, Maddalena? I have enough for both of us to live in comfort. With God's help these hands will paint many, many more altarpieces. I only want you, not some settlement on you as though you are a piece of property, like a horse or a cow. You are much dearer to me than that. As for your mother, a

finer woman I have never met. The Albizzi were an honorable family who fell on misfortune. I, of all persons, understand how that can happen."

"I am pleased you feel as you do, Piero," she answers, her heart pounding. Thoughts crowd into her head like a flock of pigeons settling to roost. Things are hurtling along too fast. Why, she is only beginning to feel comfortable around Piero. What indeed are her true feelings about this man? He bends low to speak softly in her ear, sensing her uncertainty from the anxious look on her face.

"Maddalena, I know it would be better if we had more time. But I have only a fortnight before I must leave for Urbino. Why cannot we try to become closer now? Then let me speak to your mother if all goes well. We can announce our betrothal at the time I depart."

Maddalena is bedazzled. What Piero suggests is reasonable, but she knows she must think carefully. Suddenly she remembers *The Misericordia Altarpiece* he has just begun. What of it? Surely he must stay and finish it? She questions him.

"I have three years in the contract in which to complete it," he answers her smoothly. "I am almost finished with your face and figure, Maddalena, in the largest panel. Those sketches I completed have sped me along. When the sketches of the other figures are finished, I can take them with me and work on the smaller panels during my free time in Urbino. An artist must follow his chances, Maddalena. I simply cannot turn down such an important opportunity as the Duke of Urbino has given me."

"Then we must use the time you have left to decipher our feelings for each other, Piero." Maddalena's voice is resolute, putting on a brave front. "Yes. We must make plans."

TWENTY SIX

Piero and Maddalena return to the refectory to find Bianca deep in conversation with an unknown lady. Tall and thin like Bianca, large gray eyes fringed by long lashes which give her an arresting face, enhancing dark hair and olive skin. Her long, slender neck is like the stem of a delicate flower, her clothing deceptively rich, yet simple, of the finest gray wool, so soft it could be gossamer. She fixes a bright gaze on Maddalena.

"Signora Doni, this is my daughter Maddalena and the artist, Signore Piero della Francesca." Bianca turns to them. "La Signora Giovanna has come all the way from Florence for the unveiling, bringing with her Sister Marta, a nun at the foundling hospital and a sister of Mother Scholastica. Signora Doni and I knew each other long ago." Maddalena dips in a curtsy and Piero bows low.

"So you are that delectable angel in the front of the painting, Maddalena." Signora Doni smiles, her voice musical and friendly. "Congratulations." She turns toward Piero.

"And you, Signore, what a beautiful altarpiece. All Tuscany will be singing your praises." Piero bends low over her gloved hand, murmuring his thanks.

Observing the shape of Signora Doni's eyes, her face, Maddalena realizes that she is probably related to her mother, a member of the Albizzi family. What secrets she and Bianca must have shared when they were growing up. Her eyes follow Giovanna Doni as she leaves them to speak with Sister Marta and Mother Scholastica. She must remember to ask her mother to tell her more about Giovanna Doni.

As Bianca and Maddalena walk the return journey to the palazzo, Maddalena tells her of Piero's letter from Federigo da Montefeltro. Bianca's eyebrows fly up at the mention of his name.

"The Duke has claimed the title by virtue of his beloved nephew's assassination. He is known to be not only a fierce warrior, but a great scholar and student of the arts. This is a

superb opportunity for Piero, Maddalena. No doubt he will be painting works to decorate the new palazzo the Duke is building, a palazzo which is already the talk of all Tuscany and Umbria."

"Yes, of course it a wonderful chance for Piero, but I dread his leaving and I know I shall be lonely when he departs. It is a pity, just as we are becoming better acquainted." Maddalena tries to keep disappointment out of her voice.

Bianca coughs delicately and speaks firmly. "Many men and their loved ones are separated in this world. At least he is not a soldier, facing danger on a daily basis from the enemy."

Maddalena's cheeks redden. Of course, her mother was often left alone, even before she became a widow. Luigi, too, is a soldier, Maddalena gasps as the sudden thought flies waywardly into her mind. But thoughts of Luigi must be banished. He must be relegated to the past; she must dream of him no more. In any event, he appears to have forgotten her.

They continue in silence, each wrapped in her own thoughts. When they reach the palazzo they are greeted by the sight of stacks of boxes and several trunks. The hall has been turned into a baggage area .

"Whatever can be going on?" Bianca asks as they hear hurrying footsteps running down the staircase and the anxious voice of the manservant Georgio calling out to the maids. He comes into view wringing his hands.

"Signora dei Crespi, a cousin of the Castellani has arrived. She is upstairs supervising the turning out of one of the vacant bedchambers which she intends to occupy."

"Who is this cousin, Georgio?" Bianca asks. The old servant wrinkles his brow, brown eyes flashing.

"Julietta Vespucci is her name. She comes from a village called Impruneta, near Fiesole. Oh, I do wish the Castellani were here. So much fuss. She wants a thousand things done, all at once."

Maddalena looks at Bianca in dismay. This must be the distant cousin Luigi mentioned to her earlier. Maddalena has the feeling that trouble is descending on the palazzo in the form of Julietta. For what purpose has she come to San Sepolcro? To celebrate her betrothal to Luigi? To gain favor with her future parents-in-law?

TWENTY SEVEN

*L*uigi Castellani arrives at Palazzo Castellani riding at full speed, his horse covered with foam. He has hurried home from duty on the only pass he could obtain, granting him a mere twenty four-hour leave from his post on the frontier. Exhausted, he pries himself from the saddle, feels his legs start to buckle as he tries to stand. He pauses, still clinging to the horse, then takes a few halting steps to ease his cramped legs.

He wishes to see his mother, to speak privately with his father, then, a meeting of an hour with Maddalena before he must climb back on a fresh horse and return to the front. His heart is on wings. His uncle has promised to make him manager of his estate outside Prato, a small town near Florence. And he will try to secure other estates for Luigi to manage in the Prato area. This will enable him to marry Maddalena and, in the future, provide money to prop up the Castellani holdings.

But just inside the palazzo, Luigi discovers his timing is terribly wrong. He is greeted by his joyous mother and father with the news that Julietta has arrived and will be downstairs for dinner presently. Luigi and his father retire to the study where his father greets Luigi's plan for the future with an explosion of temper. He is furious and adamant: Luigi simply cannot afford to marry a woman without a dowry! He points out that Maddalena is no longer available in any event. She has a suitor, the artist Piero della Francesca. And Julietta has arrived, trusting him. His angry words spill out like vinegar from a broken ewer.

Indeed, Signore Castellani tells Luigi, Signora dei Crespi has only a few minutes earlier confided to Luigi's mother of her hopes of marriage for Maddalena to this artist, and has received permission to entertain him in the small *salotto* immediately after their evening meal.

Taking their light supper of soup and bread in the small dining cabinet off the kitchen, Maddalena and her mother are unaware of the arrival of Luigi and the ensuing tumult. Their thoughts are centered on Piero, who will be calling in a short while, and the unexpected arrival of Julietta, the cousin of the family from Impruneta. Both of them have a normal

curiosity about Julietta, and Maddalena knows Julietta and Luigi have been special friends, sweethearts, since childhood.

"I wonder what she looks like?" Maddalena speculates.

"La Signora Castellani says she is pretty. Small and dainty in appearance with shining brown curls framing her face. Her nose is a touch long, but not noticeably so. She is perhaps your age, or she could be a year older. La Signora hinted to me that she has been chosen by Luigi to be his wife." Bianca looks carefully at Maddalena.

Maddalena, remembering what Luigi has said about Julietta and reminding herself that she has had no word from him, nimbly avoids the subject. "Do you think I should be upset that Piero is leaving?" she asks her mother.

"Upset?" Bianca's beautiful brows fly up. "Of course you are upset, Cara. Who would not be? To see the man one admires going far away. But, if he should become your betrothed, why then you must understand and be glad. After all, in a sense he is doing it for you. A man must follow his work." Her voice is firm.

"If he were a soldier," she continues, "then you would have the additional worry that he might be wounded, or even killed. No, Maddalena, I will not feel sorry for you. You should be happy a suitor of such exemplary character has declared his love for you. And because he has told you a dowry settlement is of no consequence to him, Piero is indeed a remarkable man."

*

Luigi Castellani, thwarted in his plans to see Maddalena and share his good news from his Uncle Baldassare, smarting from his father's angry words, feels the last person he wishes to see in the whole world is Julietta Vespucci. He has already written to her, breaking off their understanding. Apparently she is going to try to worm her way into the good graces of his parents, as though he himself has nothing to say about the matter! Her arrival can only mean trouble. Claiming a need to return immediately to the front, he takes solemn leave of his parents and rides away in a foul temper.

*

Piero, on the other hand, has been in the highest of spirits on this day. In the hour before calling on Maddalena and her mother, he returns to the Priory. It is deserted, well before Compline; he wishes to see the altarpiece once more, alone. He kneels before the altarpiece and gives a brief prayer of thanks. As he lifts his eyes he is moved by the actual sunlight portrayed in the painting. He catches the majesty in the face of Christ, a portrait of a Graziani forebear; the grace of John pouring the bowl of water over Christ's head; the aching vulnerability of the young acolyte's back as he removes his shirt for Baptism. *It is finished,*

and may it prove a gateway to many, many more. He rises and begins making his way toward Palazzo Castellani.

TWENTY EIGHT

A small fire crackles merrily in the fireplace of the *salotto*. The walls of the cozy room are lined with valuable old maps of early *Toscana*. This is a much more inviting space than the drafty *salone*. A small *cassone* holds a covered tray of almond cakes and goblets of watered wine. All is in readiness for Piero.

"How good it is to sit before a warming fire," Piero says, taking his place between Maddalena and Bianca. "The day did not have enough hours for me."

He tells them of the Graziani family luncheon during which he accepted a gold medallion from the grateful family. They expressed their satisfaction with the artist for their new altarpiece, elated to learn he has been offered such a prestigious post in Urbino. Next he visited officials of the Confraternity of the Misericordia, to inform them of his summons from Federigo da Montefeltro. He assured them the altarpiece would be finished by the time allotted in his contract with them.

"By the way," Piero says, "A single horseman was leaving the palazzo at breakneck speed as I approached. He almost ran me down." Piero shakes his head in bewilderment. But neither Bianca nor Maddalena can shed any light on the mysterious horseman.

"Now, Maddalena," Piero crosses his legs comfortably and turns to her, "Have you had enough time to come to grips with this sudden turn of events?" Dark eyes bore into blue. She cannot help but notice the undercurrent of excitement which animates his voice. Clearly he is delighted to receive the summons from the Duke. She quells a tiny flame of resentment in her heart because he seems so eager to rush away, while at the same time she feels happy for his appointment to such a prestigious court.

"Piero, of course I am pleased for you. I realize it is a turning point in your career. If I have been somewhat hesitant, it is because our situation is unclear, and I will miss you sorely."

Bianca rises quickly. "We need more wine. I will replenish the jug."

"Your mother is a sensible woman," Piero says thoughtfully following Bianca's departure with his eyes. "She is very quick to sense the feelings of others."

"Cara," he begins, turning to her. "I think I understand your worry. We must use the time I have left here to become better acquainted, to make our plans. Give me a twelvemonth in Urbino, then I will come back to you and we shall be wed. If the Duke wishes me to stay longer, it might be possible for you to return there with me, after our vows." Piero, mellowed by the comfort, the companionship, the warm fire, relaxes.

Hope lights Maddalena's face. To go with him! A dream, surely, but no, Piero would not say so if it were not true. She clings happy and contented to this possibility. Bianca returns to find the two whispering softly to each other.

She delivers a pretty reply to Piero's formal request for the hand of her daughter. He tells her the house on Via della Chiesa is basically a good house, and can be altered to suit Maddalena's wishes. What is needed is someone like Maddalena to love and care for it. On the pretext of taking away the tray, Bianca leaves them alone again for a few minutes.

"Are the winters very much colder in Urbino?" Maddalena asks, holding his hand, but thinking of his remarks about his house in San Sepolcro. Would she always be left there, after they are married? Surely not, she thinks, not possessing the courage to ask him.

"Winters in Urbino are frigid. It is akin to living on a glacier," Piero answers happily, gazing into her eyes. Such purity, with those beguiling lashes rimmed in gold, he thinks. He is delighted to be paying court to such a beautiful and desirable woman. A wife with such a distinguished pedigree will increase his stature as an artist. They sit in a companionable silence as the embers of the fire sigh and heave, as though settling themselves for the night. At last, Piero rises to depart.

"Stay well, my love," he murmurs, kissing her forehead, then her lips. Maddalena hugs his words and kisses to her heart. "We shall make the most of our time together before I depart. I will return tomorrow."

As she lies in bed waiting for sleep to come, she imagines herself married to Piero in Urbino. Being present---in the background of course---when the Duke comes for a sitting. Living with Piero in the Palazzo Ducale! Her heart warms to Piero. How fine his dark eyes, the strong yet delicate hands, the commanding voice. She counts his attributes like a miser counting gold. Only as she drowsily drops into sleep does she remember the strange horseman Piero saw, leaving the palazzo in such haste. Who could it have been?

TWENTY NINE

Piero invites Maddalena, Father Bruno and Bianca to his studio for a final visit before departing for Urbino. He wishes them to view the center panel of the new altarpiece for the Misericordia. The figure of the Madonna is so large, so massive, it dwarfs the tiny figures grouped under her cloak. She is the universal mother, sheltering the world as the Confraternity shelters its citizens. Piero is well pleased, especially with the contrast of the crimson of the Madonna's gown with the spun gold of her hair, the blue of her mantle.

Maddalena inspects the painting of herself in awe of the transformation. A belt clasps her waist, her gaze is downcast, displaying no emotion. The background of the panel is filled in completely with gold leaf, giving the figure the glittering appearance of an icon.

She recalls Piero's earlier conversation about the use of gold leaf as a background with Signore Castellani. How long ago it seems, and now Julietta has become a fixture as a house guest. Maddalena knows there has been a quarrel between Luigi and his father because he has renounced Julietta, or so La Signora Castellani has whispered to Bianca. Julietta's attitude toward Maddalena is smoldering. She obviously blames her for trying to steal Luigi away. Maddalena tosses her head, willing herself to ignore Julietta's jealousy, to forget about Luigi, and to savor her time with Piero. There are so few hours left before Piero departs and her betrothal will be announced. Her thoughts rejoin others in the studio.

"And who will serve as models for the sheltering figures under the Blessed Lady's cloak?" Father Bruno inquires. Piero has asked him to pose for the portrait head of Saint Francis, one of the saints in the many panels of the altarpiece. Piero replies that four men of the Confraternity will be ranged on the left.

"Of the four women on the right, Signora dei Crespi will be the woman in black wearing a necklace of coral while Signora Castellani will wear a dress of deep red with gold embroidered sleeves," Piero is saying as Maddalena lets her thoughts dream of going to Urbino. "Mother Scholastica has given permission to use her face for the figure of the nun in this group. I have these sketches from life packed into my portfolio. They will go with me to Urbino."

68

Father Bruno nods in satisfaction. Indeed, this is a story destined to have a happy ending. The good priest is overjoyed to witness the blossoming affection of Piero and Maddalena. His little feet begin to tap.

As Father Bruno and Bianca examine Piero's paintings on easels around the studio, Piero and Maddalena, heads close together, whisper happily. He tells her he has engaged a guide with two mules to lead him over the rough road, "Over the Mountains of the Moon" he says, "That is what those mountains are called."

"How beautiful," exclaims Maddalena. "Then I will think of you on your travels as you make your way over the Mountains of the Moon toward the city of Federigo da Montefeltro. Tell me about his palazzo."

After describing the new palazzo, a complex construction not yet completed, Piero takes Maddalena's hand in order to share a private moment with her. Slowly he begins to speak.

"I remember years ago, walking in the dark toward our home here in San Sepolcro after working so long and so hard I could barely manage to put one foot in front of the other. I could see light in other houses gleaming behind the shutters. Lights in every room. When I came to our house, there was only darkness. Only one poor candle burning in the room where we ate, slept, worked. We were that poor, after my father died." He pauses, lost in thoughts she cannot share.

"I promised myself that when I could afford it, I would have a studio filled with windows, and candles to burn at night in every one of those windows."

"It is truly beautiful, Piero, the most beautiful *studiolo* I have ever seen." He looks at her hand, smiling sadly.

"How red my mother's hands were, not smooth and lovely like yours. I determined to do all that I could to hide the pitiful existence of my youth, to make a better life for myself and my mother."

"And you have, Piero, you have."

"Not for her," Piero murmurs, shaking his head. "She died before I could give her some of the comforts of a better life. But thanks to God, Maddalena, your hands need never look like her hands. Thanks to Federigo and other patrons, I shall be able to keep you as you deserve."

"But Piero, to have you is what I want, for better or for worse. Do not think of me as a sort of lap dog, a creature to be pampered."

"Maddalena, Maddalena, your beauty won me first, but your warmth and willingness to be open and give of yourself bind me as surely as silken threads. Of course I will cherish you! I am the luckiest of all men." Piero gazes fondly at her, kissing her long, tapering fingers. Does he, Maddalena wonders, really understand how I feel? Does he sense my longing to be a partner with him when we are wed?

THIRTY

Valentina sits alone on the edge of her hard bed in the tiny cubicle she shares with four maids in the dank basement of Palazzo Castellani. Tears stream down her face, tears of joy which she must celebrate alone.

Bianca has just told her of her good fortune, that a suitable husband has been found for her, a young joiner from Prato. In a short time she will be married, with a fine dowry of one hundred florins. Tina is overwhelmed. *One hundred florins!* Many merchant's daughters receive less than this. And Bianca has also told her she will wear a fine wedding gown, have a new wool cloak, two embroidered chemises and nightgowns, a fine apron made of lawn with a matching head-dress. Tina reflects on her good fortune, remembering details of the wedding banquet.

The banquet will take place in Prato where her future husband lives in a house left to him by his parents. She will be mistress of her own house! Tina can hardly believe her good fortune. Signora dei Crespi has told her Signore Castellani has ordered the banquet from his own stores: 406 loaves, 250 eggs, 100 pounds of cheese, 2 quarters of an ox, 16 quarters of mutton, 37 capons, 11 chickens, two boar's heads and feet (for jelly), sea fowl, Chianti from his vineyards and sparkling *Carmignano*. What a feast! Her new husband will indeed feel fortunate to have her, she muses.

What will he be like? Signora dei Crespi has said that he is 'comely' with dark hair and eyes, and that he is well-respected among his fellow joiners in Prato. Tina knows she has received a dream come true. She will no longer be a servant. The impossible has happened. The only cloud looming on the horizon is that Signora dei Crespi has warned her she must speak to none of the other servants of her good fortune. This is hardest for her to accept. How she would love to see their faces if they could hear the news! But she vows to Signora dei Crespi to keep silent. Tina knows she must not jeopardize her emerging dream.

As a realist, Tina did not expect Signore Castellani to acknowledge her. Since her dying mother Ginevra whispered into her ear who her father was, she has never dared hope that

71

someday he might treat her with a true father's warmth, wonderful as that would be. No, she knew that was not likely to happen. But she did not expect to spend her life in unremitting drudgery as a servant, either. Now he has at last acknowledged her, in his own way. She puts aside her wish to share the good news with her fellow servants. Nothing must endanger this wonderful chance to better herself. She is content.

THIRTY ONE

Maddalena and Julietta are alone in Signora Margherita's sewing room. They make an attractive picture, two girls, one fair the other dark, bending over their embroidery, the skeins of silk strewn in colorful profusion around them.

Julietta Vespucci likes Maddalena in spite of herself. And now that her betrothal to the artist Piero della Francesca is apparently a sure thing, she no longer fears her as a rival for Luigi's affection.

"What did you think of Luigi the first time you met him?" she asks, her eyes taking on a calculating glint as she regards Maddalena under dark lashes. She thinks Maddalena is perhaps not beautiful in the usual sense, but the wonderful color of her hair! Even her brows of that golden, honey tone. And she is tall, with the bearing of an empress. Yes, her looks are compelling. Anybody would agree, but she has no dowry.

That is why Julietta finds it hard to understand Luigi's infatuation, for surely that is all it was, with someone so unsuitable. Now he will come back to her, she is positive he will. She is confident of her power to win him back, if not with her beauty and her coquetry, then with her wealth, which she knows his family sorely needs.

Red suffuses Maddalena's cheeks as she frames her answer. "I only spoke with him a few minutes, Julietta," she replies, embarrassed, remembering with a pang the magic of that brief encounter with Luigi in the *giardino segreto*. Quickly she pushes the memory from her mind. She hardly can recall his face anyway, their meeting was so long ago.

"Oh, Julietta, I cannot remember much about Luigi. It was some time past that we met." But Julietta's thoughts have already gone skittering away in another direction.

"I wonder what painting you will be in next?" she muses, striving to keep the envy out of her voice. "It is so romantic, to be painted in a famous work of art."

"Maybe I won't be in any others," Maddalena says pensively. In spite of herself she is downcast because Piero will be leaving very soon. The long, cheerless days of winter seem to stretch endlessly in front of her when she dwells on Piero's departure.

But Maddalena's preoccupation with this artist seems genuine to Julietta. And if she says she has heard nothing directly from Luigi, then it must be true. She is so guileless. "I don't suppose you have heard from Luigi just recently, have you?" Julietta asks, just to be sure, and her eyes narrow.

"No, nothing." And Maddalena's honest reply, her clear eyes, put Julietta's mind at rest. Surely Luigi would have written to Maddalena if he were in love. But why did he write *me*, she thinks, breaking things off, and not write *her* of his news?

Grateful for the chance to be silent, Maddalena half-listens as Julietta rambles on with tales of her life, the balls in *Firenze*, the fetes, the endless stream of admirers. Maddalena lets her thoughts drift toward Piero, wondering what he may be doing at this moment.

La Signora Castellani, captivated by Julietta's glossy charm, enters the room, beckons to Maddalena, whispering that she should try Julietta's hairstyle, small ringlets framing the face. Maddalena murmurs polite, non-committal thanks as she conceals her feelings. Such a fussy hairstyle would never suit her.

Julietta's dainty appearance makes Maddalena feel awkward; her ready smile and dimples make Maddalena dislike her own smooth countenance and more solemn demeanor. The ringlets mock Maddalena's straight tresses, and she knows they would look fussy and overdone on her. As for conversation, Julietta talks only of fetes, gowns and her many suitors. Nothing more substantive, and, Maddalena suspects, she invents artfully embroidered facts. How could Luigi have been attracted in the first place?

Bianca coughs delicately behind her handkerchief, sensing her daughter's discomfort and unhappiness. "What a joyful day for you, Maddalena, now that your betrothal is settled."

La Signora Castellani is aflutter with excitement when she hears this news and loses no time in telling Julietta what a gifted and important artist is Piero della Francesca. "And his new position!" she exclaims. "He will be the envy of all of the artists in Tuscany."

"And just what is his new position?" Julietta asks, curious in spite of herself.

"He has been named court painter to Federigo da Montefeltro. He will reside in the ducal palace in Urbino. He leaves presently for Umbria," Bianca murmurs in her softest voice. Julietta's eyes are as big as saucers, looking as though her ears have played tricks on her.

Urbino

ONE

Piero holds himself erect somewhat grimly in the saddle. He and his guide have been on the road, little more than a trail, most of the day. His muscles are tired, bone tired, and his thoughts are downcast. He had not realized what a wrench parting with Maddalena would be as they stood together, embracing in the little room with the early maps of Tuscany covering the walls while Bianca thoughtfully left them alone.

He did his best to disguise his feelings at their meeting, the usual feelings of loss and desolation, as they embraced for the last time. Later, sleeping, he dreamed she would not wait for him. But surely he is mistaken. Those had been tears swimming in her lovely eyes, certainly real tears. It is just the same old unlucky feeling that everything in life will be taken from him, like baby birds snatched from the nest by vultures. Always the fear hovers near.

At any rate, he will write her, pouring out his thoughts, the minute he arrives in Urbino. It is not possible to do so on the trail, so primitive are the arrangements. Why he must sleep on the hard ground cocooned in blankets, with only the saddle for an uncomfortable pillow. But he is composing a love poem to her, in his head. Yes, he will set it all down and send it to her as soon as he can. He will let her know how deep are his feelings of grief at their parting. He will hold nothing back. He *will* do it!

Holding the reins in one hand, he rubs his fingers to bring some circulation to them. The cold is punishing, and they have many more lengths to travel before Urbino comes into view. He entertains himself by working on various poems to Maddalena. One comparing her to the seaside, another to Maddalena as white and pure as a snow princess.

TWO

Maddalena receives her first letter from Piero about a fortnight after his departure. He writes:

My Beloved Maddalena, Soon it will be two weeks since I left you that cold night at Palazzo Castellani. I miss you and pray for you every night. Keep up your courage. We shall not be apart forever!

As I left San Sepolcro I was struck by the beauty of the hills of olive trees and vineyards as we climbed steadily toward Umbria. A bluish haze in the air lent an ethereal mist to the landscape and I yearned to stop and capture it with paint, but of course I did not, else my guide think me deranged.

We took days of steady traveling into wilder and wilder country, most of it uphill, to reach Urbino. The roads were mainly little more than trails and the Mountains of the Moon ensure that I am either struggling upward or bracing for the descent. Most middays we stopped for a brief meal and my guide heated up a thick kind of stew which he had brought along, prepared aforehand by his wife, if he indeed has a wife. He is a lonely, silent man most of the time. We kept to our own thoughts. The food was warm and nourishing and gave us strength. At night, before banking our fire and bedding down, we ate bread and cheese. Every sunset was our signal to stop and make camp for the night. We soon had a good fire roaring to warm us and to keep the jackals away. Our hope was to press on to Urbino as fast as we could, so as to avoid the snow the guide was sure was at our heels. As we entered the city gates, it began snowing, so the journey proved blessedly uneventful and he was right about the weather.

Urbino is majestic, no question about that. The Palazzo Ducale sits atop a steep hill, its beautiful towers and domes punctuating the heavens. It is built of warm red bricks and pale stone, the tiled roofs of a russet color tying it all together. This place will be the envy of all Italy when it is finished.

The Duke is a complex man, a warrior and a passionate patron of the arts. He is also a learned, serious scholar. He is determined to create his palace using the best architects and painters he can find, painters who can fill the rooms with masterpieces. His appearance is startling as he lost an eye in battle and at the same time suffered a broken nose from the sword thrust. But it is a face of tremendous energy and strength of character. I long to paint him. I have not yet been presented to the Duchess. She is Battista Sforza from Milano, a member of the ruling Sforza family there. I shall tell you more about her in my next letter, but I must get some sleep now.

I am writing a poem for you. That too, will have to wait, as my candle burns low. Please know that I, who can only express my feelings with paint and brush, adore you every night in my dreams. Yours, Piero.

His letter is full of lyricism and an austere poetry, Maddalena thinks as she reads it. And how she longs to read the poem he is writing.

But in Urbino, Piero tosses and turns this way and that on his comfortable bed in his studio at the Palazzo Ducale. Is she missing him as he misses her? Does she feel despair as he does because they are apart? Suppose she decides that she cannot, will not, wait for him? He knows that in the past, what he treasured most, he lost. A kind father, a saintly mother. . . and nothing, nothing in this world, can ever bring his mother back.

THREE

On days when the weather is passable, Maddalena hurries to the Priory for lessons with Father Bruno. On this day, he waves a letter from Piero, a letter relating details of the man, Federigo da Montefeltro.

"He is a *condottiere*," Father Bruno reads, "a fearless soldier, who has won many battles. The money he earns abroad fighting, he spends at home in his beloved Umbria, taxing his people as little as possible. He builds beautiful buildings, encourages the cultivation of land and thus gives employment to many of his people. His subjects repay him with affection and loyalty. He has five hundred persons in his service and allows neither vice nor dissipation in his court. He conducts a school of military education and courtly behavior for the sons of the great houses in Italy. They come here from all the noble houses, to learn." Here Father Bruno pauses for breath, as much in wonder of this man Piero is serving as is Maddalena.

"His library is his greatest treasure. As he takes his meals, Livy is read to him. In the afternoons, he listens to a lecture on some classical subject, then goes to the monastery of the Clares and talks of sacred things through the grating with the abbess there, a learned woman. Evenings when it is fine, he watches martial exercises on the meadow below the palazzo." Piero concludes saying the Duke is accessible to his subjects, kind, and above all, fair. Both Father Bruno and Maddalena are dazzled by this portrait of Piero's employer.

They sit in the *bibliotecca* and imagine Piero painting Duke Federigo. "He goes to the abbess of the Clares for learned conversation," breathes Father Bruno reverently. "Just consider!" He reflects on this.

"Oh, what a wonderful opportunity for Piero to live in such exalted surroundings with such a virtuous ruler," Father Bruno says. "It is said, I believe, that the Duchess, who is a daughter of the ruling family of Milan, is truly the most beautiful woman in all Christendom."

Maddalena falls silent, wondering if Piero will remember her as often as she would wish, or if, in his preferment, she will no longer seem so desirable to him as she once did. To her, the court in Urbino seems almost too glittering, too perfect.

FOUR

Snow clamps its grip on San Sepolcro. Maddalena sits shivering in her little room under the eaves. In her hands she holds a small pouch which has just arrived. Trembling with cold, her fingers untie the parcel, uncovering layers of a soft cloth. She lifts from its depths a silver ring, pierced with an intricate design and set with a large amber nugget of irregular shape. She knows it is amber because of its golden color and the black specks of tiny insects long trapped in its depths. How beautiful, she thinks. And Piero wants me to have such a precious thing. She lifts folded parchment beneath the layers of cloth and discovers Piero's poem :

Can I compare you to the moon? Its glow pales beside you.

Or to limpid blue of sky above? Dull, beside the azure of your eyes.

Your lips so soft and pink as fairest petals of the rose,

Your hands in quiet repose, speaking to me of gentle grace.

Precious beyond measure your face,

I am robbed of what I most desire when we are parted.

Maddalena, my Prize, my Treasure.

She holds the paper in one hand, the ring circles her finger. So now I am truly his, she thinks, looking at the nugget of amber, feeling sad because they are apart. She reads the lovely poem again, her heart full of love for Piero. A tap at the door.

"There was another letter for you, Maddalena," Bianca hands it to her, "At the bottom of the pouch." Bianca sees the amber ring.

"What a beautiful thing!" she exclaims. "It must be from Piero." Maddalena nods. "How like an artist to find something so rare. Where could Piero have got it? It must have come from the East, perhaps by way of Venice, or Constantinople."

"Wherever it came from, I cherish it," Maddalena says, hugging it to her chest.

"And so like Piero to send something that is perfection itself," Bianca murmurs withdrawing, her voice filled with admiration.

Maddalena's brows knit into a frown. She does not recognize the handwriting across the face of the letter sealed with wax. She pauses before breaking the seal. In a moment of prescience she knows who has sent the letter.

Carissima Maddalena,

I vow the fates conspire to keep us apart. When I slipped the note under your door as I left Palazzo Castellani last autumn, never did I dream so many days would pass before we met again. I feel as though unseen hands are pushing us farther from one another and unseen cloths bind my lips from speaking my heart to you. No longer. I determined to wait until all was arranged, but I fear that by waiting I have made a terrible mistake.

I came to Palazzo Castellani a fortnight past to see my parents and of course to see you. I came to tell my father I had decided to marry you, to tell you of my steadfast love. When I arrived I walked into a tempest. My father railed against my intention. He is worried about the future of the Castellani Estates and is depending on a huge dowry settlement from the woman I marry. Moreover he kept repeating that you were already as good as betrothed to an artist. That you and your mother were expecting him that very evening. Then my father revealed another surprise. Julietta had arrived for a visit and would be coming down to dinner right away. Julietta! The person I least wanted to see in the whole world, having earlier written her that our childhood understanding was at an end. I was so disheartened I left my father's house at once, without seeing you or, thankfully, Julietta.

Even though I have been showered with evidence to the contrary, Maddalena, I refuse to believe you no longer love me. Your eyes told me differently that day in the garden when we shared a few moments. So if you tell me yourself you no longer care for me then I will believe it, but not before. I will not walk away and give you up.

As soon as I can resign my commission with honor in the army, I will become manager of my uncle's holdings near Prato. He has promised to speak to some friends in the area and believes I can manage other estates there. I have determined to make my own way and will provide the sort of comfort and surroundings you deserve. And I will help my father bring back the Castellani fortunes, even though at the moment, he refuses to speak to me. I know my father; in the end, he will come around. If you will, write to me in care of my uncle in Fiesole. It will keep up my spirits in this dark hour. With all love and affection, Luigi

Alice Heard Williams

Maddalena, eyes brimming with tears, rereads the letter. What does he mean, the note slipped under her door? She never saw such a note. The temperature seems to have taken on the warmth of a midsummer day in the freezing little room. Still wearing Piero's ring, she touches her pounding heart. Finally, Luigi has declared his love for her. But all has come too late, too late.

What cruelty the fates have played on us, she thinks as she reexamines the letter. So much might have been different, had the timing of events been more agreeable. And to what note is Luigi referring in the beginning of the letter? Why did she not receive it?

FIVE

Piero is dressed in his best tunic of a soft, brown wool, matching hose immaculate, curly brown hair brushed carefully, crimson *berretto* carefully resting on his head. He is awaiting the arrival of Duke Federigo for a sitting. and this time the Duchess, the legendary beauty Battista Sforza of the ruling Sforza family of Milan, will accompany him.

Nervously Piero aligns the goblets of wine on the silver tray, checks the dish of sweetmeats, the linen napkins on the *cassone*. All is in readiness. Piero knows the importance of pleasing a monarch's wife. Did he not discover this to his misfortune when in Rimini he failed to provide such refreshments for the wife of the ruler, Pandolfo Malatesta, during a similar studio visit? Alert, he stands near the door, awaiting the Duke.

Once inside. Duke Federigo strides without preamble to his chair on the dais to take up the position. Piero bows low as Battista sweeps in behind him. Tall, regal, assured, her glittering eyes take in the room and its objects. She turns to the artist, the pale, slate blue eyes revealing nothing of her true thoughts.

Dio Mio!, what a woman, Piero thinks, his lowered eyes registering the purity of her face, the skin white as the petals of a lily, straight hair the color of butter hanging loose, pulled back severely from the face and held in place by a black band on which rests the largest, most perfect pearl Piero has ever seen. The forehead is incredibly high, probably plucked, he thinks, but how perfectly such simplicity suits her. A real Cleopatra, he muses, continuing to bow deeply.

She carefully arranges the stiff folds of blue brocade with sleeves of a cream lace, seats herself in a chair facing her husband. As yet, no words have been exchanged. Piero waits for the monarch to speak.

Federigo da Montefeltro's disfigurement shocked Piero at the time of their first meeting. He is more accustomed to it now: the missing eye, the grotesque broken nose, the result of a sword thrust from the enemy in the heat of battle. Yet the Duke's manner belies his startling

appearance. He is mild speaking, gentle in his movements, an incongruity Piero finds appealing. In his soft voice, the Duke exudes mature bravery, intellect and wisdom. Yet his is a strength permitting no crossing of his iron will. His reputation of fierce warrior and just ruler is well-earned.

But Battista! Whew! Here is a woman of such intensity the very air seems charged with the currents of her presence. Beware to any fool who finds himself on her wrong side. Piero is instantly on his guard.

He takes up brushes and begins to paint as the Duke indicates he is ready to begin. Battista fires a barrage of questions aimed at Piero. Where does he come from? Is this his first trip to Urbino? What is his opinion of the Palazzo Ducale? Who was his master?

Confidently, Piero stands at the easel, guiding the brush as he answers. He is struck by her restless quality, the child-like shrillness of her voice. He has learned previously that she is only seventeen, about Maddalena's age. He reflects on his betrothed a moment before switching back to the present. Maddalena, younger, fresher, is of Battista's type.

He is working on a portrait of Federigo which will hang in the library of the ducal apartments, a simple profile view which will disguise the horrible disfigurement. He is painting the head from life. Later, he will use a model to pose for the body of the figure in all its armor.

"So what will you be painting next, when this is finished?" Battista has left her chair and is peering intently over his shoulder (she is very tall) at the emerging likeness of her husband. Normally Piero will not tolerate such interference, but he is at a loss as to how to dislodge this beautiful vision from the vicinity of his easel.

"Whatever his grace wishes me to paint, I shall paint," Piero answers her mildly, refusing to show anything other than calm.

"Are you married?" she asks suddenly, the glittering eyes forcing him to meet her gaze.

"No, my lady," he replies and it is on the tip of his tongue to tell her about his betrothal to Maddalena when suddenly he holds back, letting the old curtain fall down once more covering his feelings. He purses his lips.

"Ah, that is good," she replies. "One's loyalties are immediately divided, once the marriage vows are in effect," she says, giving her husband a mischievous look. "Is that not true, my dearest?"

The Duke, frozen in position, blinks his one eye slowly. He looks on her as his Goddess Venus, Piero thinks. He is in awe of such a beautiful creature, one whom he possesses, but he knows he does not own her thoughts. Piero feels a momentary flicker of sympathy for the Duke.

"I am thinking I would like to have Piero paint us in a diptych, looking at each other from the frames of our respective panels, one that would proclaim our dominion over all Umbria." Battista suddenly speaks. Piero notes the compelling eyes, voice a little breathless with her speech, delivered in the high, singsong tones. "One that would enable us to have separate sittings---not so tiring as posing together for such long sessions."

Piero, working with a brush of tiny sable hairs on the hairs of the Duke's head, says nothing, but he thinks, this could be very dangerous. *I must be wary, tread my way carefully as though walking on eggshells.*

He cannot know what is in the thoughts of this strange, beautiful woman, yet he does know an artist must be mindful of the daily pitfalls lining his path. And one pit into which he will never fall again is that chasm of hunger and privation. He dare not.

SIX

Bianca, taking respite from her duties, opens a letter from her cousin Giovanna Doni.

Dear Bianca, How pleasant it was to see you at the dedication in San Sepolcro of Piero's painting of the Baptism. Do you remember the last time we met as children? It was at my father's birthday fete, and I recall how we made ourselves sick eating a dish of sweetmeats! Such a happy time, that fete! And to think, only a few short weeks later that our parents were taken away and imprisoned by the dei Medici. I thank God that those horrible times are finished, and our blessed parents now rest in peace.

But no more of these unhappy memories. I am writing to ask if Maddalena might come for a visit with us in Firenze. The winter is so long and dreary, we would welcome Maddalena's sunny presence and would be pleased to introduce her to some of the delights of Firenze. Let me know what you think. I can send Lorenzo down with the cart to collect her at any time , if you are willing for her to join us. Your loving Cousin, Giovanna

Bianca taps the letter lightly on her cheek. Just the thing for Maddalena who has been so sad lately, because of Piero's departure. A trip to Florence would lift her spirits, Bianca is certain. She is unsuspecting of the contents of Maddalena's second letter, the letter from Luigi, which is at the root of all the unhappy lines on Maddalena's face.

Maddalena, entering the kitchen of the palazzo, offers to take Giuseppe out for a romp in the fresh air while Maria finishes the pasta making. Already the kitchen is festooned with drying strands of pasta hung on wooden rods, like laundry hung up to dry. Maria plunges her hands into the flour bowl for yet another batch as Giuseppe, bored with keeping still while his mother works, lets out a whoop of joy and bounds outside. Maddalena quickly follows, taking a small ball from the folds of her cloak.

"Here, catch!" She throws it gently into his hands as they shiver in the cold sunshine. Maddalena hopes the bracing air will raise her spirits, clear her head. For the hundredth time, she reflects of the cruelty of fate: Luigi's letter and its declaration of his love for her arrived

after her betrothal to Piero, *after* she had unwrapped the beautiful amber ring, *after* she had accepted him, sure of her love for him.

Over and over she has thought about this chain of events. Do I really wish I had not accepted Piero? Am I ready to admit I love Luigi best? Thoughts of Piero come crowding in as she throws the ball to Giuseppe again and again. Piero, so strong, so solid, so sure of his love for her. And what of Luigi? Is he impetuous? Volatile? Fickle? There was that long period of time when she heard nothing at all from him.

And yet, her thoughts keep returning to the magic of that single encounter in the garden. Tardily she thinks of her mother, who would be devastated to know what she is dreaming of at this moment. And Il Signore must be furious to think of the irresponsibility of his son, his failure to look for a wife with a big dowry settlement to bring to the marriage. And Piero, could she bear the hurt in those solemn, dark and somehow vulnerable eyes if she renounced him? She would give up being a model for his paintings also.

No, better to keep to her course, bear the loneliness until Piero returns to her. Slam the door shut on her yearning heart, no matter how seductive the words of Luigi's letter to her. She hurls a fast ball to a delighted Giuseppe.

Valentina is hovering in the corridor near the kitchen as Maddalena and Giuseppe hurry inside to sip a warming drink. Maria has vanished for a moment, now that the pasta making is finished. Slowly Tina approaches the pair. Giuseppe scowls. He has not forgotten how his fingers hurt when Tina slammed shut the door on them.

"Tina, it is a long time since I have seen you. We have been outside having a bit of a romp. It is terribly cold." Maddalena's voice is friendly.

"I was wondering, Maddalena, if your mother has told you I will be leaving soon?" Tina's voice rises, all traces of the sulky bravado absent. She looks uncertainly about.

"Leaving? Why no, she has not said a word to me." Maddalena glances at the girl in surprise. "Are you returning to Fiesole? Mother tells me that is where you lived."

"No, I am going to Prato."

"Prato. Goodness, what a change for you. Have you found another post?"

"No, Maddalena. I am going to be married to a joiner by the name of Guido Datini. He has a house there." Maddalena reflects on the unexpected news. Strange. Bianca has not mentioned it. Tina stands silently, her fingers twisting nervously at her black skirts.

"I am delighted to hear it, Tina," Maddalena says with enthusiasm. "I wish you happiness."

Tina summons her courage to speak what is on her mind. "I hear you too are betrothed, Maddalena, to the artist who painted *The Baptism* at the Priory, the one everyone in San Sepolcro is talking about."

"Yes, that is true. I am betrothed to the artist Piero della Francesca." Maddalena looks closely at Tina. Something is obviously bothering her, but what? Will she come out with it?

"Pardon me, Maddalena, but are you happy about it?" Maddalena is speechless at the servant's impertinence. But then, she recalls, Valentina has never behaved like a servant. She has always thought and acted more or less as she pleased.

"I am happy, Tina, very happy," she replies firmly, looking her in the eye. Tina has the grace to lower her gaze.

At this moment, Maria returns to the kitchen, reminding Tina in her sharpest tone that she has not yet swept the floor clean of all the detritus of the pasta making. Maddalena takes Giuseppe by the hand and moves toward the corridor, reflecting on the bewildering exchange with Tina. What does Maria know about the wedding? Maddalena decides to wait until she can speak with her mother rather than ask a servant. She is sure a plethora of rumors is floating about in their quarters.

Why did Tina question me about my happiness? Maddalena has told no one about the letter from Luigi, not even her mother. Why would Tina ask such a question?

SEVEN

Piero has become accustomed to the impromptu appearances of the Duchess when her husband is sitting for him. She laughs, she jokes, she flirts outrageously with Piero, cajoling him into paying her extravagant compliments on a new jewel, a pretty sleeve, a velvet purse. All is conducted in front of the mild and approving Duke, a man clearly besotted with his young and energetic wife, a Sforza who has enjoyed since birth the courtly life of flattery, adoration and tribute.

Painting the diptych of the two rulers has not been mentioned again, but Piero is sure the lady will have her way when she is ready. Meanwhile, Piero has been spending his free time working on the treatise on mathematics he is writing, a project dear to his heart and one he neglected shamefully in his last days in San Sepolcro, busy as he was chasing after Maddalena.

When he is occupied writing and painting he can pass the days thinking very little of Maddalena, but in the nights she comes to him as in a dream, haunting him with her rose-kissed cheeks and soulful eyes. Then he misses her terribly.

A manservant appears instantly whenever he pulls the bell rope, yet miraculously keeps out of sight the rest of the time, not always giving him unsought advice, like Lucia back in his house in San Sepolcro. Another servant brings Piero delicious meals, keeps his tunics brushed, his hose mended ---how much more nimble with the needle the man is than poor Lucia!--- and he is ready in a twinkling to do Piero's bidding.

But Piero shaves and dresses himself. He has always scorned such blandishments and preferred to live in an austere and solitary manner. This measured, predictable existence he leads in Urbino suits him enormously, with only a tiny tug of conscience that he can be so content separated from Maddalena.

And he is well aware that to date, he has told no one in Urbino of his betrothal. It is wiser to keep one's business to oneself, he reasons. Dismissing the nagging thought, he turns back to his notes on the treatise. If only life followed the certainties of mathematics. He sighs.

EIGHT

Tina is finding that in her own way, she too possesses a conscience. In her talk with Maddalena, she tried to learn if she is really happy to be betrothed to Piero. But would Maddalena tell her if she were not? No. The chance of Maddalena's confessing to a servant girl of her disappointment in giving up Luigi Castellani? No, it would never happen. The odds of that revelation are as likely as me flying to the moon, Tina reflects.

But the stolen letter Tina has held in her possession for so long has become an intolerable burden. When her world looked bleak, Tina felt like striking out and hurting everyone, even blameless souls like Maddalena who had done nothing to her but behave in a kindly way. But now, now that hope has arrived in the form of a dowry settlement and a respectable husband, Tina is transformed. The prism through which she views the world has taken on a new, more expansive luster. She wants to set things right before she leaves.

But faced with the prospect of revealing all to Maddalena, who is sure to be furious if Tina confesses the theft of her letter, is too daunting. Tina knows she cannot do it.

NINE

Mother and daughter are meeting in their little dining room for the noonday meal of soup and bread. Like most Tuscan households, Palazzo Castellani can set an unbelievably sumptuous table for special occasions and fetes. However, the business of everyday eating means plain Tuscan food expertly cooked and sparingly offered.

Bianca first tells her daughter of the invitation from her cousin Giovanna to visit Florence. It has the desired effect, and Bianca's heart leaps up as she sees the stars in Maddalena's eyes. She is overjoyed.

"Mother, what a wonderful chance for me. I long to visit Cousin Giovanna in Florence."

"Then I shall write her that you would like to arrive next week," Bianca says, dreading the lonely days without her daughter's company, yet glad to see her happy for a change. They finish the meal in silence.

Maria brings in oranges and fruit knives for dessert. They have been picked by the old gardener from his precious trees wintering in the *lemonaia*, the hothouse of sorts where the citrus trees receive the southern sun during the day and are carefully covered up and protected during cold nights. Maddalena and Bianca are Pietro's favorites. He often brings them fruit or flowers.

"Delicious," Maddalena pronounces, sinking her teeth into the juicy flesh. "How he can coax such large fruits in the middle of the Tuscan winter is beyond me."

"Maria told me Pietro prays daily to the Blessed Virgin for a bountiful orange harvest every winter," Bianca says.

"Mother, Valentina says she is betrothed to a joiner in Prato. Why have I not heard this?" Bianca is silent for a few moments collecting her thoughts.

"Yes, it is true," Bianca answers at last, busily examining the bread she is crumbling beside her plate. She keeps her eyes lowered, hoping that Maddalena will ask no more questions, but she doubts her daughter's curiosity will be satisfied.

"But how did it happen? Who would want to marry a woman without a dowry, a servant girl? Unless of course, somebody paid the dowry settlement." The silence between mother and daughter lengthens. Still Bianca does not speak She looks into her daughter's eyes. Always she has tried to be truthful to her. She knows Maddalena trusts her to tell the truth.

"Maddalena, what I am about to tell you must not go beyond this room. It is a secret you must not reveal." Maddalena nods. Bianca then tells her the facts of Tina's parentage and the decision of Il Signore Castellani to put up a good dowry so that a suitable husband can be found. One hundred florins is the amount of the dowry settlement, Bianca tells her. More than many merchants' daughters are given, a princely sum. There will be a fine wedding banquet in Prato and new clothing for the bride.

Maddalena is numbed by the news. All she can first grasp is the fact that Tina and Luigi have the same father. Poor La Signora Castellani. Poor Luigi. The sadness of it all is unbearable. No wonder the groom is from another town! Maddalena's imagination is unequal to the vision of Il Signore, so cold and remote, conducting an affair with a household servant. The servants' quarters must be buzzing with rumors about Tina, Maddalena reflects.

Tina is a servant with many enemies and few friends. She can hardly expect the other servants to share in her joy, and Bianca tells Maddalena she has warned Tina to keep the secret. Is that why she asked me if I were happy, becoming betrothed to Piero? In a flash of perception, Maddalena turns to her mother.

"Mother, do you remember the second letter you brought to me after I received Piero's letter and the amber ring?" Bianca nods.

"I haven't felt like telling you before, but that second letter was from Luigi. In it he says he still intends to marry me, even though I am betrothed to another. He wrote me a letter when he first left, but someone intercepted it. I never got it. I, I think Tina must have taken it." She quickly draws in her breath as she watches her mother's features slowly dissolve into a mask of ill-disguised anguish. How dreadful, Bianca is thinking. This will only lead to disaster.

Wisely Bianca keeps silent, forcing herself to treat this unwelcome news lightly, reminding Maddalena of her duty to remain cheerful for her betrothed, Piero, who is so far away and undoubtedly very lonely. Let no distractions keep her from a loving and loyal path to his affections, she cautions. By ignoring the news of Luigi's letter to her daughter, she hopes it will diminish in importance to Maddalena.

"Luigi, for all his charm, is not a man you can take seriously," she declares. "Why this is the first word you have heard from him in months. Who knows if he truly wrote to you earlier?"

firenze

ONE

*I*n the sewing room of the Palazzo Castellani, Julietta, feeling envious of Maddalena's forthcoming visit to Florence, amuses the company with accounts of her previous visits to that city, for shopping, fetes and balls and other grand occasions. But if she wishes to cast a shadow on Maddalena's upcoming visit to Florence by rendering it ordinary, she does not succeed. Maddalena simply walks as though suspended in the heavens, her thoughts in the clouds. Her spirits soar unchecked until the appointed time of departure on a windy March day.

At last she is sitting in Giovanna's cart, driven by Lorenzo, the Doni groom, waving goodbye to Bianca who is standing in the doorway, feeling a little forlorn.

"I wish you were coming along also, Mother," Maddalena calls as the cart moves off.

"Nonsense. You will be far too busy to think of me. Be a thoughtful guest and keep your cousin Giovanna amused. Write me when you can." With a final wave, Maddalena turns her face toward Florence.

The cart jolts along past uneventful scenery. When Florence finally appears on the skyline she can pick out the dome of the cathedral of Santa Maria dei Fiori, Saint Mary of the Flowers, from the descriptions of Father Bruno. She looks for other landmarks as they approach, noting that the houses are becoming grander, surrounded by high stucco walls over which blossoming vines tumble. This surprises her, after all it is winter, but the driver Lorenzo explains that the sun-warmed walls on the inside are protected, causing the vines to blossom early.

They pass a large, open air market, overflowing with exotic looking fruits and vegetables. Kitchen maids and housewives hurry about making purchases. One woman struggles to

keep a plump goose under her arm. From deep within the market float the sounds of a violin. Already Maddalena feels captured by the charm of the city.

The Doni villa stands on Via Ghibellina, near the Piazza Santa Croce. From the street it looms dark and severe with upper windows tightly shuttered like sightless eyes. But once inside the walls and into the courtyard, Maddalena is delighted by pots of palm trees and lemon trees, thriving in the protected climate of the southern exposure.

As Maddalena steps down from the cart, Giovanna rushes out, arms open wide, to greet her. Maddalena allows herself to be led inside and up the wide marble staircase which sweeps up to the *piano nobile* where the largest rooms are found. Giovanna leads her into an airy, comfortable chamber overlooking the courtyard. Already Maddalena feels like a princess.

*

"Refresh yourself, Maddalena," Giovanna points to a basin and ewer. "Simonetta will come to help you unpack." Smiling, Giovanna leaves her with the warning that Rosina, the cook, is a tyrant who beheads anyone late for luncheon.

I feel as though I am reborn, Maddalena thinks, going to look out her window at the verdant courtyard. Then she tackles the unpacking of her small trunk. Taking out the last garment, she discovers a small scroll of parchment at the bottom of the trunk which she has not noticed before. Quickly she opens it to find a letter from Luigi, the missing letter of some time back, apparently written to her the night before he left the Palazzo in the autumn, after their first meeting.

"Carissima,

It breaks my heart to leave here without the chance to speak to you alone. You have made my heart soar like a falcon, my spirit rise as high as the meadowlark at dawn. Do not, my love, forget me. I must think of a plan for us so we can be together forever. Soon I will return to you. I kiss your cheeks, your lips, your eyes, my dearest. Do not forget me. I will come to you as swiftly as the eagle flies and until I see you, you are each minute in my thoughts. Yours, Luigi

Maddalena cries out: So he did write to me of his intention back then. But what evil monster has kept this letter from me all these months? She weeps in frustration as she hugs the letter to her heart. Who could have done such a thing? And with such devilish consequences? Yet in her heart she knows that Tina is responsible for the disappearance of the letter. But why? Why would anyone do such a cruel thing?

TWO

Maddalena and her hosts are seated at luncheon. Alfredo Doni, Giovanna's plump, good-natured husband, whose pockets bulge with bits of scribbled notes and spectacles, presides at head of the table in the enormous *sala da pranzo*. His sweet, unfocused gaze marks him as near sighted and a scholar. Indeed Maddalena soon learns his days are devoted to research on his two passions, architecture and obscure saints.

She timidly mentions her studies at the Priory with Father Bruno, which have included forays into lives of some of the lesser known saints. But it is when she asks for more details on Saint Fina's life that his face lights up and he is off on a mission to inform her.

"We must have another talk about Saint Fina someday soon," he says as he carefully begins spooning his soup.

"You are quite right, Alfredo," Giovanna chimes in lightheartedly, gazing fondly at her cherubic husband. "But we must not keep Maddalena indoors today when she must be yearning to see something of our beautiful city."

"Certainly, certainly," Alfredo agrees. "You will want to see Santo Spirito and San Lorenzo, churches designed by the great Brunelleschi. And of course, his Ospedale degli Innocenti, the foundling children's home, the first Renaissance building in Florence. Then I would recommend..."

"Please, Alfredo," Giovanna interrupts, throwing up her hands. "The poor child has only just arrived. Do not overwhelm her." She turns her beautiful gray eyes on Maddalena who reminds Giovanna she has brought something to Sister Marta at the Ospedale from her sister, Mother Scholastica.

"Then we shall go there first. And we shall leave Alfredo with his Saint Fina and the other saints while we set off to view the sights, eh Maddalena?"

*

Piazza Santissima Annunziata. The Ospedale degli Innocenti. Shining white in the sunshine with a delicate loggia supported by slender columns. Della Robbia roundels of the babies in blue and white ceramic plaques above the arches, the facade displaying order and symmetry, all the work of Brunelleschi's genius. Maddalena sighs contentedly, almost forgetting how much she misses her mother, so moved is she by the sight of the famous building.

They enter, a Sister approaches, directing them to the nursery where she says they will find Sister Marta. The nursery is filled with cribs, all containing babies. The children appear healthy, and for the most part, content. Only a few are whimpering. Several wet nurses from the neighborhood sit holding infants at the breast.

Sister Marta is a short woman, but a slim figure makes her appear stately in dark robes. She is much younger than her sister, and very beautiful in Maddalena's eyes, unlike the somewhat austere Mother Scholastica, whose daunting appearance makes Maddalena quake inwardly every time she sees her. The blue eyes of the two sisters are the same, however. The skin looks almost transparent, the eyes hold an enveloping sense of calm. Gratefully Sister Marta accepts the parcel which Maddalena has brought.

"Dear Bibi," she cries. "She has sent the tracts I requested, and the money for the children's caps, just as she promised." Both Maddalena and Giovanna are struck by an aura of radiance projected by the nun.

Could Bibi be Mother Scholastica Maddalena wonders, wishing she could share the joke with her mother, Bianca. "Bibi," an unlikely name for someone as unyielding as Mother Scholastica! As Maddalena ponders this, Giovanna is asking questions about the babies.

"We are very crowded at the moment," Sister Marta replies. "In winter there are always more children left with us because of the cold and the shortage of food. Winter is so cruel for the poor," she adds, glancing over at the children lovingly.

They follow Sister Marta's eyes to the cribs. How could anyone give up these precious little ones, Maddalena wonders as her eyes sweep over the room. *I really know very little about hardship so many endure. I must do something to help these little ones.*

Giovanna also is touched by the children. Maddalena remembers that Bianca has told her of the great sadness of Giovanna and Alfredo Doni. They have no children of their own. Giovanna pats the dark head of a sleeping baby boy.

"Here, Signora Doni, hold Donato," Sister Marta says, placing the limp little body, fed and content, into her arms. The nun seems to sense Giovanna's longing as she places him. Then she lifts a little girl with blond curls, depositing her in Maddalena's waiting arms.

Oh, to have a *bambina* such as this, Maddalena thinks. Her heart reaches out to the little one. *I want to come here again and again.*

Presently Sister Marta takes them to another part of the Ospedale where the children are busy sewing. In another room a group of boys are learning sums. Along the corridor older girls are singing, led by a young and pretty Sister.

"Some of the boys work in a deserted courtyard at the back. The Brothers from Santissima Annunziata teach them wood carving. Others will go with the Brothers to the monastery fields to work, when the weather is warmer." Proudly Sister Marta shows them everything.

"We must come back here," Giovanna says suddenly. Can we help you in any way?"

Sister Marta's eyes shine. "There is always much to be done. And love is the thing these children crave most. Please, return whenever you can."

THREE

Maddalena is alone in the Doni villa except for the servants. Giovanna and Alfredo have gone to attend a ceremony at Alfredo's textile factory, an annual event when the workers present the first bolt of cloth of the new year to the owner. It is symbolic but important, to show the loyalty of the workers, and in appreciation, Alfredo provides a banquet in the factory courtyard after the ceremony. Twice postponed because of rain, the day has finally arrived.

Maddalena lets her eyes drift from vine to vine in the courtyard below, inhaling the sweet smelling jasmine before turning away from the window to shampoo her hair. Her visit has turned into something magical. Even her first sight and smell of the mornings in Florence fills her with delight. On this fine day she plans to write letters to her mother and to Piero.

Breakfast is always taken in her room. Maddalena thinks it is the height of luxury to have the tray brought by little Simonetta, to enjoy the warm milk and rolls in comfort. Her visit is spoiling her, and Florence has so much to offer which is new and exciting. But she and Giovanna must make time to return to Sister Marta and the babies of the Ospedale degli Innocenti. Maddalena has an attraction she cannot explain for the place, and for the inspiring nun there. She is vigorously toweling her damp hair thinking about what she and Giovanna might do to help the children when her thoughts are interrupted by a knock on her door.

"There is a gentleman to see you downstairs, Signorina." Simonetta bows daintily as she gives Maddalena the news.

Who can it be? Quickly Maddalena throws on the old gray dress as she brushes her still damp hair into place.. She hurries down the wide staircase to discover Luigi Castellani standing before her, gazing at her with earnest wood-violet eyes.

"Luigi! What brings you here? How did you know where to find me?" Her face is a puzzle.

"My mother told me," he says simply, taking her hand. He shrugs. "And in Firenze, everyone knows the Doni villa. I've been on a brief visit to San Sepolcro and am now on my way to my garrison outside town. I've finished at the Pisan front."

"And did you find your mother well?" Maddalena slips her hand away but she cannot avert her gaze.

The wood violet eyes speak much more, as he answers, "She is well and in good spirits."

"And Julietta, how did you find her?" Maddalena, her smile teasing, cannot resist asking.

"I hardly saw her." His voice holds contempt. "Maddalena, you must know I had no idea she would take herself off to my parents' house after I wrote her bringing to an end what can only be called an infatuation of childhood between two young children." Color rises in his cheeks, as Maddalena beckons him toward the small *salotina*, a receiving room beside the grander *salone*.

"Julietta made her plans on her own. I had nothing to do with them. I sincerely hope her presence was not an embarrassment. She knows from my letter that I am in love with you and plan to marry you. All she can say to me is that you are betrothed to some artist already. My mother and father say this to me as well. Tell me, Maddalena, is it true? Do you love him?"

Perhaps the little *salotina* was not the best choice for a meeting with Luigi, Maddalena reflects tardily. It is very small, rich and precious like a jewel, covered in tapestries depicting nymphs and the fauns who are their lovers disporting themselves. The one sofa in the room is small, designed in the French style with delicate gilding. Maddalena and Luigi are so close to each other, even at opposite ends of the love seat, that their knees almost touch. And they are surrounded by cupids in the tapestries shooting darts and other love symbols.

"Yes, Luigi," Maddalena speaks barely above a whisper. "I am betrothed to Piero della Francesca, the artist. It has been true since shortly after January 20th, Saint Sebastian's Day, the day he first spoke to me about becoming his wife."

"But do you love him?" Luigi persists, taking her hands. She is silent, lowers her eyes.

"I see," he says, hands falling to his sides. "You will not answer." He looks like a prince, she thinks, sitting in this beautiful little room made for lovers, a perfect place for sweethearts to meet. Then she feels ashamed for letting her thoughts wander. Poor Luigi, he has tried to do the honorable thing. Every act has gone against him. And against her. She thinks of the stolen letter, finally returned to her. All could have been different, if only...

"And yet you came here, leaving your betrothed alone in San Sepolcro?" Luigi is clearly puzzled, thinking aloud.

"No," she answers quickly, "Piero left San Sepolcro before I did. He has gone to serve as court painter for Duke Federigo da Montefeltro in Urbino for a year. When he returns we will be married."

"Gone for a year? Are you sure this is the man you love, Maddalena?" He looks solemnly into her eyes. "I must know the truth, Maddalena. Until I know it, I will not give you up."

"I am betrothed to Piero," she repeats, unable to declare that she loves him. She keeps her eyes lowered, unwilling to meet Luigi's probing gaze. Luigi stands up, eyes never leaving her face.

"I hear your words but your eyes tell me it is different." She rises to her feet and like magnets their hands find each other again. "I won't give up hope until you tell me it is Piero you love and not me." Luigi continues to scrutinize her face.

Maddalena's heart pounds like a bouncing ball. He has read the unspoken longing in her heart. Their lips touch and she is dimly aware of her surroundings in the little trysting room as he kisses her.

"You must marry Julietta," she whispers, stepping back. "She will make you a good wife. You must do as your father wishes, Luigi. Truly, Luigi, I would be but a poor bargain."

"Bargain!" He scoffs. "Do you think I am seeking a bargain? To marry without love would make me despise myself. I have already told my father as much, and I mean what I say. I am going to make my own way and provide honorably for a wife *and for the Castellani estates.* You'll see, if you will only hear me out."

"Luigi, I cannot. I have promised someone else."

He turns to go. Standing in the doorway he repeats so softly she can barely hear. "I am not giving up. I have not yet found a way, but I will keep trying to convince you of the sincerity of my love, and its endurance. You have not proven to me your love for someone else." He turns and is gone.

Maddalena sits for some time after he has left in the joyous little room, a room celebrating love. She is mourning the end of her childish dreams about a Prince Charming who would come and bear her away to his castle. Enter Luigi, the encapsulation of all those dreams of childhood. No matter how aware she is of her responsibility to Piero, and her determination to fulfill it, she cannot deny the attraction.

FOUR

The Brancacci chapel stands at the right transept of the church of Santa Maria del Carmine in a poor section of Florence near the River Arno. Already a small gathering of onlookers has collected to admire the frescoes painted by Masaccio in 1423. Unfinished at the time of his death a mere five years later, they have achieved the status of a shrine to the declared genius of early Renaissance painting.

Maddalena stands in front of the most famous panel, *The Tribute Money*, rectangular, showing on the left side in smaller scale, Christ sending Peter to the shore to take the coin from the mouth of the fish. Then, in the dominant center panel, Christ and his followers stand, magnificently garbed in loose, flowing Roman robes. On the right, in smaller scale, Peter offers the coin to the tax collector, the tribute.

The three scenes in one are the most famous example in all art of the principle of Continuous Representation. Maddalena has learned this from Father Bruno. This group of frescoes is at the top of a list to examine in Florence which Father Bruno has given her. Maddalena notes that the figures of Christ and his disciples are sculptural and fully drawn, with natural light suffusing the entire panel. Light from a window in the chapel matches the light source in the fresco. Here indeed is genius at work, she thinks, remembering how Piero also told her every artist worth his salt studied over and over again these frescoes by Masaccio.

She next looks at the small panel of Adam and Eve Driven from Paradise, *The Expulsion*. The looks of shame and anguish on the two faces represent new heights of emotion expressed in art. Maddalena stands silently before the fresco, dimly aware of the ebb and flow of people around her.

"Signorina, *prego*." She whirls around to face a man stooped with age wearing a military tunic under a long brown cloak. "Forgive me. I am Tomaso di Paolo, a former soldier in the army of Florence. At your service. You have the face and bearing of one of my former colleagues, a soldier who died in battle many years ago, Giovanni dei Crespi." For a moment his eyes well, but he quickly recovers.

"You look so much like him, I simply had to ask." He lifts gnarled hands in a gesture of apology.

"Indeed my father was Giovanni dei Crespi," she replies. "And my mother is Bianca Albizzi dei Crespi." She speaks the name proudly, raising her chin. "She and I live in San Sepolcro."

"Then you are Giovanni's daughter! Child, your father and I were fellow officers. I knew your mother also. Before you were born, I visited in their home. And when you were a *bambina,* I held you in my arms."

As they walk slowly toward the entrance of the church, he tells her he is widowed and lives nearby, across the Arno. He is about the age my father would have been had he lived, she thinks, noting the gray hair, wrinkled skin, the limp. Before she has always imagined her father as young and youthful, somewhat like Luigi. *This man looks like my father would look now.*

"I come here often, to worship and to look at the frescoes. I like to look at Masaccio's work. He knew a lot about the human condition." And a lot about how best to paint it, Maddalena thinks.

"Is your mother well?" And Maddalena tells him of Bianca's life, how she must work very hard to maintain her position of gentlewoman and to provide for her daughter.

"I admired your mother when she was a young woman. I, I had to break the news to her when Giovanni died fighting at the front. She reacted with bravery. She did not collapse on the floor screaming as some did." He stares blankly ahead, lost in memories she cannot share.

As they part, Maddalena invites him to visit San Sepolcro. She thinks it might be pleasant for Bianca, who needs companionship and friendship despite being surrounded by people at all hours of the day.

FIVE

Piero is watching a fencing class taking place in one of the courtyards of the Palazzo Ducale. Noble families from far and wide send their sons to Duke Federigo's palace to learn courtly manners, the martial arts, and to receive instruction from leading philosophers and thinkers of the day.

He is moved by the grace and agility of the young swordsmen, and wishes he had brought something on which to sketch. The Duke and Duchess are on a visit to Milan, a visit to her family. Piero has some unaccustomed leisure which he is enjoying. Uncomfortably, it only occurs to him this very morning that perhaps he should have made a brief visit to Florence to see Maddalena during the duke's absence.

He recalls his vague promise to her that he would bring her to Urbino after they are married. Well, that may not be possible, with a duchess like Battista Sforza who might not wish to have so pretty (and similar looking) a rival blossoming on her own territory. Judging from the plainness of her women attendants, Battista does not welcome competition.

Piero is delighted with the letters from Maddalena he has received since she traveled to Florence. Her descriptions of the buildings, the art she has seen, and in particular her impressions of the city, both amuse and entertain him. And with a companion like the beautiful and dignified Giovanna Doni, he is sure Maddalena is well-chaperoned. Maddalena's forthright and impetuous spirit means that she trusts everyone, and should not be allowed to wander about the city alone. Piero sighs, if only he could be half so accepting as she. But no, the world has dealt him too many bitter blows, he must eternally be on guard.

The painting of *The Flagellation* is almost finished. The figures of Christ and his tormentors on the left side have posed no problem. It is the same scene he has pictured in his mind for years during his Lenten devotions leading up to the Crucifixion. He admits to pride in the handling of the perspective. No, the difficulty is on the *right* side, a scene that jumps to the present day and has been carefully specified by the duke himself. Through this painting he must tell of a tragedy very real to Duke Federigo.

Some years back, the nephew of Federigo, Oddantonio da Montefeltro, was assassinated just before he was to assume the ducal title. Young, vigorous, of extraordinary intelligence and physical beauty, Oddantonio was cut down in the prime of youth, his promise never realized.

Piero has heard it said that when Federigo took over the title, it was with tears in his eyes and a vow on his lips to avenge his nephew's death, but the murderers have never been exposed. Under the direction of Federigo, Piero has painted the right side of *The Flagellation* as a memorial. The young man has the physique of a Greek god, all light and innocence, draped in red robes, while he is flanked on either side by a pair of sinister political types, dressed in the clothing of Tuscan and Umbrian men of consequence.

The implication is that these men are the plotters of deeds of darkness toward the vulnerable looking Oddantonio. A puzzling assignment, Piero thinks, but he is just as certain that this painting is by far his best effort to date. He senses it will be admired for its scientific proportion and balance long after he has departed this earth.

SIX

Evening light floods the Doni courtyard making it seem lustrous like a pearl as Maddalena and Giovanna look down from her window, the smell of growth and greenness wafting upward. In the hour before dinner, her last dinner in Florence, she takes time to reflect on the visit.

Giovanna has never slowed in her eagerness to show her the beauty of the city. *She also admired the ring Piero gave me*, Maddalena recalls, turning the amber ring slowly on her finger. Purposefully, she pushes Luigi from her thoughts as she might push away a troublesome ball, bobbing in water as she swims along some unknown shore of the mind.

"And do you not think waiting a year perhaps until you see Piero again will be a hardship?" Giovanna asks, looking quizzically at her as she helps her fold garments into her trunk.

"Of course I think it a hardship," Maddalena replies, "just as I think leaving *Firenze* is a hardship after collecting so many beautiful memories. They are like a basket full of everlasting blossoms which I shall always treasure."

"We shall both miss you my dear Maddalena, more than you know, and I shall be daily scheming and plotting your return. Remember, we must visit Sister Marta and her darlings at the Ospedale degli Innocenti again. We must do that because we promised. You will return. You have truly entwined yourself around our hearts."

As she is preparing to leave the next day, a letter from Piero is delivered.

Dear Maddalena, I am busy trying to finish the Flagellation painting I told you about in an earlier letter. I have had some difficulty just today in getting the perspective of the black and white floor tiles right in the painting. In solving this problem, I have received help from a new friend who has joined the group of artists under the protection of Duke Federigo here at the Palazzo Ducale. His name is Leone Battista Alberti, an architect who is also the writer of several learned books. His family are merchants in Firenze.

106

Alberti is at present writing a treatise on the principles of perspective. What a mind this man possesses! In truth, I feel honored to discourse with him, so perfect and clear is his intellect. With God's blessing I hope to complete the painting soon.

Alberti and I have recently received letters from Sigismondo Pandolfo Malatesta, the Lord of Rimini. He invites us to come for a brief stay, long enough for me to paint a portrait of him and his name saint, Saint Sigismond of Burgundy. He possesses a drawing of the saint which I may copy.

Of course, before sending the letters of invitation he received permission from Duke Federigo. You must understand, Maddalena, how it is essential for an artist to seek out important patrons. I do not expect to be away from Urbino more than a month or two. Your letters from Firenze keep me in good spirit. Write to me again soon. With love and devotion, Piero

The letter, combined with sadness at leaving Florence, occupies Maddalena's thoughts on the journey home. Could this trip to Rimini be the beginning of a pattern? A pattern of Piero departing time after time? Turning marriage to him into one prolonged separation?

San Sepolcro

ONE

At Palazzo Castellani, Bianca is even more harassed than usual. Julietta has departed hastily, apparently with hardly time for a proper goodbye to her host and hostess. Il Signore has shut himself up in his study in a temper and La Signora has taken to her bed. From what Georgio has been able to whisper hurriedly to Bianca, Julietta received a letter earlier which put her into an unattractive pouting state, and she decided to decamp on a moment's notice.

All of this Bianca relates quietly to her daughter as they snatch a few moments together before Maddalena goes up to her room to unpack.

"I can think of one reason why Julietta might be in a rush to leave," Maddalena says softly. Bianca raises her eyebrows.

Maddalena tells her of the meeting with Luigi in Florence, of his declaration of love. She tells Bianca of his determination to win her from Piero, of his vehement insistence that he wants nothing to do with Julietta or her dowry. Luigi insists he will make his own way, even if Maddalena ultimately rejects him. He declared he would write Julietta, telling her his intentions, once and for all.

"I suspected it from the outset," Bianca admits with a sigh, "From that night of the little dinner party last autumn. It was in the way Luigi looked at you, his eyes following you everywhere you went. I knew he was infatuated then. The surprise to me is that he has followed through with it, in spite of his father, in spite of your betrothal to Piero." Bianca shakes her head.

"Poor Julietta," she says. "Even with your betrothal to Piero, apparently she has still lost Luigi."

Suddenly Maddalena bursts into tears. Furious with herself, she dabs at the rivers streaming down her cheeks. Bianca looks at her daughter in amazement.

"Maddalena! Whatever is the matter?" Bianca puts her arms around her daughter's shoulders and tries to comfort her.

"Mother, I simply cannot bear to be told again how lucky I am to be betrothed to Piero. At this moment I am as close to despising him as I have ever despised any human being." She presses a square of linen from her pocket to her eyes.

"I don't understand. What are you trying to tell me, Maddalena?"

"Simply this: Piero has written to me that he is going to Rimini to work for the Lord of Rimini. Then he will return to Urbino. I do not think he has any plans to visit San Sepolcro. At last I understand perfectly what marriage to him will be like. In the future I will only be a possession he can summon forth to impress his patrons. A token wife. That is all I'll ever be to Piero. And always, always, I will be left behind."

Bianca is shocked at her daughter's depth of bitterness. She is also dismayed. Surely Piero could have made a brief visit to San Sepolcro before setting off for Rimini. After all, it is his hometown and he has civic responsibilities, in addition to a beautiful woman to whom he has declared his love.

But she is careful to keep these thoughts to herself. She soothes Maddalena as best as she can, telling her that all lovers have disagreements. She must not let her imagination get the best of her. Piero will come. Wait and see.

TWO

Before Maddalena has finished unpacking, the servant's quarters are thrown into an uproar by the sudden sickness of little Giuseppe. He has come down with a fever and his mother and father are frightened and worried. Quickly Bianca summons her daughter to help.

They descend the grand staircase, then down a narrow back stairway leading to the dank smelling basement where the servants live. If paint had once covered the walls, it has long ago flaked away. A musty, damp odor pervades the rabbit warren of small doorways and corridors. Maddalena gags and quickly places her handkerchief to her nose. They enter the small, crowded room that is home to Giuseppe, Maria and her husband Antonio, one of the gardeners.

Lying on a small, makeshift bed, Giuseppe's eyes are shiny, his cheeks red with fever. Maria stands beside the bed, praying and weeping, tears coursing unchecked down her face.

"Blessed Mother, do not take him from me." Her cries are piteous.

Gently Bianca leads her away, soothing her, explaining that her cries will frighten Giuseppe. She tells her that Maddalena has come to sit with the boy and bathe his face and arms with cool, wet cloths and fresh water. Bianca leads Maria back to the kitchen and goes in search of a quieter place for Giuseppe. She sets Maria to work drawing cool well water and finding clean cloths.

Bianca reappears in the sick room with Georgio, who lifts the child tenderly in his arms and takes him to a nearby storage room used for drying herbs, a room fresh smelling and quiet. There he places Giuseppe on a small couch Bianca has covered in clean linen. In an old chair beside the bed, Maddalena takes up her station. Overhead the rafters support drying bunches of herbs for kitchen use and to strew on the floors. The space smells pungent but clean and fresh.

Even though the child's eyelids are shut, Maddalena speaks to Giuseppe calmly in a confident tone.

"Now, Giuseppe, you soon will be better." And she begins to bathe his face and arms with cool compresses, exchanging one for another after dipping them in the basin. In a few minutes he opens dark eyes, shiny with fever, and looks up at her. She is shocked by the huge purple hollows under his eyes. Smiling, she begins to sing in a calm voice as she continues bathing his forehead and face, then his hands.

"Giuseppe, you are still very hot. Your body is too dry. Will you try to drink a little water for me?"

He blinks his eyes and she pours water from the ewer and cradles his head under her arm. But he is unable to drink from the cup.

"Wait, I will let you take a sip from the spoon." Slowly, the child begins to swallow spoonfuls of the cool water. Once he starts, he cannot get enough. No one, Maddalena realizes, had thought to give him water.

The routine is unvarying. Maddalena bathes his face and arms, gives him water from the spoon. Time passes. Bianca and Georgio come to check on the patient, as does Maria, who is quiet now, pathetically grateful to Maddalena. Maria pats her son's head lovingly, but does not wail or moan, even though her cheeks are still blotched from weeping and her eyes red. At bedtime, Bianca comes to relieve Maddalena.

"Not yet, Mother. I want to stay with him until the fever breaks. You go to your rest. I will take mine tomorrow."

Later, there is a timid knock and Antonio, Giuseppe's father enters, hat in hand. The gnarled, roughened gardeners' hands tremble slightly, Maddalena notices his eyes are misty.

"Signorina, he, he will live, will he not?"

"I pray that he will, Antonio. He is a strong and brave boy. We must pray that the fever will break soon."

Giuseppe sleeps fitfully most of the night, awaking intermittently and asking for water. By dawn his forehead feels cooler. With a brief prayer of thankfulness, Maddalena leans against the wall in her chair and dozes. In an hour he is awake, asking to drink from the cup. He sips noisily and falls back on the couch exhausted. He sleeps again, almost immediately. When he wakes, it is midday, and Maddalena sees the fever has left his eyes. His face feels cool.

Giuseppe smiles wanly and asks for food. Maddalena leaves his side to bid Maria prepare a bowl of beef broth. When Maria arrives, tears run down the cook's cheeks as she whispers her gratitude to the Blessed Virgin.

"I must leave you for a little while, Giuseppe, but your mother will feed you the broth."
Maddalena plants a kiss on his forehead.

"Broth is all right for now, but for supper I want *Mamina's* pasta." He smiles.

"Very well, if you will promise to keep drinking water until I return."

At that moment, looking at the face of the child as he struggles to sip the broth, Maddalena knows his recovery is certain. She feels peace, exaltation also, for in some inexplicable way, she understands she has been witness to a miracle. The boy has been restored. Is this what Sister Marta and the nuns feel at the Ospedale when they witness a sick child's recovery?

In the past months of turmoil, Maddalena has never felt a peace like this. Not to depend on anything but God's love and care; to nurse those in need. Is it not the most noble calling of all? She is still uncertain, but she has learned one thing. She knows she must find a life for herself that is full and rewarding and embraces other people. Not for her a solitary life of pining, being left behind. Her visit to Florence and Giuseppe's illness have changed her expectations of life and have made her more thoughtful.

THREE

A few days later, Maddalena realizes the servant Valentina has departed Palazzo Castellani.

"Oh yes," Bianca tells her, "she is now in Prato. You were in Florence when she went. I must tell you, Maddalena, she seemed like a different person the day she left. A smile on her face, a spring in her step. You hardly would have recognized her. It was as though she had suffered something intolerable and was now free. Why, she even made up with Giuseppe. She gave him some of the wedding sweetmeats."

"Just when did she leave, Mother?"

"Let me think. Right after you left for Florence, the next day after it was. She said she was sorry she did not see you to say goodbye."

In a flash of prescience Maddalena is certain now. Tina and the mystery of the missing note is solved. Tina cleared her conscience before leaving by placing the letter from Luigi in the bottom of my trunk as I was getting ready to leave for Florence. How she managed to get her hands on it in the first place I will never know, Maddalena thinks. But find it she did, and it has caused a misunderstanding of colossal proportions between Luigi and me, a disaster that will probably never will be corrected.

Yes, she muses, that is what happened: in desperation, and to atone for her wrongdoing, Tina must have slipped the letter from Luigi into my trunk. But by then, Maddalena thinks sadly, it was too late, too late.

FOUR

"Unity of *La Famiglia* is more important than the happiness of any one member." Giuliano Castellani is speaking to his son Luigi in the little study of Palazzo Castellani. Luigi eyes are downcast as he listens in silence. It is their first meeting since the explosive encounter between them when Luigi told his father of his plans for the future.

"Fathers chose the sons' professions in my father's time. And so it was before him. It worked well. Why can you not accept it now?" He looks fixedly at his son but continues.

"But no, you come to me demanding to choose both your profession and your wife! What is wrong with being an officer in the army of Florence? What is wrong with marrying Julietta? She is comely, she finds you attractive. Your actions have wounded her deeply, and I understand how she feels." Without expecting an answer he hurries on.

"Do you realize that her dowry alone would erase a mountain of our debt? Do you realize that I am responsible not only for your mother and you, but also for aunts, uncles, cousins to say nothing of our farmers and an army of servants and their dependents, all of whom demand my charity?" Luigi shifts uneasily in his chair. Has he finished? It appears that he has.

His father is like a wily old spider, safe in the corner of his web, but ready for the attack at a moment's notice. I'll never be able to accept his ideas, Luigi speculates, but he cannot grasp that. Like his father, Luigi too has a stubborn streak. In a low voice he begins to speak.

"Father, I am aware of traditional customs in the family. I have nothing against them, but the world has changed. I feel that I can build a much stronger marriage if I choose my wife rather than if I am yoked to someone else's choice. And since I have given you my promise that I will bring money into our family by my labors, why should you object as long as the profession I choose is an honorable one?"

The elder Castellani looks at his son as he pushes his fingertips together. And that is the crux of the matter, he thinks. At least we are not at each other's throats as we were in our last meeting. He is painfully aware that Luigi is his only surviving son.

"And will you not try to set things right with Julietta?" The older man asks the question softly. He must keep his temper under control. After all, Luigi is his one hope.

"No, Father," Luigi speaks firmly. "Even if I fail to win Maddalena, I will never marry Julietta."

So, the elder Castellani thinks, it is now crystal clear. His son is fixed on his course. It would be naive to assume that Luigi has failed to become independent and self-sustaining in the fourteen years he spent away from his home. *Heaven help me. I cannot lose my one remaining son.* What I must do is to scale down my own feelings to an acceptance of the facts as Luigi sees them. I must do this. I will somehow have to fend off my creditors a little longer. He sighs heavily.

Luigi feels exultant as his father grudgingly agrees with him, but he does not dare show it. I thought the old boy would come around to my way of seeing things, he muses. Now he can focus all of his persuasiveness on Maddalena.

At the very moment the heated exchange is taking place in the study, Maddalena is traveling along the road to Florence in the Doni cart driven by Lorenzo. Her heart is beating rapidly and she can hardly come to grips with the suddenness of her departure, the shocking letter brought by Giovanna's groom who arrived earlier from Florence.

Dear Bianca and Maddalena,

Firenze is under water. The River Arno has overflowed its banks. Alfredo and I are safe on Via Ghibellina but the church of Santa Maria del Carmine (the Masaccio frescoes!) has two feet of water in the sanctuary. Many houses along the river are washed away, countless others are flooded. There are untold numbers of the sick and homeless.

I have only this day paid a visit to Sister Marta at the Ospedale degli Innocenti. She pleads for our help. She did not realize, of course, that you had returned to San Sepolcro. Many are being given shelter at the Ospedale and at the nearby church of Santissima Annunziata.

I am writing to ask if you, Maddalena, can possibly return to Florence. Many hands are needed. It is hard but rewarding work. Whether you can return with the cart or not, I have instructed Lorenzo to go to the Priory and give Mother Scholastica a letter from her sister, asking her for whatever she can spare in the way of medicines and bandages as well as food. As for the Doni Villa, we are safe, on higher ground. But oh the misery of my poor Firenze.

Blessings to you both. Keep us in your prayers. It is raining again as I speak. Yours in haste,
Giovanna

Over and over Maddalena recalls the brief message as the cart jolts toward Florence. How in a dream-like state she hurriedly packed her trunk, embraced Bianca and climbed quickly into the cart. In a matter of a few minutes, they reached the Priory of San Giovanni Battista. Mother Scholastica, after reading the letter from her sister, acts with similar dispatch.

She sends the Sisters running toward the herbarium and the kitchens, where the ovens have just turned out freshly baked bread, thirty loaves for the nightly meal. Without hesitation Mother Scholastica, who has accompanied the Sisters to the kitchens, nods toward the cooks. Freshly baked bread will be handed out at the Ospedale in *Firenze* tonight, along with supplies of bandages, potions and remedies from the skilled hands of the Sisters in charge of the herbarium.

Maddalena, seated up front in the cart with Lorenzo, looks back at the back of the cart, brimful of supplies from the Priory. She can smell the bread. They will have delivered it easily by nightfall, in time for supper. She is unaware in her haste that once again, she and Luigi have missed each other.

As the cart draws nearer to Florence, a sorrowful procession of horsemen and people on foot comes into view. All leaving the city, bound for higher ground. A few well-to-do ride in carts while some pitiful pedestrians carry all they possess on their backs. Litters pass on which the old and infirm are being carried. Dazed and uncomprehending, the refugees stagger on, bound for shelter they know not where. In their silence, the travelers proclaim their misery.

"Those two, they are the worst off," says Lorenzo, pointing to an old couple limping along on foot. "Everything they have is gone, even hope, judging from the look of them." Maddalena struggles to keep back tears. Never in her short life has she seen such tragedy. What will she find when they reach the Ospedale? They draw closer to the city and she is surprised to see torches burning, even though it is still daylight.

"To purify the air," Lorenzo answers her unspoken question. "There are fevers about," he finishes grimly.

The horse canters along hushed, deserted streets. Ordinary workaday noises are missing: the sound of doors opening and shutting, the chatter of servants at open windows, the bustle of peddlers moving up and down busy streets.

They pass a small field where a few bewildered looking cattle stand uncertainly. Maddalena looks closely and sees water shining like silver running along channels in the green grass. The meadow is flooded. The cattle are standing in water and no one has come to take them to higher ground.

As they approach Via Ghibellina Maddalena notes with dismay that it lies covered in water.

""Do not fret, Signorina, I will take us in from the top end of the street, where the ground is higher." Lorenzo turns the cart around and the horse sets off in a new direction.

Presently they enter the upper end of the street and she can see the Doni villa well above the water's encroachment. In a few seconds they are within the courtyard where all looks normal, Maddalena is relieved to see. Then she is being embraced in Giovanna's welcoming arms, a silent Giovanna whose dark eyes proclaim the tragedy which has befallen her beloved Florence.

Firenze

ONE

Seated on the small love seat in the little *salotina* of the frolicking nymphs, Giovanna and Maddalena face each other. The hope is, Giovanna tells her, that the rains have ended and perhaps the waters may start to recede, unless there is a new surge flooding downstream. Water stands at one and one half *bracchia* in Santa Maria del Carmine, still well below the Masaccio frescoes, Giovanna tells her as she offers Maddalena a small plate of bread, cheese and a cup of watered wine. For the time being, it appears, the Doni villa and the Ospedale degli Innocenti are safe.

In the cathedral, Santa Maria dei Fiori, Maddalena learns that planks had been laid up over the aisles for safe passage, but the waters surged and washed them away. It is impossible to enter now. The Baptistery with its sublime doors by Ghiberti stands in several inches of water. The old church of Santa Croce nearby, where she and Giovanna visited Brunelleschi's beautiful little Pazzi Chapel, a hallmark of the new architectural style, lies underwater.

Nervously Maddalena nibbles at the bread and cheese, sips watered wine, as Giovanna describes the devastation.. She is anxious to be off to see Sister Marta at the Ospedale, where Lorenzo has hurried on ahead of them with the supplies from Mother Scholastica. As soon as Lorenzo returns for them they will go, to see how they may help.

*

They arrive at the loggia of the Ospedale to find it teeming with victims of the flood, sitting or lying on the stone floor of the loggia or standing together in listless little groups while the dark robes of the Sisters weave among them, giving what aid and comfort they can.

"Have you ever seen such misery?" Maddalena whispers. "How will I be able to help here, when I myself am stricken with their tragedy? The worst thing of all is the utter sense of hopelessness and desolation."

"Please, Maddalena. Do not be bowed down by events we cannot understand. What we must do is shine bright the beam of hope on these people. They are alive, they have survived the terror of the flood. Rain will stop, waters will recede, and lives will resume living. That is what we must hold high in our hearts as we try to help."

Maddalena nods in agreement, stirred by Giovanna's courageous words, remembering how she herself kept up Giuseppe's spirits when he was so ill. *But how much worse this is*, the thought presents itself. *All the more reason for you to think and act with conviction!* An inner voice speaks to her.

Carabineri, police, are patrolling the open areas, but there is little to occupy them. The majority of the refugees are too dazed, too weak for misdeeds or lawlessness. Inside the Ospedale, an emergency ward of sorts has been set up to minister to the most serious cases. Patients sit or lie on mats, some awaiting help in bandaging up their wounds.

They find Sister Marta in a corner where she is speaking to an old woman and a small boy, shivering and badly frightened. Giovanna and Maddalena watch silently as she embraces the pair warmly, speaks a few soft words of encouragement, assuring them all will be well. She looks up from her task of wrapping a bandage around the young boy's arm and sees Maddalena and Giovanna.

"Praise God you have come." the nun says simply, but the magnetic, lambent eyes convey her feeling of all embracing love and compassion. "We are already putting the food and medicines you brought with you to good use, Maddalena," she smiles, indicating the clean bandage on the child's arm.

"Perhaps you will go with me to the kitchens for a bit, and Giovanna, could you assist the Sister Marcella in the nursery? She is alone with the little ones, as I have deserted my post." Again her beautiful smile lights up the room. Maddalena follows, numbed by the misery which surrounds her on all sides. *Perhaps it is just as well I am put to work in the kitchen until I can better cope.*

In the kitchen a Sister is stirring a giant cauldron of bubbling soup. Another is slicing bread. A huge mountain of dirty bowls stands at the sink. "You see, we have already begun to use the supplies you brought." Sister Marta indicates the soup and the bread. "Dear Bibi, how thoughtful of her to send the bread. We have had not one minute to think of baking today, so busy it has been here."

Maddalena smiles, thinking of Mother Scholastica, also known to her sister as Bibi. She walks toward the mountain of dirty dishes in the sink. "Good, Maddalena, I hate to ask you to spoil your pretty hands, but we must have clean bowls and spoons before we can serve the

soup, eh?" And again, Maddalena is enveloped in the warmth of Sister Marta's smile. She begins work with a great energy received from Sister Marta, as the earth is warmed by the rays of the sun she thinks, idly swishing bowls in the water.

Soon her hands are as wrinkled as prunes; the mountain dwindles. It is time to serve the soup. Two porters carefully lift the cauldron onto a litter and carry it to the loggia. The soup is ladled into bowls by Sister Marcella, then Maddalena passes it along with thick, crusty slices of bread, to a line of waiting refugees. The soup, rich and nourishing with bits of ham and pasta afloat in it, smells inviting. Soon the line grows longer. When the cauldron empties, porters arrive with another steaming pot. Maddalena thinks of Piero. How surprised he would be to see me now.

She serves an older couple, who look to be over eighty. The man does not speak, he is apparently quite deaf, but his wife is pathetically grateful. *"Grazie, Signorina, Grazie,"* she mumbles as she spoons the soup.

"My son lives in Lucca," she confides, warmed by the soup. "When he hears of the flood, he will come for us. He is a good boy." Over and over she repeats the words to anyone who will listen. Maddalena takes soup to a young mother with three small children who are eyeing the food hungrily.

"Where is your husband, Signora?" Maddalena asks.

"He is among the missing," the mother answers bravely, hands trembling, determined not to cry in front of her children. Maddalena silently berates herself for the thoughtless question.

"I am sure your husband will find you soon," she says, with a sense of bravado she hardly feels. She pats each child on the head. Back inside the Ospedale, she asks Sister Marta what will become of the people whose houses are washed away.

"Some of them will be claimed by relatives and taken into their homes. Others who remain will possibly return to their houses as the waters recede. If a house has been destroyed and they have no place to go, we try to help them find work and new homes. One thing we cannot do, we cannot turn them away, not so long as we have a cup and a crust here," she finishes passionately.

Maddalena glimpses Giovanna in the nursery bending over the cribs as she hurries back and forth to the kitchen. But there is no time for leisurely talk. Later, as the evening wears on and the children are asleep for the night, Giovanna will be at work in the sick ward, bandaging wounds, bathing faces, giving whatever comfort she can alongside Sister Marta. Maddalena, still dispensing the last of the soup, begins to think with longing of her bed. So long since she began her journey earlier in the day from San Sepolcro.

"Leave the washing up until tomorrow. It is time for you to go home." Sister Marta's voice rings out as she hurries into the kitchen. It is growing very late. All of the soup is finished,

the cauldrons are empty. Sister Marta, still as energetic and as fresh looking as in the afternoon, dismisses Maddalena and Giovanna. They make their way to the cart driven by Lorenzo, who has also been helping with some of the carrying and lifting jobs.

It has been a long day for everyone, Maddalena thinks, sinking into bed at last. *Never in my entire life have I felt so tired.*

But lying in her comfortable bed in the Doni villa, before her eyes close, she recalls the misery she has seen. And if she has been able to help, even in a small way, it has been worthwhile. She is reflecting on this feeling of fulfillment as she falls asleep. And her sleep is deep, full of peace and calm.

TWO

*L*uigi Castellani is alarmed by the numbers of dazed, plodding homeless he encounters as he approaches Florence following the brief visit with his parents in San Sepolcro. What can Maddalena be rushing off to Florence for when Florence is caught in the worst flooding in years? Are they never destined to enjoy a simple face to face meeting? He spurs his horse onward, knowing he will surely receive a reprimand from his superior officer for taking longer leave at such a time of crisis.

The visit with his parents, he reflects, has gone well. At last he and his father have matters straight between them. It is to his father's credit that he is able to retreat gracefully from a losing position. He knows the outcome was a foregone conclusion, and it must stick in the old boy's craw that he lost.

I'll just have to make it up to him somehow, Luigi thinks. By doing all I can to heap honor on the Castellani family. What was it his father said about *La Famiglia*? Something about the unity of *La Famiglia* being more important than the happiness of one of its members? Well it is true, and his father has bowed to the inevitable and accepted defeat graciously. He likes him all the better for it.

He reaches the center of Florence, realizing he is quite near Via Ghibellina and the Doni villa but resists the temptation to pay a call to Maddalena. In San Sepolcro, her mother, Signora dei Crespi, was decidedly cool when he inquired after her. Merely told him she was in Florence visiting a cousin.

Signora dei Crespi would like me to keep clear of Maddalena. She sees me as someone who threatens her happiness with this Piero, the artist. Well, I won't interfere. But if Maddalena is miserable, I won't ignore her either. And I must let her know my father no longer objects to my plans for marriage. And Maddalena never would admit she loved Piero at our last meeting, he recalls with hope.

He turns his horse onto the street toward his garrison, on the opposite side of the city, crossing over the one bridge still spanning the Arno. His horse, daintily picking his way through the few streets not underwater, tries to avoid the muddy quagmires. This is no place for Maddalena, Luigi thinks again. Why is she here? But his heart is lifted by the hope he may soon see her again, flood or no flood.

THREE

Tomaso di Paolo is traveling toward his estate in Arezzo. The flooding of the Arno in Florence has swept away his small house there on Via San Frediano. He sighs. It is time he returned to the land of his birth, to Arezzo. Time to take over the running of his farm in a country whose verdant hills grow the best wine in Tuscany, he muses.

Now that his daughter is happily settled in Florence with her husband, there is really no good excuse for lingering. With his small house swept away by the floodwaters, clearly it is time to move back to Arezzo. He needs to start thinking about his land. In spite of a dutiful daughter and son-in-law, he has felt like a fish out of water in Florence.

And Arezzo is so very close to San Sepolcro, Tomaso reflects with anticipation. He will find it much more convenient to pay a call to Bianca dei Crespi and her daughter, Maddalena. I wonder if Bianca feels the loneliness as I do, he thinks wistfully of his widowed friend as a plan for the future begins to take shape in his head.

FOUR

Among the trickle of horsemen traveling toward Florence are two strangers and their groom. Both are of mature age, their station revealed by the superior quality of their clothing, the well-kept condition of their horses and the loaded donkey being led by the groom as he brings up the rear. They are gentlemen courtiers, probably emissaries of the dei Medici, judging by the subdued richness of their garments.

But such an assumption would be erroneous. They are not courtiers in the usual sense, rather they are employees, an artist and an architect, in the service of Duke Federigo da Montefeltro of Umbria. Piero and his new friend Alberti are riding toward Florence, planning to stop over for a few days, on a leisurely, indirect journey before returning to Urbino after completing their preliminary assignment in Rimini.

Unaware of the flooding, they realize as they approach the city that something is amiss. Encountering the ragged, defeated columns of refugees fleeing, they first think Florence must be under siege. But as the dank smell of decay and disease seeps into the air they realize it is a flood. The Arno has again overrun its banks. The seemingly endless procession of the homeless, downtrodden and miserable confirms this. Suddenly the plan to snatch a few days pleasure, looking at what is new in art and architecture in the city, sours. With trepidation they urge their mounts on toward *Firenze*, not at all certain what awaits them.

Piero, already troubled by his failure to receive a letter from Maddalena in several weeks, thinks he must make time for a visit to her at the Doni villa, if indeed, she is still in residence. Perhaps she has been called home because of the flooding. Little does he know that she has departed once for San Sepolcro and has returned again, this time on a mission to help Sister Marta at the Ospedale make comfortable some of the many who have been injured or rendered homeless by the flooding.

Piero is unaware of her feelings of deep resentment because of his neglect. He has no idea that her nursing of the boy Giuseppe in San Sepolcro and her work at the Ospedale with the dynamic Sister Marta has prompted thoughts of dedicating her life to the service of others, as

a nun. If by some miracle he might be privy to her thoughts, he would be astounded to learn of disturbing changes in her views of him and of their future life together.

FIVE

A messenger gallops noisily into the courtyard of the Ospedale late in the evening as Maddalena and Giovanna are preparing to return to the Doni villa after another long day of unremitting toil. At first sight of the messenger, a soldier, Maddalena fears the river is rising with another surge, but he tells them a small boy, near death, has just been rescued from the floodwaters. Soldiers are at this moment bearing the child to the Ospedale.

Making a routine patrol down the river, the soldiers heard sounds coming from an abandoned defense tower on the Via Saccarini. As they approached, the cries grew louder, cries they recognized as a child's cry. The tower, built for defense without windows, its walls pierced only by narrow slits for shooting off arrows, with only a winding staircase inside, had become a tomb.

The soldiers hastily battered and tore at the tower's wall until they were able to pry loose an opening. Inside, they found the small boy, barely alive, huddled miserably on the stairway beside the figure of his dead mother.

Sister Marta flies into action upon hearing this news, calling for blankets, bandages, hot water and warm milk. The sound of horses approaching sends the nuns rushing into the courtyard.

Maddalena and Giovanna join the scene as one of the horsemen quickly dismounts and advances holding a small bundle protected by his cloak His demeanor is grave. Gently, he hands the boy over to Sister Marta. Maddalena, hardly believing her eyes, recognizes the long, blond hair, and, beneath an extremely dirty face, the features of Luigi Castellani.

Disheveled, bleeding from cuts on his hands and forearms where he fought to gain entry to the tower, Luigi sees Maddalena standing in the background with some of the Sisters, but gives no sign of recognition during this moment of suspense. The tension of fear grips the onlookers watching as the drama unfolds before them. Is the child out of danger?

The bundle Luigi holds is strangely silent. Is the boy alive? Sister Marta gently unwinds the cloak, wrapping the child in a blanket. Luigi patrolling the Arno in a boat at night? Who is this mysterious child? Questions fill Maddalena's head.

Sister Marta quickly carries the boy inside followed by a train of Sisters. Still no sign of life. Then slowly, as though awakening from a long sleep, tiny hands grasp at the air. A slight rise and fall of the covers over the boy signals that he is breathing. Then the small mouth opens, frames itself into a cry, but no sound emerges. The vocal chords must be exhausted from prolonged cries of hunger.

Using the smallest of spoons, hardly bigger than a little finger, Sister Marta cradles the child in her arms and begins to moisten his lips with warm milk. Over and over she tries with consummate patience to feed him. Slowly he begins to take some of the droplets.

"It will come, it will come," she says to herself as she plies the spoon. "He is used to the cup. He will not suck."

Tirelessly she bends over the little body, trying and failing, trying again, softly crooning old melodies as she lovingly enfolds the child in her arms. She hums tunes from her childhood, as though this is her child and she is his mother.

Maddalena, Giovanna, Luigi and the soldiers accompanying him, the Sisters, watch spellbound, hoping for a miracle. Partly from contentment, partly from exhaustion, the child relaxes into a deep sleep, breathing regularly. The onlookers expel a collective sigh of relief.

Luigi waits in the corridor as soldiers and the Sisters file out, leaving the sleeping child alone with Sister Marta. "I did not expect to find you here, Maddalena, even though your mother told me you had returned to Florence." His voice is low but happy, his eyes shining as he walks up beside her. Puzzled, he notices the rumpled apron, her hair in disarray.

"I came back to Florence to help here at the Ospedale, because of the flood. But Luigi, why were you in a boat patrolling the flooded areas? I thought you were with your regiment. And how on earth were you able to break into the tower to save the boy?" Maddalena longs to take his hand, but they are in a busy corridor surrounded by the Sisters, and the specter of a disapproving Piero looms in her mind.

"We have been reassigned to help with the emergency," he answers. "As for the tower, it hadn't been used for a hundred years or more, so it was crumbling away in places. The arrow slits were framed in rotten wood and we pried them loose with a crowbar. Dislodging the brick enough to make an opening was the work of a few minutes. We clawed at it with our hands." She winces, looking at the pitiful cuts and scratches on his hands and forearms.

"There was a stairway the mother and child tried to climb, to escape the rising water. She must have been terrified when no one came to rescue her and the boy."

Maddalena shakes her head in horror as she thinks of the mother. And she is shocked at Luigi's appearance. Never has she seen him in such a disorderly state. But his torn hose, bleeding hands confirm the fact that he is a hero.

In a few sentences Luigi whispers to her of the meeting with his father. All objections to his marriage plans have been smoothed away. Just as he is planning to arrange a meeting with Maddalena, Giovanna steps up to greet the young soldier-hero.

"Thank goodness you were passing at just the right moment, young man," Giovanna says. "That child would not have survived much longer I fear. I am Giovanna Doni, Maddalena's cousin." She looks Luigi over carefully as Maddalena presents him and explains that he is from San Sepolcro, the son of Il Signore and La Signora Castellani.

Luigi bows low. "I had planned to call at your villa soon to visit Maddalena. I am delighted to meet you now."

"Of course. Maddalena has spoken of you. But it is growing late; we must take our rest so that we will be fresh for tomorrow. Perhaps you will pay us a call at your earliest convenience?" Luigi has met with Giovanna's approval, Maddalena realizes happily, as she sees her cousin give him her brightest smile. Luigi accepts and glimpsing the waiting cart outside the loggia, escorts them toward the door.

"You come here every day Signora Doni, you and Maddalena?" Luigi sounds surprised.

"But of course," Giovanna shrugs. "Is there not much to be done every day?"

"Certainly the need is great. I find it inspiring that you are willing to work so hard for these poor homeless people. Not many would do it." How different they are from Julietta, he thinks to himself. She would never be so unselfish. They reach the waiting cart.

"Please. Go to your well-earned rest. Tomorrow comes quickly enough." He bows, handing them into the cart.

"Luigi, let one of the Sisters bandage up your poor hands," Maddalena cannot resist suggesting it as the cart rumbles on its way.

"I will see to them," Sister Marcella, listening shamelessly from the loggia, calls out. "Run along now, Maddalena," she adds bossily. Stung by her words, Maddalena turns toward Luigi, giving him a goodbye with her eyes.

Back at the Doni villa, brushing her long hair, she cannot free herself of the image of Luigi walking into the Ospedale with the child in his arms. How brave he has been.

She thinks of the unknown mother, hurrying up the stairway with her little boy, trying to escape the rising waters in the dimness of the tower. Frantic she must have felt, finding no escape, slipping slowly into death, leaving her child behind.

How fragile life can be; none of us know how long we have. All the more reason not to waste a single moment.

<center>*</center>

"We will call him Gino," Sister Marta is saying the next morning as Maddalena joins her at the child's bed. "*Povero ragazzo*, poor child, to think, he will never see his mother again. But thanks be to God, he has the gift of life." Maddalena nods, looking fondly down at the sleeping boy.

"Yes, we shall call him Gino, the diminutive of Luigi, in honor of the brave young officer who rescued him," Sister Marta says, planting a light kiss on the tiny cheek. She tells Maddalena of the many splinters removed from Luigi's hands last night after she left the Ospedale. Maddalena listens in pleased silence, wanting to heap her own praises on Luigi, but too shy.

"And does he know you have given the child his name?" Maddalena asks.

"He knows. Already he has been here this morning to see the boy." Maddalena realizes Sister Marta also has been won over by Luigi's charm. And Sister Marta senses Maddalena admires the nice young man with eyes like wood violets.

"Sister Marta, what will happen if the child's father comes to claim him?"

"Then of course Gino will be returned to him. But I do not think it very likely. We have had scores of inquiries about lost family members, but no one has been asking about a missing mother and boy. It is likely that the father also died in the flood."

The people of Florence have suffered so much, Maddalena muses as she serves soup and bread to the hungry at noontime. She hopes for a few free minutes after everyone has been fed, to steal into Gino's room for a short visit with the little boy. Most of the homeless people she is serving will have the chance to rebuild their lives, unlike Gino's mother. Her life is finished.

Helping the needy, this is a cause which brings me much satisfaction Maddalena reflects, handing out the bowls of soup. As she finishes her task, she sees Luigi leaning against a column of the loggia, watching her from a distance. Has he been watching long?

"Most women would not put themselves through this hardship, Maddalena," he says, approaching her. "You have a kind and generous nature. Julietta would not bother herself to do it."

<center>130</center>

"Luigi, how can you be sure? You cannot look inside Julietta's heart."

"But I know her well. Her thoughts are primarily of herself." He grinds a muddy footprint with the heel of his boot. Maddalena is thinking, how handsome he looks when he is angry.

"I was surprised to learn when I returned from my first visit to Florence that Julietta had departed for her home suddenly. I was not on hand to tell her goodbye," Maddalena says.

Luigi laughs. "She would have been ungracious, I imagine, had you seen her. I hear she returned to Impruneta in a temper. My letter to her was clear and final. I think she understood at last. And what is the news from Piero?" he asks abruptly, a note of irony creeping into his voice.

"Piero has gone to Rimini," she answers quickly, trying to sound matter-of-fact.

"Rimini?" echoes Luigi. "How he does travel about. And is there no work for him in San Sepolcro?" The scorn is undisguised.

Unwilling to provoke a quarrel, Maddalena shrugs and says she must return to the kitchen. Both of us are probably irritable from lack of sleep, she thinks. Better avoid a quarrel and hope for a more pleasant encounter next time. But her thoughts are filled with the certainty that Luigi truly loves her and is doing all in his power to win her, Piero or no Piero. And he is a powerful attraction, she admits.

Plunging her hands in the soapy water of the sink she considers the merry go round of feelings in which she plays a part. First Julietta, disappointed because of Luigi's rejection of her; Luigi, unhappy because she, Maddalena, has promised to wed Piero. Then Maddalena, wanting to admit she has made a mistake in thinking she loves Piero when it is in truth Luigi who claims her heart. Finally Piero, where does he fit into the puzzle? And how can it all be resolved?

SIX

The facade of the Ospedale degli Innocenti looms impressively as Piero and his friend the architect Alberti approach, following a visit to the Fra Angelico cell paintings at the newly completed Monastery of San Marco. Alberti is speaking with great passion on the design of the monastery by the architect Michellozzo, comparing it with the order and simplicity of Brunelleschi's design for the foundling hospital which they have both visited on previous occasions.

As they dismount and enter, Piero's attention is diverted by an approaching young woman carrying a tiny baby in her arms. A Madonna figure, one he would like to paint, he thinks as she draws nearer. He peers more closely and starts in confusion as he recognizes Maddalena.

At the same instant she sees him and her cheeks and slender white neck turn a deep rose color, similar to that of the chubby fists of the baby she is carrying so carefully in her arms. Agitated, Piero nonetheless registers the becoming blush and again wishes he could paint her at this moment as he quickly advances to greet her.

Meanwhile, Alberti, sensing he has lost his audience, stops his dissertation in mid-sentence and follows Piero's gaze.

"You did not tell me you were returning to *Firenze* again," Piero stammers, coming to an abrupt halt in front of her, keenly aware of both Alberti and Maddalena, each calmly regarding the other.

"I did not know the Arno would overflow its banks," she says simply, returning her gaze from Alberti to Piero. "I have had no time to write you a letter since returning." She nuzzles the downy head beneath her chin then squares her shoulders in a defiant gesture while she studies Piero in a glance mingling veiled surprise and thinly disguised hostility.

"You came from Rimini?" she asks him, her voice flat, hardly a question at all.

Flustered, Piero nods but does not answer. Instead he presents his friend, the architect Leone Battista Alberti to Signorina Maddalena dei Crespi of San Sepolcro. Bows are exchanged. So this is the new friend Piero finds so compelling, Maddalena thinks.

What a stunning girl! But she must be fifteen years younger than Piero if she is a day, and has a temper into the bargain, if I judge the blushes rightly, Alberti surmises. Tactfully, he exchanges a few pleasantries then moves to study the Della Robbia roundels on the loggia's facade while the two continue scrutinizing each other.

Piero, his poise somewhat recovered, speaks first. "Cara, what a joyous surprise. I had not dreamed to see you still in Florence. Indeed we are planning to visit San Sepolcro in a few days before turning our horses toward Urbino. I, I planned to surprise you. But I must not keep Duke Federigo waiting too long, you know." He gives a hearty laugh which Maddalena does not find amusing. *I sound patronizing,* he thinks wildly, put off by her coolness. He knows she is upset.

"What brings you here to the Ospedale, Maddalena?" He tries another topic.

She shrugs, shifting the child to her other arm. "So many are in need because of the flood," she murmurs. "I came back to help Sister Marta, along with my cousin Giovanna Doni. You remember her?"

"But of course I remember your charming cousin. What a noble cause you have undertaken. Sister Marta is a perfect example of selfless devotion to God. Would it be possible for me to pay a call on you and Signora Doni? I would like so much to talk with you, Cara," he finishes hopefully. "I, I have missed you so much."

Why are we standing here like strangers? We are betrothed! Why does Piero not embrace me, kiss me, show me he cares? Am I an embarrassment to him? Maddalena's cheeks burn.

Piero tugs at his tunic, a wayward lock of hair. His hands will not rest. *She is giving me that look again. Looking as though she disbelieves me. What has come over her?*

"I really do not think a visit is possible at this time," Maddalena replies, her voice matter of fact. "We spend our days here giving help to Sister Marta in the nursery or wherever it is needed. The Ospedale is overwhelmed with homeless, surely you can see?"

Piero nods miserably, his tongue tied in knots. What does she want him to do? Jump through hoops? This new Maddalena, so poised, *so assured,* is like some stranger. Of her disapproval, her displeasure he has no doubt. He is bewildered, confused, just a little bit resentful.

"It is time for Donato's feeding, Piero," Maddalena's business-like words break into his thoughts as she pats the baby she is holding. "I must go. Say farewell to Signore Alberti, will you?"

Numbly he nods, aware he has made a botch of things. But with Alberti looming like a shadow between them, what can he do? He must be wondering what is going on, especially as he has told him nothing of his betrothal. Piero shifts his weight uncomfortably to the other foot and bows low.

"Then I will bid you goodbye, Maddalena. We need to speak more, but it appears it is impossible at this time," he finishes stiffly, his face covered by the usual mask.

Quickly she walks toward the nursery. If he had only taken my hand, swept both Donato and me into his arms, shouted out in joy that he had found me. *Given some sign!* He has never even told Alberti of our betrothal, that is part of the reason for his confusion, she realizes. *He has told no one in Urbino about me!* The truth dawns. *Not the Duke, nor the Duchess...nobody!*

Quick, hot tears spill out under the blond lashes as she hurries out of sight. Her heart is heavy with the knowledge that Piero is able to divide his life into locked compartments. Her thoughts careen like a tumbling avalanche. *And I am locked away in a very small chamber marked "Maddalena: Not Urgent".*

I have changed, she thinks, entering the nursery and handing the baby over to the wet nurse, a jolly, red-cheeked neighborhood woman with seven children of her own. Months ago I would have accepted whatever came with grace, unquestioning. But no more. I am *not* hurrying blindly into a life of loneliness with Piero, he painting all over Italy, me left behind. Even if it means I take the veil and spend the rest of my life as a nun like Sister Marta, helping the miserable and downtrodden. I *will* be a part of the mainstream of life.

And as Piero rides away silently beside his friend, he too ponders this change in Maddalena. She is a different person, he concludes in amazement. She is more independent, sure of herself. Not nearly so soft, so pliant as he remembers.. He puzzles at their encounter in which he knows he came off a poor second.

*

The unexpected meeting with Maddalena at the Ospedale degli Innocenti has unsettled Piero greatly and is bringing a return to the night time sleeplessness which has plagued him for many years. Even when he and Alberti arrive in San Sepolcro and comfortably settle into Piero's old house in the Via della Chiesa, he cannot relax.

Seated in the old armchair by the fire, a purring Giotto in his lap, he is left with his thoughts after Alberti has retired to his chamber, wishing to work on a manuscript. He turns the events of the surprise encounter with Maddalena over in his mind for the hundredth time. How did he go wrong? Aside from his momentary confusion and surprise at seeing her there, he cannot understand why she acted so distant, so remote. Surely she realizes the importance

of my position, he thinks, that I must be about my work and cannot dance attention on her every minute of the day.

But then the uncomfortable fact asserts itself into his consciousness: *you did not mention to Alberti that you and she are betrothed. Nor to the Duke, nor the Duchess. And you have been traveling, yet not paying her a visit.* Maddalena resents all those things. He knows she does.

Alberti, the soul of discretion, has said nothing since the unfortunate encounter at the Ospedale. His tact and good breeding forbid awkward questions. Piero sighs heavily and interrupts the purring rhythm of the cat. It is not that he did not plan to tell everyone in Urbino of his betrothal. He is not ashamed of his choice.

It just seemed, well, inconvenient and unnecessary since all was going so well in Urbino and he was still feeling his way. *And after the Duchess made those remarks about marriage dividing one's loyalties.* Of course he planned to tell them, when the wedding date was set. Piero lets this rationale take hold of his thoughts.

Slowly he sips the glass of *Carmignano* at his side and strokes the orange cat. Should he pay a call to Maddalena's mother at the Palazzo Castellani while he is in San Sepolcro? But what if Maddalena writes her of their unhappy meeting? Surely her letter would show Piero in an unfavorable light, and Bianca would certainly take the side of her daughter. Unseemly words might ensue. No, better not to risk paying a visit. The old self-doubts and fears bubble up. Who can be trusted? Anyone?

The truth of the matter is, he is longing to get back to work. Nothing soothes him like standing in front of an easel, brush in hand. As for Maddalena, who can fathom the whims of women? He certainly cannot. No, better get on to Urbino and get to work. Hopefully, Maddalena will come to her senses. Abruptly he stands, upsetting the cat.

First he reasons, making his way toward his bedchamber, he has a responsibility to his art, then to his patrons, Duke Federigo at the top of the list, of course. God has given him the talent, he must use it wisely. Calmed somewhat, he prepares for bed, resolved to start out for Urbino as soon as he has talked it over with Alberti in the morning. They have been absent long enough.

But as his head touches the pillow, the vision of a young Madonna, like Maddalena, appears before him, holding a small downy-haired boy in her arms, and the nightly tossing and turning begins.

SEVEN

Maddalena, continuing her work daily at the Ospedale, thinks about Piero. The realization that she apparently is considered by him to be merely a tangible asset rather than a future partner in all aspects of his life, forces her to reconsider her feelings. What at the outset she mistook for love has turned out to be an infatuation, an excitement if you will, based on being chosen future bride (and model) for Tuscany's most prestigious artist. She sees that clearly now.

The awareness dawns that she looks forward to Luigi's daily visits to the Ospedale to check on the progress of his little namesake Gino, and of course, to be near Maddalena as she works. He helps the porters carry soup on the litters, gathering up the empty bowls and transporting them on heavy trays back to the kitchen. As Gino's strength returns, the little boy leaves his bed and, like an adoring puppy, dutifully follows Luigi everywhere on his visits to the Ospedale.

Maddalena is struck by Luigi's kindness to the homeless, his tenderness with Gino, his consideration for her well-being. Slowly the flood victims are being reunited with their families, returning to their homes, now that the waters have begun to recede. She knows she must soon think of returning to San Sepolcro. Luigi tells her his company will be taken off flood duty soon. In her new found happiness, seeing Luigi every day, she wishes this time of drudging, backbreaking work to last forever.

*

Maddalena and Giovanna are sitting in the courtyard of the Doni villa, perfumed by the scent of jasmine and pungent lemon leaves, as they let the pale spring sunshine warm their faces.

"Luigi will be leaving soon, and so will I." Maddalena sounds pensive, caught up in a longing to keep everything unchanged..

"I know, Cara, and I am sad. But we will not let our spirits droop, eh? Let us plan a fete!" Giovanna's gray eyes sparkle as Maddalena's face glows. "I shall invite Luigi to join us, I want Alfredo to become his friend also. He is such a hero in our midst, because of Gino." Giovanna looks fondly at her cousin, realizing that she seldom mentions Piero now. She is aware of the turmoil in Maddalena's heart.

"Sister Marta has been urging us to take more time away from the Ospedale. The numbers of homeless are dwindling. I think she wants you to explore Firenze before you must return to San Sepolcro. At least that is what she hinted to me. She encouraged me when I mentioned the idea of a farewell dinner party honoring you and Luigi."

Maddalena's eyes widen. "You mean you actually mentioned the possibility of the fete to her?"

"But of course, Cara. She is not made of wood. Do you not think she feels as we? She would be such a wonderful guest herself. Too bad the stuffy rules of her order prevent such a thing, else I would invite her."

Maddalena laughs. "Giovanna, you are shameless. The idea. What would Mother Scholastica think? Or Mother Ursula?" At the thought of Mother Ursula, the strict, dour head of the Ospedale Sisters, the two bend over with laughter.

"How sweet the warm air of spring," Maddalena sighs, straightening up from her mirth and stretching her arms toward the sky.

"And there is spring in your heart also, Maddalena?" Blushing, Maddalena nods.

"It is all because of Luigi, is it not? Surely I cannot be mistaken?" The older woman places her hand on Maddalena's arm. "Maddalena, you are so alive. Do not think Luigi's attentions to you have gone unnoticed. Nor have I failed to note your unhappiness with Piero's behavior." Maddalena lowers her eyes.

"You feel Piero has let you down, forgotten you. I understand. This is the time for you to examine your feelings honestly, Maddalena. If the hurt and resentment persist, do not let yourself be yoked to a man who will not make you happy. You are for loving and living life to the fullest. Do not settle for half measures."

Maddalena looks up, surprised by her cousin's words. How easily she reads my feelings, she thinks. It is as though she is a mother, no, more like a sister to me. She is powerless to stop a tear rolling down her cheek.

"But Giovanna," she whispers, "I don't know what I must do. Since Piero and I met by chance at the Ospedale recently I have been trying to sort out my feelings for him. I respect him. I thought I loved him, but I am not sure of that now." Quietly Giovanna covers Maddalena's hand with her own as she listens.

137

"If he truly loved me, would he go from place to place without telling me, without making time for one small visit? Would he not tell his best friend about our betrothal? I feel that to Piero I am only a possession, a thing with no feelings."

"In his heart Piero surely must feel he loves you, Maddalena," Giovanna speaks softly. "But love means different things to different people. Perhaps your idea of love is not at all like Piero's. He may be unable to give...to express... more. He may be incapable of showing more affection. To bestow on you his name, his fame, his worldly possessions and achievements may be all he can give of himself. Your job is to decide if what he feels for you is enough. If it is not, then you must ask him to release you from your promise. The greatest mistake would be to marry a man whom you cannot love and respect."

Maddalena is struck by the truth of Giovanna's words. She has judged the problem rightly. *But am I able to stand up and admit my mistake? To tell Piero I wish to be released?* She sighs. Women all over Tuscany have no voice in selecting the man whom they marry. It is all decided for them. She realizes she is lucky in being able to choose, but oh, the responsibility of that choice.

"Do not despair, Maddalena. Both your mother and I know what it is like to overcome hardship. We are Albizzi, remember? Life was so difficult for us at times, even now I cannot bear to think of it. But one does not give up. Thank God the Albizzi believed in educating their women so they could reason things out for themselves!" She stands up.

"You have the strength and the intelligence to make the right decision about your life, Maddalena. You will do what needs to be done, and at the proper time." Her voice is firm and reassuring.

EIGHT

A warm evening in springtime, the perfect night for the fete. Beautifully gowned women and handsome men dressed in their best turn the courtyard into the colors of a prism struck by moonlight. Lanterns cast a soft glow overhead, the air is perfumed by the lemon trees. The guests gather in small groups. Maddalena is radiant in blue damask with slashed sleeves lined in satin, the dress a farewell present from Giovanna and Alfredo. The strumming of lutes by unseen musicians wafts gently over the company.

Giovanna, stately in soft gray silk, calls them to table. The women move slowly, pausing like giant butterflies in yellow, orange and green as they make their way. Under the stars, they dine on plump capons stuffed with saffron, raisins, almonds; a fish pie and fruits carefully hoarded in cold rooms over the winter, quinces poached in a rich wine sauce.

Talk at the tables runs largely to business. Florence is a city made up of merchants like Alfredo and his cousin Matteo Doni, who are partners in the production of cloth. The women listen as the men discuss far-flung trading outposts, the demand for spices from the Far East, the new English wool beginning to appear on the market (such fine quality!), how a war with Pisa might affect their commerce. Maddalena feels pride to see Luigi taking part in the animated discussions.

After dinner Giovanna rises to her feet to lead a promenade around the courtyard. She chooses Luigi, as guest of honor, to be her partner, while Alfredo escorts Maddalena. Then Luigi takes Maddalena's arm and the two walk off together.

They speak of their recent experiences during the flood which have brought them closer together. Luigi takes her hand as they stroll, asking her what will become of Gino at the Ospedale.

"If no one claims him, he may live there as long as he wishes. Sister Marta told me." Maddalena replies.

"But do you not want something better for him? A real home?" Luigi looks deep into her eyes.

"Why, of course I do, Luigi. He needs a set of parents to love and cherish him," she answers firmly. "We must hope and pray some suitable couple comes along."

"I know of such a couple, two who would be good parents, raise him up to be a fine man." Luigi is speaking so softly she barely catches his words. As his meaning becomes clear, she blushes.

"You forget I am betrothed, Luigi," she answers.

"But your eyes tell me you love another," he replies in a bantering tone, turning to face her.

"Maddalena, I think God is giving us a marvelous chance to do something for a small, helpless child who has lost everything. We could take him into our home as our son, after we are married." Luigi's voice sounds grave.

"Surely you can deny no longer that our love is right? I have my father's approval. I will be able to support you. The man you have chosen is not worthy of you and you know it."

Maddalena is silent. His words numb her. "I remind you I am still bound to Piero," she replies. "And should something happen to that understanding, I have considered giving my life to the service of others."

"So you admit there is a possibility you will not marry him?" Luigi pounces on her first revelation. "Can you deny Gino needs a home with two caring parents?"

"Of course not, what you say is true, but I repeat, Luigi, I have also given some thought to becoming a nun, like Sister Marta."

"Surely you are not seriously thinking of taking the vows?" His expression is one of incredulity. "You are not meant for such a life, Maddalena. You are meant to live life fully, with a loving husband and children at your side. You are warm and tender and compassionate, the perfect mate for a man, and mother to his children."

"Wait, Luigi, do not confuse me. I must have time to think."

""Hush, Cara," he closes her eyes with his lips as they reach a far corner of the courtyard, beyond the lantern shine. "I have never stopped loving you. And I will not make the mistake of keeping silent this time."

"Just give me pause, Luigi, until my heart is certain," she pleads. I must behave honorably toward Piero. I owe him honesty at least. Do not press me."

"Very well, then I shall wait a bit longer to ask for your hand. But you must be in no doubt how I feel. I love you and will try to marry you, if it takes a lifetime to gain your consent."

NINE

Slowly life in Florence after the flood resumes normalcy. Luigi will soon depart, and Maddalena begins packing her belongings to return to San Sepolcro. On the morning of the last day with Giovanna and Alfredo Doni she makes an early morning call to the Ospedale to visit Sister Marta and the boy Gino.

Closing doors, scurrying nuns, frightened whispers greet her. The Ospedale is in complete disarray. The nursery ward is almost empty of children, Sister Marta is nowhere in sight. Maddalena stops a harassed Sister Nona to inquire.

"Oh, Maddalena," the older woman replies, wringing her shaking hands which flutter like imprisoned doves trying to escape. "Sister Marta is ill. There is a fever running through the Ospedale. Most of the babies are feverish and have been taken to the Sisters' cubicles to prevent the sickness from spreading."

"Fevers?" echoes Maddalena. "Surely the wells have not become polluted?"

"I fear so," Sister Nona shakes her head as if in disbelief. "The floodwaters seeping in you see.

"Then I must go to Sister Marta." Maddalena grasps her arm. "Please tell me where I can find her and what her condition is."

"They have placed her in the tiny room behind the nursery. But Maddalena, I really must go now to the herbarium for more medicines." Sister Nona departs, robes swirling around her tiny, wizened form as Maddalena watches, stricken by what she has heard.

She moves trance-like through the empty beds of the nursery. Only a few infants remain, sleeping soundly in their cribs. The door of the little room off the nursery is ajar. Maddalena eases inside.

Sister Marta lies on a narrow bed, heavy covers drawn up to her chin. Maddalena notices the prone hands folded on top of the covers. Limp and white, like the petals of some fallen flower, not fluttering with life like Sister Nona's. Her face against the white pillow could be the pale, lifeless marble of a Donatello saint.

"Sister Marta," she whispers softly. "It is Maddalena. What can I do to help you?"

The woman turns her head slightly and opens eyes alight with a flicker of recognition and shiny with fever. Huge moonlike circles beneath are filled with icy blue shadows, but the startling beauty of the eyes remains. Maddalena realizes she is very ill.

"Maddalena." Sister Marta manages a weak smile. "You have come."

"Please, don't dissipate your strength. Just whisper to me what I can do for you."

The woman on the bed gives a slight shake of the head. "No, Maddalena, nothing for me. I am in God's hands. For Gino. You must take care of him. You and Luigi." The blue eyes plead, then the eyelids come down and she is silent. Transfixed by the slight rise and fall of the covers over the nun's body, Maddalena steps back slowly, then leaves the room.

Gently closing the door, she turns to face a small procession approaching: Mother Scholastica from San Sepolcro, Mother Ursula, and a priest from Santissima Annunziata. Mother Scholastica nods briefly in Maddalena's direction as they enter Sister Marta's door.

Fearful, Maddalena dispatches Lorenzo with the cart back to the Doni villa, to inform Giovanna of the news. She begins searching for Gino in the nuns' cubicles.

She finds Gino lying in a small bed, Sister Marcella sitting beside him, fingering the beads of her rosary, eyes closed in prayer. Maddalena touches the boy's forehead. It is fiery. He opens his eyes at her touch, the eyelids flutter. He recognizes me, she thinks, and she is alarmed at his listlessness.

"When did he last have water?" She asks, but Sister Marcella ignores her, continuing to count her beads, lips moving soundlessly. Why did she ever come here, if she can't be of more help? Maddalena sighs with frustration as she realizes nothing will pry Marcella away from the beads. Whispering to Gino that she will be back soon, she hurries to the kitchen for water.

There she discovers the giant fireplace holds only dying embers. A cauldron of cold water rests on the hob. A small, frightened looking girl is standing over the sink, washing crockery in a basin of soapy water. Her eyes are the eyes of an animal trapped in a net.

"Where is all of the kitchen help?" Maddalena asks softly of the little girl.

"The cook is sick, the other Sisters are caring for the children who are ill," she answers in a small voice, looking as though she might momentarily burst into tears.

Povera ragazza, poor child, Maddalena thinks, noting the untidy braided plait hanging down her back, the wide brown eyes. The white apron covering her dress is far too large; she can hardly keep it from falling off her thin shoulders.

"What is your name, Cara?"

"Anna." The child's voice is solemn.

"I am Maddalena, Anna. Do you think you can build up the fire, so the cauldron of water on the hob will come to a boil? We must have clean water for everyone to drink. That will help stop the spread of the sickness." She glances to see if there is plenty of wood nearby.

"Yes, Maddalena. I can do that. I have done it before." Pride in her voice.

"Splendid. I must leave now to help Gino. He is very sick. I will come back as soon as I can, Anna."

"I understand. I can do it." Anna leaves the washing and begins placing new wood on the dying fire, then topping up the cauldron from pitchers of water standing near the sink.

Returning to Gino's room, Maddalena finds Sister Marcella still reciting the rosary. Maddalena begins ripping up a clean drying cloth to make compresses for bathing Gino's face in cool water.

"What are you thinking, Maddalena? Those are perfectly good drying cloths!" Sister Marcella's voice proclaims outrage.

"He must be bathed with cool water, Sister, else he will expire. We must bring down the fever." Sister Marcella frowns at such fussiness, returns to her beads, continues to cast disapproving looks in Maddalena's direction. Maddalena ignores her, croons softly to Gino as she bathes his face and arms with cool, damp cloths.

Anna appears bringing a pitcher of the clean water, a cup and spoon. Gino begins to drink spoonfuls of the water. Sister Marcella, completing her rosary, drifts away. Maddalena loses track of time as she sings to the boy.

Recalling Sister Marta's words, she wonders, *Will this be my life's purpose, mine and Luigi's? To bring up Gino as our son?*

She ponders this, realizing she will have an important task to perform tonight before her head touches the pillow. The time has come to compose the most difficult letter of her life, a letter to Piero, and then she must write a second one, to her mother.

Gino falls into a calm sleep and Maddalena's thoughts turn toward Sister Marta. She cannot dispel the nagging fear that the woman is slipping slowly toward death.

At twilight a harried Sister Nona appears at the doorway bearing a candle on a small stand. It casts ominous shadows over the walls assuming the shapes of a shroud, then a giant bird looking like a vulture to Maddalena's fearful eyes. But as she changes the compresses, Gino's forehead feels cooler and he continues to sleep.

Nearing midnight, long after Compline, she hears footsteps outside the cubicle. It is Giovanna. She tells Maddalena that Luigi is in Gino's old room waiting to see her.

"He has come here on his way to the Pisan front with important papers to deliver to his commander from the dei Medici. He called in on the chance he might see you. I came as soon as Lorenzo brought the news. This is the first free moment I have had, Maddalena. I can watch over Gino. Hurry to Luigi. He only has a few minutes before he must be off."

"Giovanna, I can leave Gino for a few minutes only if you promise not to leave his side. You must give him water if he awakens." Giovanna nods, taking up her position as nurse.

Luigi stands alone, waiting for her in Gino's deserted room. "How is he, Cara?"

"Slightly cooler, Luigi. But he is still feverish. He is not recovered yet. Have you heard news of Sister Marta?"

"Only that she is very weak and cannot swallow now. The doctor arrived at the Ospedale as I did. He is with her. Mother Scholastica, Mother Ursula, and a priest are there also." Luigi's voice is so low she can hardly hear. His face reflects a despair which she has never seen before. Maddalena feels stunned as though she has been struck a numbing blow.

"Luigi," she whispers, "I cannot bear it. That she, of all people, so pure, so good, so unselfish. That she should be struck down."

"Hush Maddalena. We must hope for a miracle. Let me call one of the Sisters to relieve you with Gino. You look tired; you need rest."

"Luigi, I cannot leave him, not yet. Listen to me. I was able to speak a moment with Sister Marta when I arrived. She told me that we, you and I, Luigi, should take care of Gino. It is her wish, her last word." She looks at Luigi in wonder. "I promised her. It is a sacred trust, Luigi. I will keep my promise."

Luigi quickly enfolds her in his arms. "Here, in all of the sorrow surrounding us, one thing will be right. We will marry and raise up the boy Gino as our own." He closes his eyes, making a brief prayer of thanks for this unexpected blessing.

"Yes," Maddalena whispers, "I promised. It is right. My mind is made up. I will marry you, Luigi."

A loud moan tears across the corridor outside setting up the wailing of many voices. Luigi opens the door as one of the younger Sisters collapses on the floor moaning. Around her others are clustering, gnashing their teeth and crying.

"She is gone," one screams. "Our Sister has departed this life." The wailing and moaning intensifies as Luigi and Maddalena stand mute in the doorway, mesmerized by the scene before them. Suddenly the door to Sister Marta's room flies open; Mother Scholastica makes her way toward the women, robes billowing in angry waves.

"Hush!" she cries. "Hush at once! Would she have wished you to frighten the Innocents with your cries? She would have hated it! Go about your duties now. She is at peace." Then, more gently as she looks down on the grieving women, "Praise God as you work. Pray without ceasing. That is what Sister Marta would wish you to do."

Turning her back on the scene, Maddalena fights to keep back tears. "It is not right. It is not fair." she whispers.

"Hush, Cara," Luigi answers, taking her hands in his. "Who ever said life is fair? Ours not to question, Maddalena."

Maddalena's thoughts turn to Mother Scholastica who has lost the one remaining member of her family. There is no one left to call her 'Bibi'. Tears well up and run down her cheeks, but she does not make a sound. Kissing Luigi tenderly on the cheek, she tells him she will wait for his return. Parting from him is the hardest thing she has ever done, for she must face alone the death of one whom she dearly loved and admired.

Returning to Gino's room, she embraces a grieving Giovanna who leaves her to return to the nursery. The Ospedale is hushed now; mourning for its most cherished Sister has begun. Gino wakes, taking the water Maddalena offers him, sleeps again. She begins to sing a song of her own composition, telling the sleeping boy that one day when she and Luigi are wed, he will come to them to live with them as their son.

Sitting with the boy through the long night, Maddalena recalls the tragedy of Luigi's childhood, when he was sent away from his parents. Now Luigi will provide a home for this little orphan boy. It will become our life's purpose, mine and Luigi's, something good for the world, she whispers to herself. She touches Gino's brow and finds it is cool. A feeling of relief seeps over her.

TEN

Maddalena sits at the little table in her room overlooking the courtyard at the Doni villa. She has vowed to stay there until letters, one to Piero, the other to Bianca, are written. Her departure for San Sepolcro has been postponed until the funeral mass for Sister Marta is past.

The letter to Piero is the most difficult to write. She realizes that no matter what she says Piero will be greatly offended, deeply wounded. She can think of no way it can be helped, if she is truthful. Sadly she takes up the pen.

Dear Piero, At the time you began your journey for Urbino, I did not realize it, but I too, began a journey of my own, a journey toward maturity. I began searching for the path which would lead me to a satisfying, fulfilling life.

I thought I had found the way when we became betrothed. But as the weeks and months went by, I realized that our goals in life, yours and mine, were startlingly different. I was not the kind of person suited to be your wife, I was a different person inside.

Piero, how can I say this without hurting you? I believe your intentions are sincere, but our expectations of marriage are so very different.

You see, Piero, I was seeking a close partnership with the man I love, one in which we are together in body and in spirit; we would think in unison; even though we might not always agree, that closeness of thought, rapport, if you will, would be paramount.

I did not care much for the wealth and fame of being married to a famous artist, although I was flattered and greatly honored when you painted me in your pictures and spoke to me of luxuries you wished to provide for my well-being. I was dazzled by the attention. But neither fame nor luxury dominated my thoughts of what I desired most in life.

I want to make something worthwhile of my life, Piero, to have children to raise, yes, children who also are important to their father. Their father must want to be close to the children, have a role in their upbringing. I never had a childhood memory of my father, Piero. You see what I am thinking. I do not want a marriage in which the husband is often far away, engrossed in his own affairs with little time to think of or be with his wife and children at home. I do realize, Piero, that your painting is the primary concern in your life. I understand. The problem is---it does not allow much time for me, and in time, for a family. And to me, that matters terribly.

I was fearful of this kind of marriage soon after you arrived in Urbino and I could see from your letters that you fitted in so well with the Duke's circle. I understand, and I am happy for you, Piero. The picture became clearer when you departed for Rimini, then again when we met by accident at the Ospedale in Florence. I realized then that I was no part, no part at all, of your life in Urbino. You had not even told anyone there of our betrothal! Is that not the truth of it, Piero?

I began giving serious thought to taking the vows and becoming a nun during this period of disappointment. Sister Marta at the Ospedale was a great inspiration to me. However, events have intervened, and I believe I have been handed the real purpose of my life. I have fallen in love with a man who respects me and whose goals are similar to mine. When we are married, we plan to adopt one of the orphans of the flood, a little boy, and to raise him as our own child. This is where my journey has taken me, Piero, and this is why I am returning your ring along with this letter, begging you for my release.

Please try to understand. I wish you every success and true happiness in your life and work. I pray that in time you will find the perfect wife. I shall always remember our friendship with affection. Your friend, Maddalena

With a sigh, she puts down her pen and looks out on the darkened courtyard lighted by a silver moon. The next letter, to her mother, will be almost as difficult to write. She is sad because she will disappoint Bianca, who has pinned her hopes on this marriage to Piero. But she is certain of her mother's steadfast love for her. Bianca would not want misery for her daughter. And surely, when she learns how straightforward Luigi has been in every facet of their courtship, surely she cannot raise real objections to him any longer.

*

Sister Marta's requiem mass is taking place at the church of Santissima Annunziata, across the piazza from the Ospedale. It is raining on the day of the mass, raining heavily and steadily, as though the very heavens are mourning for her.

Sisters in their gray habits of the Ospedale, black-robed nuns from the Priory of San Giovanni Battista who accompany Mother Scholastica, lead a procession into a sanctuary overflowing with mourners. The bier stands in front of the altar. The audience is sprinkled with women,

unusual since few women are welcomed at mass for the dead in *quattrocento* Italy. For this funeral, however, Mother Scholastica's wishes have prevailed.

Maddalena and Giovanna take seats opposite Alfredo and Luigi, forced because of the crowd to find seats in one of the side chapels near the high altar. Luigi has been given a brief leave from his duties to attend the rites.

Of all of the churches in Florence, Santissima Annunziata is by far the darkest and most foreboding, Maddalena thinks, looking at the chapel altarpiece painted by Andrea del Castagno, a contemporary of Piero during his days of apprenticeship in Florence. It is a painting of *Saint Jerome in Penitence*. Never, Maddalena thinks, has she seen such a frightening, ghoulish scene. Somehow the subject seems appropriate to the dismal, gloom-filled horror of witnessing Sister Marta's last rites.

Maddalena studies the figure of Saint Jerome, holding a large stone with which he has beaten his chest into a blood-soaked pulp. Overhead a sky streaked with red contains fluttering, grieving cherubs with red wings below a suffering, blood-stained Christ on the Cross, and the image of the Holy Father and the Dove. Crimson suffuses the entire painting, on Saint Jerome's chest, on the wounds of Christ, the cherubs' wings, the sky. Maddalena is reminded that for the past three days she has cried for Sister Marta as though her heart would break. Now her eyes are dry; every tear wrung from her body.

Mother Scholastica kneels briefly in prayer at the conclusion of the rites, then steps firmly behind the bier as the Confraternity of the Misericordia bears it down the aisle, weeping mourners on either side. Mother Scholastica looks drawn and pale. Maddalena wishes she could touch her hand. Her worn face is deeply lined. Death is no respecter of persons Maddalena realizes, as she silently watches the passing of the cortege.

This cruel blow will leave its mark on Mother Scholastica, more than on the rest of us, she thinks. Mother Scholastica, the only surviving family member, seems shrunken and somehow diminished as she makes her way out. She will make the long, lonely pilgrimage with the body over the hills to Settignano, the birthplace of Sister Marta, who will lie at rest there with two brothers and her parents.

As Maddalena watches the cortege disappear, she renews her vow to Sister Marta. She and Luigi will marry, take Gino, raise him to adulthood as their own son . Looking over at Luigi, she senses that he too, is having thoughts similar to hers.

ELEVEN

Plans of Maddalena and Luigi for little Gino have been kept secret. There is much to be done preparing for marriage, let alone arrangements for adoption of the boy. The couple decides to keep their hopes for Gino locked in their hearts until after the wedding. In their short time together after the funeral, Luigi reveals news to Maddalena .

"I have been called in by Alfredo and Matteo Doni to discuss the possibility of working in the Doni business," he tells her. "They are opening a new branch of the company in Prato, a town famous for its excellent weavers, as you know."

Maddalena nods. Cloth woven by the women of Prato in their homes and sold by the piece to the cloth manufacturers is highly prized. In truth, it is more usual for merchants to buy direct from housewives and cottage workers, rather than to operate from a central factory of weavers, as Matteo and Alfredo conduct their business in Florence.

"This could turn into a very profitable venture for them," Luigi says. "And they have offered me a handsome salary to oversee the business in Prato, since our home will be located there anyway, as I will be managing my uncle's Prato estates."

"I confess I am not surprised, Luigi," Maddalena answers, giving a fleeting thought to Valentina, now married and living in Prato, as she congratulates Luigi. "I could tell when we were present at Giovanna's fete you were well-informed on business as well as on the management of vineyards and olive groves. How very proud of you I am."

"This means, Maddalena, we shall be well able to start at once reducing the mountain of Castellani debt. My father will be elated, and because it is your Doni cousins who are benefiting us, he will be even happier. It looks as though after the horror of this tragedy, our stars are rising, Maddalena."

"Yes, Luigi, and I see no reason why we cannot claim Gino soon after we are married and settled into a house. Have you approached your superiors about leaving the army?"

Unexpectedly Luigi colors a deep red. "Ah," he mumbles. "Well, there has been some delay about that."

"Whatever do you mean? It has been some weeks since you first indicated your wishes."

"It is true. I've not changed my mind. After all, I have served in the army longer than I anticipated. It is just that my superiors wish me to wait until late May to leave."

"But why?" She is puzzled. Luigi looks down at his feet, hesitating.

"Ah, well, It seems there will be a ceremony in May honoring those who helped in the flood. A Cross of Valor will be presented to three people who showed courage and bravery during the time of trial." He is obviously uncomfortable telling her, but he has no other choice.

"And one of them is you!" She throws her arms around him impulsively, hugging him. Luigi, singled out for his heroics and his bravery. And with scars on his hands and arms to prove it. She is so proud of him. Of course he will want to represent his loyal fellow soldiers in their efforts to save young Gino; of course his commander wishes the award to go to one of his bravest men!

But Maddalena's joy about Luigi's position in Prato is tempered somewhat by the thought that they will be living in the same small town as Luigi's half-sister Tina, and that Luigi has said nothing to her of this secret half-sister. Should she mention it now? No, better to let Luigi savor this honor he will receive. Time later, after they are married, to bring up the matter of Valentina.

San Sepolcro

ONE

On this spring afternoon Palazzo Castellani is quiet except for bird songs filling the warm air. Bianca is resting, rereading the startling letter from Maddalena which arrived at midday, when she is summoned downstairs where a visitor awaits her.

Tomaso di Paolo stands before her, smiling, hat in hand, his tunic and hose dusty from the journey from Arezzo where he has now settled on his farm.

"Bianca, Bianca, you have hardly changed in all the years. Quickly he takes her hand, bowing before her. "I am overcome with joy, seeing you at last."

She is surprised at his appearance. A hundred quick memories of her dead husband flash before her eyes in a second. Can this man before her of the stooped shoulders, the iron gray cap of bristling hair, the barely concealed limp, be the dashing lieutenant, Giovanni's fellow soldier and friend she remembers from long ago? How the years have done for us all, she thinks, touching the gray at her temples and returning his bow.

She invites him into the small *salotto* where they will not be disturbed. The brown eyes still hold their sparkle and the smile is a winning one she notes, leading him to a comfortable chair.

"I have been expecting you, Tomaso. Maddalena wrote me that you would be coming to visit some months ago."

"Ah, so much has happened since I saw Maddalena in Florence," he answers her solemnly, seating himself opposite her in the little room and beginning to tell her about the flood, the loss of his house and belongings.

"But things are looking better now," he concludes, smiling at her, grateful for a sympathetic listener. "I am learning to be a countryman all over again. At last I have returned to the land of my birth. The vines are beginning to show green and the grain is planted. Soon shoots will spring up. Arezzo is a pretty place. Life is good."

"Oh, Tomaso," Bianca answers. "I am happy for you. I wish I could share your optimism. I have just received the most unsettling letter from Maddalena." And Bianca commences to confide in Tomaso.

Her daughter's decision to reject Piero and give her heart to Luigi is roundly discussed. Bianca reveals her fears and uncertainties to her old friend Tomaso. He listens carefully to her, then tells her she has a responsible daughter and should trust her judgment.

The afternoon takes wings and Bianca hastily invites him to sup with her in the little room off the kitchen where she takes her solitary meals. There is still much to talk over. The hour is late when he says goodbye and departs for the inn in San Sepolcro. For both of them, it has been a magical meeting.

Bianca's fears for her daughter have been put somewhat to rest. Is not Maddalena a sensible daughter? Would she endanger her future happiness by acting rashly? Tomaso's logic has done much to allay her fears. Maddalena can be trusted to make the right decision, surely. Bianca now begins to anticipate her daughter's imminent arrival from Florence. There is much to plan. And, feeling light hearted like a girl, she wishes to share with her the details of Tomaso's visit, the friend from earlier days whose visit has brought her great comfort.

Bianca is feeling animation, happiness, a relief from the endless hours of loneliness stretching before her after Maddalena marries, a dark veil she has been unable to throw off. To listen, to speak with someone who seeks and enjoys her company, this is cause for elation she realizes as she climbs the stairway to her room. *Tomaso's visit was good for me!*

Bianca knows Maddalena will return to San Sepolcro only for a short time. She will marry soon. In thoughtful mood, she brushes out the long, dark tresses from her plaits in the silence of her tiny room. Putting aside the brush, she takes up the small hand mirror and inspects her face.

The gray eyes have not dimmed, the brow is unlined. Only a slight dusting of gray at the temples in the luxuriant black hair. *Why should not I look forward to life, instead of looking back?* When she is handed a note from Tomaso the following morning, his brief words of endearment bring a becoming pink to her cheeks.

He writes that he has enjoyed her company. He also speaks of the loneliness he feels, and he wishes to see her again soon. Bianca takes up her many duties of the new day with a renewed spring in her step and a contented smile on her face.

TWO

When Piero's letter arrives, Maddalena, now returned to San Sepolcro, takes it to her small room under the eaves. She has not yet settled down into a routine, rather her thoughts are on Florence and all which has happened there in recent weeks.

As she reads the letter, her tears overflow like water leaking from a brimming pitcher. Piero has indeed poured out his heart to her, but he offers no solutions. He will not, or cannot, change, any more than Maddalena can change the deepest feelings of her own heart.

"Oh, Piero," she whispers, "Forgive me if I have wounded you. I did not wish to cause you pain."

Dear Maddalena,

I have returned to the Palazzo Ducale in Urbino where I found your letter waiting for me, and for three nights I have not been able to sleep. I am lying on the couch of my studio trying to fall into the arms of Morpheus, but the torment of your image inserts itself into my mind and I lie sleepless. Weeks without receiving a message from you of any kind, not even the briefest of notes, and now this, in which you beg to be released from your promise to me. No wonder I cannot sleep!

Do you realize that loss of sleep is a serious impediment to an artist? I need to awake refreshed, to greet the day with senses alert, my mind clicking. Especially with a patron so demanding as Duke Federigo, whose intellect is intimidating, so clear and precise it is. It annoys me no end that I am unable to will myself back to sleep. Calm and order are the two primary principles with which I try to govern my life. Now, because of this upset, there is serious disruption of my habits.

So I take my pen in hand to you while the rest of the world is sleeping. I hate the idea of something unfinished between us. No, better to end it decisively, once and for all, if you have expressed your true feelings. I reach the same conclusion each time I compose an imaginary

154

letter to you. Then your image floats before me and the nightly torment begins. No, this will not do!

I remember when we first met. Your appearance arrested me from the beginning. You possess the tall, statuesque type of beauty I like to paint, a natural beauty without artifice or fussiness of any kind. I was lost from our first meeting at the Priory with Father Bruno---did you know? Your wit and intelligence further sealed the wound. Ah, your zest for life! You seem more alive, Maddalena, than anyone I have ever known.

I wanted you for my wife. Thought of you from the beginning as a suitable companion for a rising artist destined for fame. Your bearing and demeanor were charming, regal, even if your station in life denied it. And I had the power and the means to rescue you!

I am thinking of a time now, long before we met, when my mother and father were alive. My mother understood me better than anyone, understood this strange boy who preferred drawing with a piece of charcoal on stone to playing the rough and tumble games of the street. I recalled my father, a tanner, who worked so hard, yet never seemed to keep up with the demands of raising his family. How he sickened and grew weaker until one day he was unable to work at all and died soon after.

Then, Maddalena, memories take on a sepia color, for life became grim, existence hewed out by my mother, cooking, doing laundry, taking in sewing. Poor food, and never quite enough, drab clothing worn year after year, becoming too small for my growing body. I resolved, Maddalena, during that sepia time, to do something with my life. To build, to plan, to circumvent the winds of chance by every means I could.

When I was thirteen an astounding piece of luck occurred. It was luck, I admit, for I was not the most promising candidate for the job. But Domenico Veneziano recognized something else in my sketches--- power and promise. He saw a talent worth developing. He took me on as an apprentice at his studio in Florence. The work was hard but it was a necessary journey on the road I wished to take. I learned much. But I remembered my mother and brother and sent them the few scudi I earned selling the odd sketch or two.

My mother lived to see me begin to claw my way up. I am grateful for that. But her years of toil and deprivation took their toll and she died soon after I earned release from Domenico Veneziano, my apprenticeship as an artist finished. Her death was a crushing blow. She had been the one who encouraged me, urged me on. She is the person who filled me with dreams of becoming a great artist, dreams I have never forsaken. I vowed I would die before I failed her.

As for women of my own age, I had little use for them. The secret meetings, kisses in dark alleys with girls in the neighborhood never tempted me. I felt contempt for them. Besides, the shame and disgrace, to say nothing of the hardship, if a baby should be born out of wedlock. No, I could little afford such complications.

155

That is why, Maddalena, you intrigued me! I had waited so long! Younger than me, more malleable. I thought. Perhaps I was mistaken about that, was I not? But you were of gentle birth. I knew you could give me status, standing. I misjudged you, thinking that you too wanted my success. Now I see you demanded more, so much more. More than I am prepared to give, Maddalena, for you see, work will always come first with me. I am too bound up in promises to my mother and my belief in my capabilities as an artist to change that. Can you understand?

I admit I have sought friendship with Alberti. He and I have a great rapport on discussions of perspective in painting, on mathematics and of course, on architecture. He has been a wonderful help to me in my painting here. I have also enjoyed the friendship, on a restrained level, with my patron, the Duke. He respects me, and gives me great freedom to work as I please. I am not so much at ease with the Duchess, a shameless coquette who looks very much like you and makes me feel lonely for you whenever I am in her company. But then I remember that like you, she is very young and beautiful and perhaps looks at the world in a different way.

So you have decided on our course of action. You will marry another, and I will go forward with my work, in the hope of becoming the foremost artist of my time. Writing this long confessional I am sure places me in peril. There is so much I have revealed of my weaknesses, my early poverty, which can be turned against me. Nonetheless, I feel the better for having put it all down, Maddalena. Our betrothal is finished. We have determined to take different paths. I will now get on with my work. Your obedient servant, Piero

Ah, Piero, Maddalena thinks, *you understand me better than anyone*, and yet you cannot change. That you will become the greatest artist Tuscany and Umbria has ever known I have no doubt. That I cannot accompany you on your journey is also clear.

THREE

Signore Giuliano Castellani, in spite of the burden of debt, is a proud man. He comes from a long, honorable line of Tuscan land owners whose wealth is automatically invested in more land in the area around San Sepolcro, although much of this land has exhausted its fertility. He is also a sensitive man, keenly aware that Maddalena and her mother know of his previous opposition to Luigi's plan to marry Maddalena. What should he do, now that his son has been successful in his suit?

His wife, poor Margherita, has always been fond of Maddalena. She is happy at the news. Of course, she has never grasped even the most rudimentary elements of business practice. She knows nothing of the precarious nature of the family finances. Even though her marriage brought great wealth into the Castellani coffers, that wealth has now evaporated. The point is, what is he to do? How can he mend his tattered fences with Maddalena?

Idly he runs his fingers over the astrolabe in the study as he gazes out the small-paned window into the garden. He fidgets with the pile of papers on his desk. It is unlike him to utter anything which sounds like an apology, no, he is too proud for that. The faded blue eyes turn again to the window. Without a sound, he is on his feet, striding out toward the garden. Now that she has returned, I must act at once, he mutters.

He comes upon Maddalena seated on the little bench, just as he expected when he glimpsed her from his study window as she moved along the path toward the garden. She raises her eyes at the sound of his approaching footsteps.

"Signore Castellani." It is the first time she has faced him alone since her return from Florence. He bows to her.

"Welcome back, Maddalena. I have heard much from La Signora of the good works you accomplished at the Ospedale degli Innocenti in Firenze." She murmurs a graceful disclaimer, bowing her head.

He loses no time speaking what is on his mind. "You have every right, Maddalena, to condemn me for acting like a miserly old man." Her cheeks flush. She lowers her eyes. "All I can say is that I affirm my son's choice for a wife. I believe he has chosen well in choosing you. "

"Signore, it is good of you to say. I, I understand the problem the lack of a dowry settlement must present."

"Nonsense, nonsense, do not concern yourself. All will be well," he replies with a heartiness he hopes is convincing. After all, with the Doni position as well as his brother-in-law's offer to Luigi to manage the Prato farms, there should no longer be a problem. He gives her one of his rare smiles.

"What we must focus on is the creation of a new household in the Castellani family, one that will surely heap honor on our name." He takes her hand. "Will you and Bianca dine with us tonight?"

"Certainly, with pleasure," she murmurs as he bends over her hand.

"We will toast Luigi in his new role of hero," he adds, gracefully taking his leave.

Maddalena reflects on the tall, slightly bent figure with the faded blue eyes so like Luigi's, wondering if perhaps Luigi will grow to look more and more like his father as the years pass. Then, unbidden, thoughts of the servant Valentina come to mind. Poor Tina, how is she faring with her new husband, the joiner in Prato? Then the question always at the back of her mind: *Does Luigi know?* She stands, smoothes her skirts and goes to inform Bianca of this strange meeting and the unexpected invitation to dinner.

FOUR

*L*uigi Castellani is becoming accustomed to frequent horseback rides between Florence and Prato. Whenever possible, he journeys to Prato to check on the emerging cloth business of the Doni cousins and to visit the farms on his uncle's Prato estate. Thank God it will not be long until the Cross of Valor business is finished and he can depart Florence for good.

He eyes the small, perfectly proportioned villa, obviously vacant, as he reaches the outskirts of Prato. Always it catches his interest. In excellent repair with a pleasing facade, roofed in red tiles and walls covered in ochre colored stucco. Dark green cedars form a backdrop for the house, matching the green of tightly closed shutters covering the windows. The hillside rising sharply behind the villa is covered in sprouting, well-pruned vines. And beyond the hillside, unseen, the River Bisenzio winds toward Prato's center.

On impulse, he slows his horse to a walk. Inside the gate, he glimpses a pretty, overgrown garden. Who can have abandoned such a desirable property? Might there be a chance it would suit Maddalena?

The wedding date has now been fixed. November first, All Saints Day, with Father Bruno performing the rites, then, he imagines, the biggest wedding banquet in all Tuscany taking place at Palazzo Castellani. How his father loves a sumptuous show. Luigi smiles ruefully.

In spite of Signora Doni's offers to hold the banquet in Florence, his father insists and the Palazzo Castellani will be packed with Castellani cousins coming from afar. Luigi, who would much prefer a simpler occasion, sighs. After his father has behaved in such a conciliatory manner, it would hardly do to oppose him on this point. Better to give in and enjoy it.

His thoughts return to the boy Gino as he resumes the last meter of his journey. He and Maddalena must go to see Mother Ursula at the Ospedale immediately following the Cross of Valor nonsense. They must be ready to adopt Gino as soon after their marriage as Mother

Ursula will permit. More than anything else, save Maddalena's happiness of course, he wants to make Gino's boyhood a memorable one.

He pushes away thoughts of his own lonely childhood as he reaches his uncle's property, and dismounts. *All of that can be erased if I can just make it right for Gino.* He looks over the greening hillsides already spangled with red poppies, slowly opening their cups as they follow the warming sun. *Toscana, Toscana. Is there any place in God's kingdom more beautiful?*

Imbedded deep in his mind is the one unanswerable: What has become of Valentina? Is she happy with her marriage to the joiner in Prato? Is she, if the overheard stable yard gossip at his uncle's farm in Fiesole can be believed, really his half-sister? Like it or not, he is bound to run into Valentina in Prato sooner or later.

A racing cloud covers the sun for a moment then vanishes. There appears to be little doubt about those rumors of gossiping stable boys and servants, Luigi intuitively knowing that his father must have provided Tina with a handsome dowry settlement. But Maddalena must not learn of it. He cannot bear the thought that she should know of his father's disgrace. She must never know!

FIVE

Father Bruno at the Priory of San Giovanni Battista has received another letter from Piero. He sighs, recognizing the fine, flourishing script. He knows Piero is still suffering from losing Maddalena. The priest has been shocked by the outpouring of feeling in these letters. What hopeless dilemmas, what passions, can rain down on the human race! He passes a hand over his brow. It pains him that Maddalena and Piero have parted. But he has to agree with the assessment of Mother Scholastica: Better find out now rather than later, after the vows are exchanged. A daring pronouncement, for wives are expected to make whatever adjustments are necessary to their husband's wishes in *quattrocento* Italy. Nonetheless, there is no doubt that Mother Scholastica represents the most forward thinking of the times on such matters. He places a hand over his eyes, once again giving silent thanks for his cloistered life of the Spirit. He begins to read the letter.

Piero writes that the artist Bicci di Lorenzo has died suddenly in Arezzo while working on an important fresco cycle for the Franciscan church there. As to whether he fell off the scaffolding drunk, or whether age caught up with him, who can say? He had reached his eightieth year. But, Piero recalls, he remembers how Bicci could quaff the wine! At any rate, the letter continues, Piero has been given the task of finishing the frescoes.

The subject of the fresco cycle, Father, the Legend of the True Cross, is a complicated story, as you know, and a favourite in Franciscan churches such as this one in Arezzo. There are two battle scenes, two scenes of regal processions and a time period ranging from the death of Adam to several centuries after the death of Christ. A hundred years ago, I might have better understood why the Franciscan Brothers in Arezzo chose it as a subject, but not now. It is surely outdated. It is an important commission, nonetheless, and I shall be going over to Arezzo soon to see what I can make of it.

As an artist, Bicci di Lorenzo was competent, a member of Domenico Veneziano's studio team when I was Domenico's apprentice in Florence. But even as a boy, I soon discovered Bicci's only real talent: he could copy like an angel holding the brush, but of original, creative interpretation, he was incapable.

161

Father Bruno gazes unseeing at the letter before him. This means Piero will have to move over to Arezzo. Well, new surroundings, a difficult challenge, this may be just the medicine Piero needs most. To get away from all the court intrigues and gossip in Urbino, to forget Maddalena. Yes, plain hard work and plenty of it may be just the thing to erase Piero's unhappiness.

Patrons are like a pack of bloodhounds, Piero once told him. Always nipping at your heels, but better have plenty of them around, if you want three meals a day and a roof over your head. Well, the Arezzo commission will add another patron for Piero. And the Franciscans, with their swelling ranks, shouldn't lack for florins either. He wishes the Dominicans were as wealthy. The unworthy thought leaps into mind before he can stop it. He banishes the serpent of envy quickly from his thought.

Piero writes he has information that Maddalena's fiancé is the Castellani's son, the one who had been bundled off to Fiesole after his older brother's death many years past. And he asks Father Bruno (what this must have cost Piero in pride, the old priest wonders) if he knows when the vows will be celebrated.

He surprises Father Bruno by admitting he feels especially lonely, as Alberti has left Urbino, being called back to Rimini by Sigismondo Malatesta, to work on plans for a church-temple, a profanity Piero personally feels, but one Alberti is enthusiastic about.

Piero also writes that Duke Federigo, knowing nothing about the trials Piero is undergoing in his personal life, has reacted with equanimity and good will at the news of his new commission in Arezzo, immediately giving him leave to go. Plenty of time to paint the double portraits of him and the Duchess Battista, when he returns to Urbino, the Duke assures him. Father Bruno silently marvels at Piero's chatty, newsy letter brimful of information.

Piero adds a postscript saying he has found an especially beautiful old missal in Urbino, brought in some trader's pouch from Constantinople, which he will present to Father Bruno on his next visit to San Sepolcro.

firenze/Prato

ONE

The day of the Cross of Valor celebration in Florence dawns. The Doni villa is filled to overflowing with guests: Maddalena and her mother, Signore and Signora Castellani and their attendant servants. Tomaso di Paolo has been invited to the festivities, although he will be staying with his daughter and son-in-law nearby. And more Castellani relatives are expected to swell the ranks of merrymakers at the festive banquet planned for later in the evening.

"We must sprinkle the flagstones at sunset," Giovanna muses as she, Maddalena and Bianca sit in the early morning coolness in the courtyard. "Else it will be too hot for dining later on." She glances carefully at Maddalena who, she hopes, has now come to terms with the death of Sister Marta.

"You are feeling well now, Cara?" she asks softly.

"Yes, Giovanna, however being back in Florence, I find I think of her much more often, and that makes me sad."

"Ah, you are young, Cara. We will never forget her, you know. There is still a little of her in Gino, do you not think? He, you might say, is her living legacy." Maddalena nods, biting her lip. She wants very much to tell Giovanna and her mother of the plans for Gino she and Luigi have made, but she remembers her promise to Luigi to keep silent.

"Who will represent the dei Medici, Giovanna, at the Cross of Valor ceremony?" Deftly, Maddalena turns their thoughts elsewhere.

"Probably Piero, Cosimo's son, if he is able," Giovanna replies, with a nervous glance toward Bianca. "You know he is called Piero the Gouty because of his horrible affliction. They say

163

he can hardly walk, even with canes and crutches." She shrugs. "He is not popular with the people. They tolerate him, but they do not love him." Giovanna and Bianca exchange looks.

"Is the Castellani uncle coming from Fiesole?" Bianca asks her daughter. She too, is anxious to change the topic of conversation. Her memories of Piero dei Medici are particularly unpleasant; as a young man he possessed cold, insolent eyes and grasping hands.

"Luigi tells me his Uncle Baldassare will be on hand," Maddalena answers.

<p style="text-align:center">*</p>

Platforms have been erected in the area in front of the Signoria, the city hall. The most important dignitaries and officials will assemble inside, then make their stately progress to the platforms. Florentines have always loved the pomp and pageantry of a spectacle, a ceremony, and today promises to be no exception. Throngs of citizens begin streaming toward the heart of the city by midmorning.

All eyes gravitate toward the highest platform, where officials are beginning to take their places. Most of them wear brilliantly patterned cloaks and tunics of varying color. Some sport matching hats. As they solemnly take their seats, spectacular flags and banners float above in the breeze, standards of the ruling members of the Signoria. None wave as high as the dei Medici flag, emblazoned with six golden balls.

Maddalena and her group take seats. Looking over the ever-swelling sea of humanity below, she searches in vain for a familiar face, reminding herself that, except for Giovanna and Alfredo and their circle, she claims few friends in Florence, save for the Sisters at the Ospedale.

She glances at her mother. What is she thinking, seeing the dei Medici flag waving above all others? Is she remembering the time when the Albizzi were driven from power? Or perhaps she is thinking of her dead husband, Giovanni, a dei Medici who could not claim the name? Bianca's countenance however is smooth and unwrinkled.

Luigi's parents arrive: Signora Castellani fluttering as always; Il Signore, tall and solemn, at her elbow. She takes Maddalena's arm and gently draws her aside, asking her to take a small silk purse to Luigi inside the Signoria where he is awaiting the beginning of the ceremony.

The purse, it seems, contains a gold ring once belonging to her father, a cherished possession, and she wishes Luigi to wear the ring during the ceremony. The fawn-colored eyes plead silently, and Maddalena reassures Signora Margherita, accepting the purse.

She has not yet spoken to Luigi on this very important day. She hurries inside the old stone fortress, a cherished symbol to Florentines of their long and troubled history. She quickly pauses, moves to one side, as a magnificent retinue of trumpet players, flag bearers and

drummers makes its way toward the platforms. They file pass and she resumes her progress down the corridor until she hears a hissing whisper behind her.

"Make way! Piero dei Medici approaches!" She lowers her eyes as she tries to blend into the group behind her. *Piero dei Medici, the ruler of Florence. My dead father's half-brother.* Maddalena tenses and lowers her gaze, wishing herself invisible.

The man approaching, dressed in somber gray wool of the finest quality, is walking painfully with the aid of two stout canes, his face etched with lines of suffering. He is of medium height, a paunch swelling his mid-section, hair like gray steel falling over his forehead. With an impatient gesture, he shakes the strands from his eyes. The eyes, Maddalena notes, are black spider eyes, small, dark, filled with cunning.

As he approaches, she raises her chin proudly, remembering her father. The ruler comes to a halt in front of her. She looks him in the eye and does not bow.

"What is your name?" he rasps.

"I am Maddalena dei Crespi," she answers, continuing to look him straight in the eye, although underneath her skirts, her knees are weak, trembling like jelly. He stands, looking her over carefully, heavily leaning on his supports.

"Maddalena dei Crespi. So you are Giovanni's child. You are the image of your father. I thought as much!" The voice is scornful, with a touch of envy. Envy for his dead brother who was so fair, so brave? The spider eyes, however, remain cold, insolent, unrevealing. Maddalena continues to stand, unmoving, before him.

"I am proud beyond words to bear any resemblance to him. He died honorably, fighting for Florence," she speaks up suddenly in a clear voice.

"So he did, so he did," he sighs. "And Bianca? Whatever happened to little Bianca?" So it *was* true, what Giovanna had told her, that Piero dei Medici had been in love with his brother's wife! Maddalena blushes, says nothing.

"Bianca," he continues, "She who is doubly cursed to be Giovanni's widow and an Albizzi." The cruelty in the brusque voice simmers over into the corridor. The strangers behind Maddalena have been standing quiet as mutes, but now she hears their sharp intake of breath. Piero the Gouty has gone too far.

"Have you not hurt our family enough?" Maddalena whispers the words.

With a shrug he resumes his painful progress. "Others are hurting too, Signorina. Do not speak to me of hurt." And the large body, supported on the misshapen, spindly legs by the two canes, inches painfully toward the platform.

*

Hurrying as fast as she dares along the corridor, her face aflame with the memory of Piero the Gouty's scorching words, she sees Luigi in the ante room of the Signoria, waiting for the signal the ceremony will begin.

He rushes to her side when he sees her. Quickly she tells him of his mother's wishes, handing over the silken purse. Clearly Luigi is touched. This is the mother who wanted him banished from her sight years ago. He embraces Maddalena urging her back to the platform as it is time for the ceremony to begin. Knees still wobbling, she says nothing to him of her disturbing encounter with Piero the Gouty.

She reaches her seat just as another fanfare of trumpets sounds. The ceremonies begin. Quickly Luigi strides to the platform along with the second recipient of the Cross of Valor. A few more speeches follow by minor dignitaries, determined to have their moment in the spotlight. Then Piero the Gouty mounts the podium.

Now that Maddalena has calmed herself somewhat after her bizarre meeting with the man, she is able to study him with more objectivity. His rich, simple clothing is unadorned save for a huge gold chain he wears around his neck, bearing the dei Medici symbol, the six golden balls. As he painfully steps up, a commanding figure in spite of his affliction, a hush comes over the crowd. There is power in his demeanor. She searches his face, but try as she may, she can see nothing of herself in the blunt features of this child of Cosimo, her grandfather. The eagle-like beak, the piercing black eyes beneath puffy lids, nothing reminiscent of herself, she thinks with relief. She wants no part of this cruel, insulting man. She glances toward Bianca who sits frozen beside her, hardly breathing, as though his strong, powerful arms might search her out like the overgrown, grasping tentacles of an octopus.

Piero dei Medici awards the first medal to the bricklayer who jumped into the roiling waters of a rampaging Arno to save a young girl who had been swept away by the swift currents. Then Luigi's name is called and as he steps forward. His act of bravery is recounted for all to hear, how he rescued the small boy from the flooded tower as the waters rose perilously closer. Luigi's face is immobile. Luigi dislikes all this attention, thinks Maddalena, watching him closely. As the two crosses of Valor are placed over the mens' heads, a huge cry goes up among the spectators. *Brava! Brava! Bravissima!*

Piero the Gouty holds out his hands for silence. "The third Cross of Valor is awarded posthumously," he declares solemnly, as the audience strains to hear. "It goes to one who never sought attention, but worked unceasingly for good, one who saved the lives of many who came to the Ospedale when the flood struck, one who restored the very child rescued by young Castellani here. This cross goes to the late, lamented Sister Marta of the Ospedale degli Innocenti." The applause thunders. Piero the Gouty leaves the stage and the ceremony ends.

*

As the sun disappears on the horizon, guests gather in the courtyard of the Doni villa where Giovanna greets them with cooling fruit juices and wine. Matteo and Bettina Doni arrive, bringing their young cousin, Francesco, who has been recruited as an escort for Julietta Vespucci, a last-minute guest, who will be arriving with Luigi's Uncle Baldassare. Giovanna has outlined Francesco's duties carefully, for he never leaves Julietta's side and follows her about like a limpet. Comely, with large brown eyes and wavy hair, he claims Julietta when she arrives.

The courtyard is lighted by glowing lanterns and candles on long tables covered with white cloths. Fireflies hover in the dusk, winking around lemon and fragrant gardenia trees. Hydrangea blossoms glimmer in ghostly pallor. Maddalena is especially pleased to welcome Tomaso di Paolo, the old friend of her late father. She finds herself still shaken by the earlier encounter with Piero the Gouty and finds the presence of her father's friend reassuring.

At a signal from Giovanna, the lute players cease their strumming and Luigi stands, claiming the attention of the diners. Cries of *Brava! Brava!* arise which Luigi quickly hushes.

"Hear me, friends. I thank you. It is good to be with you this beautiful night, enjoying the hospitality of Giovanna and Alfredo Doni. Maddalena captured my heart the first time I saw her. I have been her prisoner ever since." Raucous shouting breaks out among the men. Women titter behind their fans.

"We plan to celebrate our marriage vows in autumn, on November first, All Saints Day, at the Priory of San Giovanni Battista in San Sepolcro. Afterward, my parents will host the biggest fete Palazzo Castellani has ever known in Maddalena's honor, maybe the biggest fete in all Tuscany." More applause and laughter. "Each of you is invited to be present, and to give us your blessing." Luigi sits down amid cheers and the cry is taken up, *Maddalena! Maddalena!*

Luigi gives his hand to Maddalena and bids her rise. "It is your turn now," he whispers, pressing her hand and looking into her eyes. A little tentatively, Maddalena stands, hoping to choose the right words. She looks at all of the beautiful women around the table. How can she compete? Then she recalls the Maddalena in *The Baptism* of Piero, and courage courses through her.

"Luigi rode into my life like Prince Charming," she begins. "The horse did not stumble, but we did, making several false starts." Laughter from the diners. Emboldened, she continues, "The road has not always been smooth, but we are sure of one thing, our love for each other. We hope to begin a good and long life together next November and we want you, our dear friends, to be a part of it. Thank you for your blessing."

Before the applause dies down, gentle Alfredo Doni is on his feet, peering, owl-like, over the rims of his spectacles. *"Silenzio, prego,"* he begins. "My good friends, Luigi and

Maddalena have brought us something rare these past few weeks. In the dismal time of the flood, they were working, bringing comfort to those in need in any way they could. Night after night, Luigi patrolled the Arno, looking for anyone in trouble while Maddalena worked tirelessly at the Ospedale degli Innocenti, with Giovanna, and of course, the blessed Sister Marta." He smiles.

"Under these trying conditions, Giovanna and I witnessed a miracle, the blossoming of the love of these two young people for one another, a deep and a lasting love, let there be no mistake about it!" Alfredo sits down among cries of *Brava! Brava!*

Signore Castellani rises to speak, followed by Tomaso di Paolo who tells of meeting Maddalena by accident at the Church of the Carmine where they had come to see the Masaccio frescoes. He tells of her striking resemblance to her father, his fellow soldier and friend who died bravely in battle long ago. He speaks of renewing a friendship with Bianca, her mother, whom he had known as Giovanni dei Crespi's young wife.

Next the company listens to Luigi's Uncle Baldassare, who recounts Luigi's first attempt to land a fish he caught as small boy. Finally Matteo Doni stands up, telling the assembled guests how proud he is to have Luigi at the helm of the latest Doni enterprise, the new cloth business in Prato, where the young couple will live after they are married.

Later in bed, after the magic of the fete has ended, Maddalena pushes thoughts of the disturbing encounter with Piero dei Medici aside. Instead she dreams of her future home with Luigi and Gino, and of Luigi teaching Gino to fish on the banks of the river Bisenzio nearby.

*

Piero della Francesca, en route to Arezzo to begin work on the frescoes for the Church of San Francesco, is traveling from Urbino by way of Florence, where he must first buy colors to grind and chalks for the drawing of the *sinopia,* the preliminary outline of the fresco, executed in red chalk on the wet plaster before the actual fresco painting begins.

Piero's arrival in Florence coincides with the celebration of the Cross of Valor ceremony. As he makes his way from the inn to the center of town, he is swept up in the crowds hurrying toward the Piazza della Signoria. Giving up and joining the good natured throng, he finds the award presentation is underway, with Piero dei Medici holding forth at the podium. Ever suspicious of the powerful dei Medici clan, Piero listens with ill-disguised skepticism.

He is astounded to learn that one of the recipients is the Castellani son from San Sepolcro, Maddalena's future husband. He studies the unassuming, comely young man standing on the platform and tries to hate him, but fails. Instead, he is drawn to his quiet demeanor, his humility and grace. It is obvious that young Castellani is uncomfortable hearing the words of praise heaped upon him by the speaker. Piero, also hating self-importance and pomposity, finds this trait to his liking.

Realizing that Maddalena must be somewhere near, Piero trains his sights on the platform. In a few seconds he has located her, gazing at her lover with rapt attention from one of the back rows, seated next to her mother, Bianca, her cousin, Giovanna Doni, the Castellani parents and others whom he does not recognize.

Piero devours her with adoring eyes from his place in the throng. He is disheartened by the somersault his heart turns upon setting eyes on her, engulfed by longing, and he feels a sadness made more poignant by the realization that he need not have lost her, had he been more careful of her wishes.

Shaking off feelings of hopelessness, he listens to the words of Piero dei Medici. Young Castellani rescued a small boy, it seems, a boy whose mother died at his side, trying to save him. This boy must be the child Maddalena mentioned in her letter, the child she and Castellani plan to adopt, Piero muses, fitting together the pieces of the puzzle.

An undertaking fraught with dangers, Piero thinks. Why, the child could turn out to be the offspring of cut throats, even murderers! Anything is possible. But deep in his heart he is awed by their noble plan. What if two kindly people had come along to lend a helping hand to him and his brother when his father, then his mother died? It would have made all the difference in how he viewed the world. Piero, intrigued, lets his thoughts meander and is seized by the realization that it could have been he and Maddalena, not young Castellani, who would take on the orphaned child. He sighs.

His attention returns to the platform where it seems a third cross will be awarded, a posthumous presentation. To the late Sister Marta, of the Ospedale degli Innocenti? But he knows her! She is the serenely beautiful nun there who smiled so sweetly when he came to play his lute for the children a year or so past. Surely she had not died! She was in the prime of life, healthy, vital. He turns to the stranger standing next to him.

Yes, it is true. She died of a mysterious fever just as the floods were ending. Shocked and saddened by all he has seen and heard, Piero, now empty of feeling, lets himself be swept along by the dispersing crowds. Caught up in melancholy, struck by the impermanence, the unfairness of human existence, he turns into a church looming up before him and kneels to pray.

Later that evening, after a solitary dinner in a tavern near the church of Santa Croce, he finds himself strolling the streets in the soft darkness of the Florentine night. On Via Ghibellina, approaching the Doni villa, he hears a banquet in progress behind the walls: the bustle of hurrying servants, the clink cutlery on plates and bowls, the strumming of lutes. The courtyard seems to be lit with paper lanterns in the trees. He listens, catching some of the words, for a celebration is indeed taking place, with speeches.

He needs only to hear the words "my son" and "Maddalena" to know that Signore Castellani of San Sepolcro is speaking. Piero's thoughts return to his last meeting with Maddalena,

the chance meeting at the Ospedale when he and Alberti came upon her, carrying one of the infants in the nursery. How cold and unfeeling he must have appeared to her. So many of his actions he regrets, now that it is too late. He curses his foolish pride and his unnatural fears.

He walks sadly away into the darkness from the sounds of merriment, hardly knowing or caring where his tired feet take him. He knows he must keep walking until he is bone weary. Only then will sleep release him; he will no longer cry silently that he has lost Maddalena.

TWO

*L*uigi and Maddalena are walking hand in hand along the tree lined streets toward the Ospedale degli Innocenti. The sun filtering through the lacy canopy overhead lights up their faces as they stroll, signaling to anyone who might notice that this is indeed a pair very much in love.

They enter the courtyard to find a lively game of tag in progress. Gino, seeing them, runs to put his tiny arms around Maddalena's skirts and Luigi's leggings. Luigi lifts him up and the boy squeals in delight. After a few minutes with him, they tell him they must make their way inside where they will seek a meeting with the Reverend Mother, Sister Ursula.

"We must go inside, Gino, but we will return to you shortly," Maddalena says, planting a kiss on his tousled head. She cautions herself to be calm as they make their way toward the nun's study.

When they enter, hooded eyes examine them carefully. Mother Ursula is seated at her desk in a whitewashed room, unrelieved save for an ancient crucifix carved of wood, hanging on the wall above her head. She is small in stature with lines on her skin giving it the appearance of old parchment. A full lower lip seems mismatched with the thinness of the upper lip.

She has been the Reverend Mother for many years, and indeed, grew up on the mean streets of Florence, the daughter of a poor shopkeeper with a house full of children. She cannot remember a time in her early life when it was not assumed that someday she would embrace a life in the Church.

This happened sooner rather than later, when both parents died of the plague and she and her brothers and sisters were dispersed, like an overflowing basket of stray kittens, she recalls, as she looks over the happy couple standing respectfully before her.

No time for frivolities like falling in love and planning a wedding in *her* life, she thinks, pursing her lips. These young people know nothing of the hardships of life. Imperceptibly,

she nods toward Luigi, a signal for him to begin. They are still standing before her. Indeed, there are no other chairs save hers in the room.

"We have come here, Mother Ursula, to tell you of our wish for Gino," Luigi begins, his earnest blue eyes engaging those of the nun.

"I saw you greet him in the courtyard," she replies grudgingly. "He seemed happy to see you." She arranges the few objects on her desk, her small hands knotted with arthritis.

"We love him as one of our own, Mother Ursula," Maddalena adds.

"Reverend Mother," Luigi begins, "Maddalena and I plan to be married in the autumn. We will be setting up a home in Prato. We feel a love for Gino as we would for one of our own flesh and blood. He has become dear to us since we have come to know him." Luigi pauses, but Sister Ursula remains silent.

"We are prepared to nurture him, to bring him up in a respectful manner and above all to educate him in the Faith. Maddalena nursed him during the outbreak of fever following the flood. From the night of his arrival, she has played a role in caring for him, under Sister Marta's supervision of course."

"Sister Marta spoke to me when she was dying," Maddalena whispers. "Her last words to me were, 'Look after Gino.' "

"And you were the soldier who found him and rescued him, were you not?" The hazel eyes under heavy lids bore into Luigi, ignoring Maddalena's words.

"Yes, Reverend Mother," Luigi answers. He does not boast, but he looks directly at her.

"And by what right do you think you are mature enough to deal with the problems of raising a child, when together you have had no experience in family life? Both of you, I understand, grew up without the benefit of a father. Are you not assuming too much in pursuit of this undertaking, when you know nothing of what life is like after marriage?"

Maddalena's spirits wilt under the barrage of objections. She has not reckoned on this unfriendly opposition. Luigi looks thoughtful but remains silent. At last he speaks.

"What you say is true, of course. We have no experience in marriage, how could we? But we do have an abiding love for each other. Maddalena, unfortunately, lost her father when she was a baby, but her mother has given her love and affection and has taught her to honor hard work and discipline. As for me, it is true what you say, my mother's health forbade my living in San Sepolcro as a child, but I always had the love and support of not only my father, but my uncle in Fiesole, with whom I made my home."

There is silence in the room, unrelieved even by the shouts of the playing children outside, who have suddenly gone quiet. At last Mother Ursula speaks.

"And when and where is it that you will take your vows?"

"The day is November first, All Saints Day, at the Priory of San Giovanni Battista, in San Sepolcro." Luigi's voice is strong, filling the little room.

"I see," she answers. "Mother Scholastica's Priory." There is another long silence during which Maddalena's thoughts recall an earlier meeting with Mother Scholastica, before the sad death of Sister Marta. She smiles at the memory.

"And what do you find amusing, Maddalena?" Mother Ursula demands sharply. Maddalena blushes as she frames a careful answer.

"You see, Mother Ursula, I studied at the Priory with Father Bruno. The lives of the saints, the early history of the church. Often Mother Scholastica would drop by to see how we were getting on with our lessons. I just remembered once when she came in and we three had a lighthearted discussion on Saint Christopher and his problem finding shoes big enough to fit." Mother Ursula frowns at such frivolity.

"I see," she answers dryly, not seeing at all, thinks Maddalena, discouraged. Suddenly Mother Ursula stands up, signaling an end to the audience.

"I am asking you to give this wish of yours careful thought and constant prayer. Come back to me six months after your wedding and we will see how things look. Then I will decide what is best for the child." Maddalena can hardly keep tears from showing as they bow deeply and leave the room. She watches sorrowfully as Luigi and Gino play a game of catch before they leave the Ospedale.

THREE

When Giovanna's eyes alight on Maddalena's face as they walk into the Doni courtyard, she senses immediately something is wrong. "What has happened?"

Quietly Luigi gives her an account of the meeting with Mother Ursula, revealing their wish to adopt Gino as soon as they take their marriage vows.

"But how wonderful that you wish to do such a thing! Many would let prejudice and fear keep them from acting. I am so proud of you both." She embraces Maddalena impulsively.

"But Giovanna," Maddalena protests, "Mother Ursula gave us no encouragement at all. You would have thought we were doing it for an unworthy reason, for gain, or something equally sinister. I think she has completely misunderstood." Quickly Giovanna takes her hand.

"Maddalena, Maddalena, do not be upset. Do you not realize Mother Ursula is incapable of making quick decisions? It is the joke over all Florence. Why once when the pots in the kitchen caught fire on the hob, she could not decide whether to alert the fire brigade or not. The entire kitchen was destroyed in the blaze." Giovanna embraces Maddalena again.

"No, be assured, she will give her consent in the end, I am sure of it. Why? Because it is a golden opportunity for one of her foundlings, and deep in her heart, she loves them dearly. Just do not expect a quick decision from Mother Ursula. She is incapable of acting with speed. Now, what exactly were her parting words to you?"

"To come back six months after the wedding, is what she said," Luigi answers. "We were both reeling from her unfriendly manner by that time. Too rattled to protest."

"Do not fret, do not fret. Maddalena, you must have happy thoughts for your wedding. You do not want your face lined like a prune! Maybe the idea of waiting a few months, so you can settle down, is not a bad idea, Cara, eh?" And Giovanna begins to laugh. Soon the three

of them are laughing at the imagined sight of Mother Ursula, watching the kitchen engulfed by flames, unable to decide she must call the fire brigade.

"Yes, Maddalena, patience," says Luigi. "We want to be calm parents, don't we? We must not let Mother Ursula outwit us. She would like that, would she not?" Laughter rings out again.

FOUR

Work remains to be done before Maddalena can return to San Sepolcro. Luigi is in the final stages of extricating himself from his duties in the army, dividing his frequent visits to Prato into time supervising the cloth business and overseeing his uncle's farms, which are approaching harvest time, the busiest season of the year.

As for Maddalena, many sessions are held with Luisa, Giovanna's seamstress, on whose tiny shoulders rests the responsibility for Maddalena's wedding gown of white damask, with inset panniers of white satin, a simple but beautiful design. A heavy veil of French lace from Chartres is unpacked from its chest in Giovanna's bedroom. It is the Albizzi wedding veil, one of the few heirlooms escaping the fires of wrath set by the dei Medici during their purge. Giovanna solemnly hands it to Maddalena.

"Wear it, Cara," she whispers. "It will be a reminder of your Albizzi heritage."

*

Maddalena begins her final day in Florence. Soon she will make the return journey to San Sepolcro to await her wedding. As she contemplates the ending of her early life and a new beginning married to Luigi, there are misgivings. *What if we are not suited to each other? What if we quarrel? Have nothing to talk over at the end of the day?* All couples, she realizes, must have similar questions.

Midway in her packing, she glances down at the courtyard below. Tiny birds dart in and out of the dolphin fountain. Beyond, she sees a solitary figure entering the gates and crossing the flagstones.

About the size of Piero, he wears a similar tunic, slightly longer than is necessary. Maddalena smiles at the memory of the artist when she first met him. The man draws closer. She steps back with a start. *It is Piero!* Maddalena hurries downstairs to greet him just as the little maid, Simonetta, is showing him into the *salone.*

176

"What a delightful surprise, Piero," she greets him warmly, motioning him to a seat in one of the room's comfortable chairs. "What brings you to Firenze?" Maddalena tries to put him at his ease. Of course his demeanor is calm, unruffled. Only those who really know him can guess at his inner turmoil. But he has surmounted all suspicions and doubts and has come.

"I am working in Arezzo at present," he answers, seating himself. "There is a large fresco commission underway at the Franciscan church there. The artist who undertook it, Bicci di Lorenzo, has died. I have been given the job of finishing it."

"Yes, Piero, I had heard. It is the talk of all Florence. What a splendid commission. I am sure you are pleased."

"The story is so garbled and disjointed, and covers so many centuries, I am really more bewildered than pleased at the moment. However, I will try to bring order and logic to its presentation." He does not add that it would be so helpful to have someone with whom he could talk it over. Now that Alberti has left for Rimini and he himself is relocated in Arezzo, he misses a companion. But it would hardly be suitable to declare this to Maddalena.

"Can you tell me a bit about the fresco, Piero?"

"Well, it is the story of *The Legend of the True Cross*. From the *Book of Golden Legends*, by Jacopo da Voragine." He looks at her to see if she is following. Maddalena nods eagerly. It seems she has read it with Father Bruno, sometime in the past.

"Fresco, Maddalena, must be worked surely and swiftly in the wet plaster else it will be ruined. No time for guesswork, or second thoughts. If the plaster dries out before the paint is applied, it will flake off." Maddalena nods in perfect understanding.

"Then you must have the progress of the story firmly in mind before you proceed," she replies with confidence. If there is one thing she has learned about this man, it is that he is *thorough*.

"That indeed is my plan on how to proceed." He politely turns the talk to her life. "And you, Maddalena, when do you leave for San Sepolcro for your wedding?"

"Tomorrow, Piero. I must go, for the preparations are already underway."

"And your mother, Bianca? How is she?"

"Very well, thank you. She was here earlier, but has now returned to Palazzo Castellani. I will be glad to be with her for a time, before I take my marriage vows." She inquires of Piero about the altarpiece for the Confraternity of the Misericordia.

177

"It is not finished yet. I have requested an extension of the contract. The largest panels are done, of course, including the panel of the Madonna for which you posed. It is some of the smaller panels I simply have not had the time to complete yet.

Maddalena nods. "And your work in Urbino?" she asks.

"I will stay on with Duke Federigo at long as he wishes, as he is very lenient with my traveling. Of course I have obtained leave to work in Arezzo at present." Piero stands up, goes to his portfolio and takes out a small parcel, handing it to Maddalena.

"I wanted you to have this, Maddalena, with my best wishes. It is for your new home."

"How very thoughtful, Piero. May I open it now?"

"It is only a little thing," he says, nodding to her.

She unwraps a drawing in charcoal of Giotto, the cat. To be more precise, a portrait of the animal. Giotto, wide-eyed, regarding the world as he curls up in a furry ball. Piero has captured the animal's vitality and life. Delighted, she clasps the drawing to her breast.

"He looks so alive he could be ready to spring," Maddalena says. "Piero, I shall treasure it always. Thank you." Piero rises from his chair, looking embarrassed, and makes signs of leaving.

"I must not tarry. I am expected back in Arezzo tonight, I must be on my way. This is my final visit to Florence for some time, Maddalena. I came today to wish you happiness."

"Thank you, Piero. Your good wishes are the best wedding gift I could ever have. I love the portrait of Giotto. I will treasure it always." So much more she wishes to say. That she admires his logic, his intellect, his goodness. How much he had helped her in learning about painting. But Maddalena knows she must keep silent. Piero, fiercely independent, would resent any seeming patronizing or flattery on her part.

Piero takes his leave, asking to be remembered to both Bianca and Signora Doni. Soon she is looking at his wide back as he walks purposefully across the courtyard, past the dolphin fountain, through the gates of the Doni villa, his head held high. She watches as he disappears into Via Ghibellina.

In spite of knowing that marriage to Piero would have meant disaster, Maddalena feels a great sadness at his departure. She knows their contact is now over. Piero will never again be a part of her life. But in this thought she is mistaken.

FIVE

Gino is trying to play catch in the courtyard of the Ospedale with Luigi and Maddalena, who are visiting him one last time before Maddalena leaves for San Sepolcro. Luigi, determined to keep the play time happy, has warned Maddalena that she must say nothing to the boy about her departure. Better keep the visit short and pleasant, he says, and she knows he is right. He will tell Gino later, after Maddalena has left.

Gino is growing taller, learning new words every day. He makes a good job of pronouncing "Loo-gi" and "'Leena". He shrieks with joy in the game of catch when he is able to get his chubby fingers around the ball. No matter how many times he misses the catch, he always bounds back for another try. Maddalena knows not seeing him for a long time in San Sepolcro will be the hardest thing she must deal with as her wedding draws closer.

Always, at the back of her mind, is the nagging fear that Mother Ursula will not give permission for the adoption. Try as she might, she cannot drive the fear from her thoughts.

San Sepolcro/Arezzo/Prato

ONE

Together again in San Sepolcro, Bianca and Maddalena are enjoying a few quiet moments in the *giardino segreto's* hidden depths, inhaling the scent of exuberant roses in the last profusion of bloom. Maddalena seizes the moment to reveal to her mother the meeting with Piero the Gouty at the Cross of Valor ceremonies.

As she listens, a look of incredulity spreads over Bianca's face, the line of her jaw hardens. She tells Maddalena of the malice he bears, this younger, half-brother of her late husband, Giovanni. As a boy, the younger dei Medici envied the older brother's easygoing manner, his bravery, his comeliness. He particularly envied Giovanni's superior skills in sports of all kinds, because from birth, Piero had always been a sickly child. Piero: the pampered, spoiled darling of Cosimo and his wife Alessandra, whose jealousy of Cosimo's *inamorata*, Giovanni's mother, was well known all over Florence.

As Piero grew, the poisonous venom of the mother's hate and spitefulness spilled over to her son Piero. When Giovanni and Bianca fell in love, Piero did everything he could to break the bonds of their affection, for he himself had fallen hopelessly in love with Bianca, although he knew she had eyes only for Giovanni. His love turned to despair, then to hate, and he taunted her mercilessly about her Albizzi ancestors and their downfall. He ridiculed Giovanni, called him a penniless beggar, a man without a name. He tried introducing other women to Giovanni, in the hope of creating trouble between them. He ran tattling to his father with the news that Giovanni was planning to marry an Albizzi.

The news made Cosimo cut off all support, stopping short of removing Giovanni from the army because he knew a public outcry would ensue if he did that. Giovanni was extremely popular both with his men and the Florentine people who knew his origins and felt the ruling dei Medici had treated his son shabbily.

And so Piero the Gouty's evil plotting and jealousy came to nothing. Bianca and Giovanni married and lived in great happiness, although very simply, until his death in battle. But Bianca never forgot the revulsion she felt toward Piero dei Medici, and her resentment at his meanness and unfairness were added to the long list of grievances Bianca had suffered since childhood.

Bianca tells Maddalena she is proud she stood up to Piero dei Medici, Piero the Gouty. Now however, she must put it aside. "For dwelling on such unhappiness and injustice can destroy you, if you let it." She wipes away a tear and embraces her daughter.

"It is unlikely he can hurt us now. His grasp on power is too uncertain. Remember, Giovanna told you he is not loved by his people. And he knows they might rise up anytime and depose him."

As they are leaving the *giardino segreto*, Giuseppe darts in and throws himself on Maddalena's skirts.

"Why hello, Giuseppe. Are you well now?"

"I feel all right, Maddalena, everywhere but here." He covers his heart with his hands and gazes mournfully up at her. "*Mamina* tells me that you have decided to marry someone else, not me, and that you will be leaving."

"Giuseppe, Giuseppe," she pulls him close and hugs him. "You know that I will always love you, but it is true, I have promised to marry someone---Luigi, you remember him. He received the Cross of Valor! So I won't be living here after we are married. But I will always come back to see you, Giuseppe, of course I will. And you always shall have a place in my heart."

"You promise?" he asks, solemnly gazing at her, his beautiful eyes as large as florins.

"Certainly," Maddalena answers, smoothing his dark curls away from his face. "How could I not, when together, we have shared so much?" And Bianca, sitting beside her, feels her heart overflow with love for her daughter. Oh my dearest, I too will miss you, she thinks. But she knows she mustn't dwell on the loneliness. Not now, surrounded by so much happiness.

TWO

The town of Prato is a pretty town, lined with canals which make it ideal for the business of cloth weaving. Fullers and dyers use the waters from the fast flowing River Bisenzio winding through the town to wash and color the wool which is turned into the finest quality cloth by the cottage weavers. The name 'Prato', meaning meadow, is appropriate, since for generations sheep have grazed on the lush grasses surrounding the town, sheep producing a very high quality wool. Indeed, an old saying in Prato declares that if a traveler cares to look beneath the foundation of the city walls, he will find a tuft of wool.

Luigi, on one of his frequent visits, is riding through the streets in a leisurely fashion, for it is an unusually warm day in autumn, with sun and an endless expanse of blue sky overhead. Many Pratese are out and about as well, enjoying what must be one of the last perfect days of the season.

Luigi notes the industry of the citizens as he makes his way. Some of the women have moved their spinning wheels and looms outside to catch the sun and warm air. His progress is punctuated by the whir and click of the looms. The *lanivendoli,* wool sellers, cry their wares from stalls in front of the *cattedrale.* Near the cathedral on a side street his attention is caught by a young woman working at the spinning wheel in the doorway of a modest cottage.

Luigi knows who she is. He cannot be mistaken, the dark hair and olive skin, the frown on her brow. It is Valentina. After all, when they were children, they played together in Fiesole in his uncle's house.

"So it is you, Valentina," he says pleasantly, bringing his horse closer. "I had wondered when I might see you when I learned you were living in Prato."

"Luigi. I did not know anyone from my old life knew I was here."

"And how is it with you, Tina? How is marriage? Are you happy?" Tina pauses before she answers, thinking about his words.

"Happy? I am married to a respectable man. I have a house of my own to look after, more food and clothing than I ever had in my life when I was a servant. Would you not be happy, if you were in my place?" She looks gravely at Luigi.

"Then I am glad," he says firmly. Better not bring up the subject of kinship. She may not know. But in his heart, he knows she must, for Tina is quick-witted. It has always been so, since she was a tiny girl.

"And you, Luigi, what is your life like now?"

"Why I am about to be married, Tina. To Maddalena dei Crespi. Had you not heard?" He is surprised to see a deep flush cover her face. Why could that news have such an effect on her?

"Then she is not marrying the artist?" The awkward question tumbles out before Tina has time to think. She is clearly in a state of agitation.

"No," he answers shortly. "She is marrying me. I suppose you wonder why I am in Prato?" he asks, turning the subject.

"Everyone in Prato knows that," she answers with a laugh, trying to conceal her earlier confusion. "They know you are buying up wool and cloth for the Doni brothers in Florence." She indicates her spinning wheel. "Even I have sold some of my work to your agent."

"And was the price you received a good one?" he asks.

"A fair price," Tina admits, her thoughts racing. So she did love Luigi after all, she thinks.

"Then I congratulate you on your good fortune, Tina," Luigi answers. " I bid you good day."

Luigi turns his horse and rides on. Tina is unsettling as always. Why must these things happen in life, he wonders, hoping fervently Maddalena has not heard the talk about his father and Valentina's parentage. Finding a husband for her, an artisan with property, he reflects, was undoubtedly his father's doing. Who else would have paid such a dowry to get Tina a respectable husband? And how did he manage it so quietly?

Who helped him in making all the arrangements? Not a whisper of the news has reached his mother, he hopes fervently. But someone surely had to give his father assistance. He ponders this puzzling unanswerable. It must have been Signora dei Crespi. She is the one who must have handled everything smoothly, efficiently, silently. *And if she did, Maddalena*

surely knows. His heart sinks. This scandal from so long ago could rise up and hurt everyone in his family, including Maddalena. He hopes it will never happen.

THREE

Maddalena arrives at the Priory to pay a visit to Father Bruno, only to find he has traveled to Cortona to receive a valuable thirteenth century missal for the Priory's collection. It must indeed be a rarity she thinks, to lure him away from his beloved library. She walks toward the sanctuary to have a quick look at Piero's painting, *The Baptism*. It has been many months since the dedication ceremony and she admits she would like to see her likeness once more before her wedding.

In the Graziani chapel she comes upon Mother Scholastica kneeling in prayer and she hastily steps back. As always, Maddalena feels dwarfed by her presence.

"Wait, Maddalena," the nun says, rising to her feet. "I am finished. It is a daily indulgence, coming to look at our marvelous painting, an inducement to worship, is it not so? Its spirituality leads one to prayer, does it not?"

Maddalena blushes, ashamed to admit she had come to the chapel solely to look at her own image in the painting. "Yes, Reverend Mother." She lowers her eyes meekly.

"And is everything in readiness for your wedding?" Reverend Mother asks in a kindly voice.

"Yes, indeed, Mother Scholastica. Luigi and I are prepared." Quickly she gathers her courage around her like a cloak, puts aside her shyness and speaks. "There is just one thing which has not been settled." And she launches into the couple's hopes for Gino. She tells of the visit to Mother Ursula at the Ospedale, her vague response. Maddalena fears they will not be allowed to adopt the boy after they are married.

"Six months is such a long time for us to wait. For Gino to wait," she finishes wistfully, again keeping her eyes lowered. She is unprepared for the Reverend Mother's burst of laughter which erupts in the chapel.

"Maddalena, Maddalena, do you not know Mother Ursula's dithering is legendary? She and I made our novitiates together, so I have known her many years. It has always been so. But hark, there is no one in Christendom whose heart is more loyal to her vows nor devoted to her Lord. Ursula will come to the proper decision in the end. I am sure of it. Whatever circuitous route she may take in the journey, she will keep uppermost in mind this splendid chance for a little one who has lost everything. Do not fear." She smiles at Maddalena.

"Did you know that she has already written to me, telling me of your request for little Gino?" Mother Scholastica peers impishly as Maddalena blushes and shakes her head.

"Yes, she has written, asking me of my opinion, and I have replied to her. Do you want to know what I said to her, Maddalena?" Her voice is teasing. For a split second Maddalena is reminded of the beautiful. smiling face of her late sister, Marta.

"Yes, Reverend Mother," she answers quickly.

"I wrote to Ursula, giving my opinion that *any* child you and Luigi should wish to take into your home would be fortunate indeed. I also suggested to her that you would surely be ready a little earlier than next May to receive the boy." Here she laughs again.

"Oh, Mother Scholastica," Maddalena struggles to curb her feeling of exuberance. "Thank you. You know, Reverend Mother, Sister Marta's last words to me were that Luigi and I should take care of Gino."

"I know, Maddalena. I know." They stand silently together, remembering.

Back at the palazzo, Maddalena no sooner has shared the good news from Mother Scholastica with Bianca than she is brought a letter from Luigi which has just arrived.

Dear Maddalena,

This will be a brief letter as I will be with you in a matter of days. I want to tell you the news that at long last I have found the perfect house for us. The small villa I told you about---the one you refer to as Villa Contenta---belongs to a friend of my Uncle Baldassare.

Uncle wrote to the owner, who now lives in Rome, and he was receptive to the idea that Uncle buy the villa. Now Uncle needs the villa like he needs a talking horse, but he plans to present it to us as soon as the transaction is complete. It will be his wedding gift, he says, and I cannot dream of a finer or more generous one.

The building is sound structurally; he took me there and with the key we were able to go inside and look things over thoroughly. It seems Signore Ciafardini, the owner, received a summons from the pontiff in Rome to manage his staff of scriveners who keep the accounts, and so he has moved his residence to Rome, my Uncle tells me. No doubt he can replicate Villa Contenta on Palatine Hill in Rome if he wishes!

186

The villa is furnished with old pieces which he says we may wish to replace, but at least there will be beds, chairs and tables to begin. We can decide what more we need at a leisurely pace. Best of all, there is a housekeeper, Donatella, who has been at the villa since it was first built, and she wishes to continue. She is too old, she says, to leave Prato. So, my Dearest, it looks like all is working according to plan. Until I see you and we shall speak again of this, I remain, Yours in Haste, Luigi.

FOUR

Preceding the actual exchange of the marriage vows, Maddalena and Luigi have been represented at the *impalmatura,* on the steps of the church. There, in the presence of a notary, agents of the bride and groom witness that all has been conducted according to plan, to the satisfaction of each party. Custom forbids Maddalena's presence at this ceremony, but Luigi was there with his father and Tomaso di Paolo served as Maddalena's agent.

The Sacrament of Marriage of Maddalena and Luigi is duly observed at San Giovanni Battista, with only the principals present: the priest, the couple, and immediate relatives. Then follows the celebration at Palazzo Castellani, the enormous wedding feast.

The only room large enough to accommodate the guests is the ballroom, at the top of the house. The servants seem to fly up and down on wings, caught up in the excitement of the feast. The lavishness of the repast is of a scale seldom seen in San Sepolcro. Cheeses, eggs, capons, chickens, fish, eels, mutton, pigeons, wine, bread, vegetables including salads and various spices have been prepared in delicious ways, including fruits simmered in honey, nuts and spices then encased in a rich pastry and offered with various confits at the conclusion of the meal.

At the wedding feast, *le donora,* the wedding gifts to the bride and groom, are presented. Bed linens, pillows, sheets, towels, table ware, draperies and blankets are offered to the young couple, many emblazoned with the Castellani coat of arms, a white cross on a blue shield, a falcon in the lower left quarter and a hart on the right. One of the most popular gifts is a child's cradle, carved of wood and outfitted with lace-trimmed linens of the finest quality.

Following examination of the gifts, Maddalena is led forward by Bianca and Signore and Signora Castellani. A newborn baby, belonging to one of the servants, is placed in her arms. She removes her shoes and gold florins are placed in each , an ancient custom symbolizing wealth and fertility. She is joined by Luigi; applause breaks out. The customary speeches of congratulation draw to a close, but feasting and dancing will go on far into the night.

*

Early morning, crisply cold but with the promise of warming sun later in the afternoon. Two days past the wedding feast, and Maddalena's trunk is packed and waiting downstairs. Luigi is anxious to begin the journey to Prato. Maddalena slips the mauve cloak over her brown woolen dress, pulls on gloves of the softest leather and descends the staircase.

With Bianca and Signora Castellani escorting her, Maddalena walks outside where Luigi is impatiently standing beside the two horses with his father. Servants cluster around. She embraces Bianca and the Castellani each in turn and is helped to mount her horse. A final salute and they are away, with the cart, heavily loaded, driven by two grooms, following at a slower pace.

As they ride, Maddalena's thoughts are on the villa she has yet to see, which will be their home in Prato. Donatella, the housekeeper, will have everything prepared when they arrive. Luigi has told her the old servant is overjoyed the villa will be occupied at last.

"She assures me everything will be *perfetto*," Luigi adds, his eyes adoring his wife. "There is a balcony outside our bedchamber, did I tell you? We will be able to sit outside in fair weather looking over our olives and grapes as they grow in good Tuscan soil." In the faraway look of his eyes, Maddalena sees the love of his land, a passion shared by all true sons of Tuscany. He will want to stake and tie his own vines, Maddalena thinks.

"Have you mentioned anything to Donatella about Gino?"

"Nothing yet. But she smiled when I asked to inspect the small chamber beside our bedchamber. Cara, I believe she is hopeful for *bambini*." Maddalena smiles, thinking Donatella might be surprised at the swiftness with which Gino appears.

In the fading twilight, after a hard day's travel, they make out the lanterns of Prato winking in the distance. Presently Luigi slackens the pace and they turn into the open gates of Villa Contenta, candles glowing at the windows and torches flaming in the small courtyard. They have arrived at last. Gratefully, Maddalena lets Luigi assist her to dismount from the side-saddle.

"Welcome Signora Castellani, to Villa Contenta." The short, squat hill woman stands in the open doorway to greet them in her harsh yet friendly voice. Beyond her Maddalena sees light and warmth, *home*. There is a wart on Donatella's nose, her teeth are brown and broken, but Maddalena focuses on the kind, dark eyes containing laughter and good feeling, as she urges them inside, first to refresh themselves, then to partake of supper.

In the dining room ablaze with candles, there is a table laid beside crackling logs in a small fireplace. Tenderly Luigi leads Maddalena to a chair.

"First, a hot *minestrone*, then meat and bread and cheese," the old woman says. Maddalena, unused to long hours in the saddle, feels a comfort and ease seeping through her as she and Luigi spoon the soup, partake of the other foods. Beautiful old tapestries cover the walls, making it seem snug and protected against the cold winds which have risen outside. Content, the two sip wine made from Villa Contenta's grapes and look into each other's eyes.

"There will be snow by morning, Signora," Donatella tells her solemnly as she removes the soup plates. Let it snow, Maddalena thinks happily. *I am home at last.*

FIVE

Piero has begun to settle into his quarters in Arezzo. He has taken a suite of rooms in one of the old palaces lining the Piazza Grande, the irregularly shaped square near the Church of San Francesco, where he will be working. Inhabited by two aging and titled sisters (also impoverished), the *palazzo* will provide him with an impeccable address and a serene, if somewhat shabby setting in which to study, sleep and draw.

Daylight is growing short now, approaching Advent, the weather decidedly cooler. Piero arises at dawn, making his way to the church after a makeshift breakfast of warm milk and rolls, determined to catch every minute of light. It is always this way when he is beginning a commission. Filled with energy, an inner excitement, which buoys him along with a powerful creative thrust almost as though he is being propelled airborne, on some invisible cloud. And the technique of fresco suits him well, because he is a master at careful planning.

Actually, the planning of the next day's work, the *giornata*, takes place in his rooms the evening before, after he has finished the simple supper brought by the aging Renata, the spindly servant who matches the sisters year for year, wrinkle for wrinkle. But she is kind, the food, if simple, is well-prepared, and he is content, eager to push aside the remnants of the repast and get on with preparations for the next day. The plaster is applied fresh each day to ensure it will bond permanently with the medium. It is well known in the world of painters that painting on *fresco secco*, or dry plaster, means the paint will soon flake off. Clearly, poor Bicci was out of his depth here, Piero reflects as he works.

The Legend of the True Cross takes twenty panels in which to tell the story. Piero sighs, knowing that his considerable powers to create a logical, reasonable composition will be tested to the limit. *Ah, but if I succeed, it will place me at the top of my field.*

Boosted by a new resolve, he returns to his drawings before him. In the flickering light of the room's one candle, Piero's enthusiasm for his vision soars, and he is happy, lost in the clutter of notes and drawings spread over his desk.

In the panel of *King Solomon and the Queen of Sheba*, he will create an interior of the fabled ruler's palace worthy of such a man. Rich porphyry on the walls, marble beams and columns framing the interior space, the figure of a ruler whose face shows wisdom and strength, a Queen whose beauty and grace are unequaled in the ancient world, matched by her intelligence and perception. The Queen of Sheba's vision tells her that the wood of the little bridge over the River Siloam leading to Solomon's palace, is crafted from the wood which will be used to crucify the promised messiah. She knows she must plead with King Solomon to subvert this travesty. Piero pictures in his mind the scene at the little bridge, the beautiful queen and her retinue, pausing to reflect. Ah, it will be a masterpiece, he thinks.

It goes without saying that the tall, statuesque queen will look like Maddalena. In Piero's mind Maddalena has become the ageless model for graceful womankind. He seems powerless to help himself.

In an adjacent panel, the scene shifts forward, centuries after the crucifixion has taken place, to *The Discovery of the True Cross.* In this scene, Helena, mother of the Christian Emperor Constantine, is on a quest to discover the burial place of the wood of the true cross on which Jesus died. Piero will place Helena, who could be a twin of the Queen of Sheba so similar are they, in front of a perfectly designed Renaissance church, a church which might have been designed by his friend, the architect Alberti.

In panel after panel, Piero is applying his love of calm and order to his world of color and light. And the Queen of Sheba and Helena could be sisters of Maddalena.

Late into the night when the candle burns low and the menacing shadows it casts become phantasmal, Piero rubs his burning eyes and straightens his sore back. He stands up, exhausted. Now, he thinks, thanks to exhaustion, I can find peace in my sleep.

SIX

1460

Gino is growing into a fine young man, Maddalena muses, watching him playing below from the balcony of the Villa Contenta. He is growing tall, like Luigi, but unlike Luigi, his hair and eyes are brown. He possesses a love of books and learning, making her wonder about who his birth parents could have been. His appetite for learning surprises even Signore Cianci, the tutor who comes each day to instruct him.

Maddalena winces as a sudden pain grips her abdomen. The baby is kicking again. Praise the Blessed Virgin, soon it will all be over! Getting about the villa is proving more difficult than she ever dreamed. Without Donatella's help, she would be virtually immobile. And Elizabetta's birth four years ago was such an easy one. Fondly, she glances at the child, quietly playing with a doll at her feet.

Gino, on the hillside, is boisterously conducting a game of Knights and Soldiers with Ricardo, the gardener's son. A year or so younger than twelve-year old Gino, Ricardo follows him about like an adoring puppy.

"Charge, Brave knights," Gino cries. "Forward into battle knowing you will be the victors, for your cause is just!"

They charge the imaginary enemy on their stick horses, olive-branch swords raised high, racing among the terraced rows of vines already developing swelling clusters of hard green grapes. They climb steadily up the hillside and soon disappear from sight.

The servant Donatella appears on the balcony, bringing warm milk with a touch of cinnamon and honey to Maddalena.

"Your mid-morning cup, Signora. And two letters which have only just arrived. Will Signore Luigi be coming for the midday meal?"

"No, Donatella, he must journey to Florence this afternoon. He will leave directly from the warehouse to save time, but he will return late tonight."

Luigi is almost too busy, she thinks, sipping the warm milk. The success of the Prato cloth venture has surprised the Doni brothers; even Luigi is amazed. More cloth is being produced in Prato now than at the factory in Florence. But the distribution of the cloth is still handled in Florence, where the greatest number of buyer-merchants reside. How long Luigi's hours sometimes are. But she is careful not to complain.

The scene before her eyes from the balcony is a beautiful one for mother and daughter to contemplate. Elizabetta, however, is engrossed in changing dresses of the new doll, a present from her father. Maddalena smiles at her. Long straight blond hair falling down her back like placid waters of a stream. Blessed with a smooth forehead, golden brows to match her hair, a small, rosy mouth and dimpled cheeks, Elizabetta has Luigi's heart twisted around her tiny fingers. She is a charmer. Maddalena is grateful for Donatella's wisdom to aid in keeping Elizabetta in check.

Lazily she contemplates the land surrounding the villa. The rows of vines and olives shining silver in the sunlight on the terraced hillside; dark, green cedars framing the rear of the house. She breathes in the aroma of wild fennel and mint thinking, truly, we live in a paradise.

Luigi's painstaking husbandry has turned the villa into a showplace. Ten years of work it represents. Idly she picks up the two letters Donatella has brought. One from Bianca, the other, written in an unfamiliar scrawl. She opens Bianca's letter first.

Dear Maddalena,

I hope you are not feeling ill. Confinement can be such a trial. However, it will all be over soon and the child will have arrived. I pray for you and the child daily. I know Luigi and Donatella will look after you carefully.

There is exciting news, but I think if you consider, you surely have known that Tomaso and I care for each other and have for some time wanted to be wed. In a fortnight we plan to marry quietly. The Castellani have found a housekeeper, a much younger woman, so at last I am free to go. Tomaso has presented me with a beautiful ring made of pearls.

We plan to take our vows at the Priory of San Giovanni Battista, just as you and Luigi did. Father Bruno, Mother Scholastica and Signore and Signora Castellani will be present. Then we shall leave at once for Arezzo and Tomaso's farm near there.

I find this decision, so long awaited, is bringing me much happiness. Tomaso's loyalty and respect for my wishes have done him honor. He is a worthy man, just and kind. And

Maddalena, I want you to know I do no dishonor to your late father in giving my hand to Tomaso. Giovanni will always have a cherished place in my heart. Tomaso understands that.

Please give my affection to Luigi and to darling Elizabetta and Gino. Tell Luigi his parents both are well. I hope that Tomaso and I may come to Prato soon after I am settled in Arezzo. Of course were it not for your confinement, I would want you here to witness our vows. But it is better this way. A quiet wedding. Your loving mother, Bianca

The letter drops to her lap as tears of thankfulness fill Maddalena's eyes. Bianca will no longer feel lonely. She has hoped for so long this might happen. Bianca's loyalty to Signora Castellani would have forbidden her leaving in haste; now that a replacement is secured, she is free to go. She takes up the second piece of parchment, folded and sealed with a messy blob of wax spattering the outside. Her name and address are barely legible in the awkward scrawl. Who can have sent it?

Dear Maddalena,

Do you remember me? I too live in Prato , and I would like to meet with you as I am very lonely here. Would you permit me to call on you? Your Obedient Servant, Valentina Datini.

A smile hovers on Maddalena's lips as she reads the closing, "Your Obedient Servant." As if Valentina ever obeyed anyone when she was a servant! Her laugh startles Elizabetta and she quickly looks up at her mother. Maddalena absently pats her head as she recalls Tina, the tempestuous serving girl, always upset and resentful about something. No wonder the Pratese women have not scurried to her doorstep to offer friendship.

Perhaps they have heard rumors that she was a servant before her marriage, or that her parentage is not what it should be. Tina may be lonely, but what could she do? Better ask Luigi about it before doing anything, she decides. She will talk it over with Luigi when he returns from Florence. So Tina has learned to read and write. She deserves credit, Maddalena thinks, tapping the parchment against her cheek.

But when Luigi arrives back from Florence, Maddalena has fallen asleep. When she awakes the next morning the message from Valentina, pushed to the back of her mind, is forgotten. She is sure her labor pains are beginning.

SEVEN

Marta Bianca Giovanna Castellani. The name has a musical sound.

Luigi sits at his desk in the little library of the Villa Contenta and writes the name of his newborn daughter on the parchment in front of him. She is like a little flower, a rosebud, he thinks fondly. How lucky he is! The *bambina* has arrived safely. Maddalena, although exhausted, has been tidied and put to bed by the midwife, who assures him she will be fully recovered very quickly, God be praised. Who would have thought one man could have so many blessings, two lovely daughters of his own.

There is also Gino, the apple of his eye, whom he loves as fiercely as he loves one of his own blood. Gino, the little foundling of the flood, now growing toward adulthood with the sturdiness and grace of a young oak tree. And a mind as bright and brilliant as a gold florin. Any father would be proud of him, Luigi thinks lovingly.

He turns his thoughts back to his ledgers on the desk. Since Maddalena and he were wed, he has become a merchant, and a very good one, a Merchant of Prato. Strange, the turns one's life takes. His father, wishing for him the life of an idle gentleman, living off the wealth of a wife's dowry. Instead, he struck out on his own, married the woman he loved, and has been successful beyond his wildest dreams. Luigi is lost in a moment's reflection.

His job has become the marketing, not only of cloth, but of other merchandise as well. Expanding Doni interests are exporting and importing rich clothing, spices, jewels, works of art, armor, foodstuffs, wine, in short, whatever the trading world demands. Pilgrims' robes from Roumania, English wool from London and Southampton, leather from Cordoba and Tunis, wheat from Sardinia and Sicily. How far-flung their nets! Exports are traveling to London, Paris, Bruges, Nice, Arles, Perpignan, Aigues Morte, Lisbon, Rhodes, Alexandria and Tunis. Who would have imagined, a few years or so back?

Luck has played a part, but Luigi admits he has a gift for hard work, for choosing honest *fattori*, managers, for employing industrious, honest *scriveners* to keep the accounts, for

encouraging loyalty among his agents who admire him because he is fair, generous and trustworthy. They repay him with hard work. He reflects on the decision to broaden the firm's trading interests, at his recommendation, by Alfredo and Matteo Doni.

They showed their belief in him by making him a full partner in their enterprise, even after he angered them when he refused to deal in slaves. His convictions were firm, he would not relent. He simply could not trade on misery in the bondage of one human being to another. In the end, they respected him for it, even came to agree with him, although for many merchants the buying and selling of slaves proved to be a profitable business.

One aspect of his new job he has not foreseen is the necessity of so much letter writing. His desk is stacked with letters from his distant managers, and he answers each one promptly and carefully. A fortnight past he was awake all night writing letters. Letters written in Latin, Greek, English, Flemish, Catalonian, Provencal and a few in Hebrew and Arabic. Whew! He did not realize when he finished his schooling he would become a scholar all over again!

But it stands to reason: if there is flood or famine in Flanders, for example, his agent will quickly let him know so he can supply what is needed---grain, oil, wine. A pope's election, the marriage of a prince, all can be important clues to a subsequent demand for the merchant who is alert. Should war break out on certain borders, his *fattori* notify him promptly and he ships weapons from Toledo. That is why military weapons and armor and wheat harvests and the finest *Chianti* from San Gimignano are all of great interest to Luigi Castellani.

What is it he read just recently? The quotation from Leone Battista Alberti, the architect and owner of one of Florence's large trading companies. Something along the lines of "It benefits a merchant to have ink-stained hands." Well, he can agree with that he thinks, looking at his ink-mottled fingers. Is not this the same architect Alberti who once was working in Urbino with Maddalena's Piero della Francesca? He frowns.

And just what goes into the makeup of a good merchant? In a somewhat lethargic and reflective state of mind due to relief at the safe birth of his little daughter Marta, he ponders the question. First and foremost, the mind of a Tuscan merchant of the fifteenth century is filled with piety, conventional in expression, but deep in feeling. That is most important.

Next, he must have a shrewd appreciation of the value of the world's goods, coupled with a natural sense of moderation. Finally a belief, almost equal in intensity to his religious belief, in the supremacy of *la famiglia*, the family, a deep conviction that all of a man's labors are fruitless if he has no heirs to whom he can transmit what he has earned. Luigi, pleased with this rare bit of self-analysis, locks up his papers and prepares to visit his wife and new daughter.

He must not let his work overwhelm the most important facet of his life, his family. And that includes his parents also. Soon he will travel to San Sepolcro, to tell his mother and father of their newest grandchild. He sighs, wondering if he and his father will ever feel easy about what lies between them? The knowledge that Luigi has a half-sister, living in Prato. A half-

sister not recognized by his father, and completely unknown to his mother. Life, he reflects ruefully, is never simple.

EIGHT

Tomaso di Paolo is paying a visit to the Church of San Francesco in Arezzo. Work on the frescoes, *The Legend of the True Cross*, by the artist Piero della Francesca has gone on for several years and Tomaso, who enjoys looking at art, has kept abreast of progress. Tomaso is finding the final two weeks before his marriage to Bianca creeping by slowly. They have waited for so long. Perhaps a visit to the frescoes will speed the hours of the crisp autumn day.

He enters the sanctuary early, along with a trickle of women, most of them elderly, who process in and out of the church door, coming to make their devotions. Tomaso hurries into the Cappella Maggiore where the frescoes cover the walls. The vault of the choir is vast, forcing the artist to climb high scaffolding in order to complete all the panels. But the upper reaches are now finished. The final work to be done remains only on the lowest tier of the choir walls. And today, the artist is not at work.

Tomaso, a former soldier, has a special interest in the battle scenes, one the battle of the Christian emperor Constantine and Maxentius, the other the battle between Heraclius and the Persian emperor Chosroes, who has profaned the wood of the cross by turning it into his throne. The two battle scenes face each other on the narrow side walls of the chapel.

Also on the lowest tier, on an end wall, is a small, beautiful night scene of the emperor Constantine sleeping, entitled *The Dream of Constantine*. This small panel draws the attention of Tomaso. Oblivious to time as he looks at this work, he is transported to another place when once before a battle he saw a scene similar to this. It is uncanny! Truly the work with its subdued coloring, the contrast of light and shadow, approaches reality as much as any work he has ever studied.

"So you came to look at the frescoes, not to pray?" a voice behind him asks, a voice low yet resounding, good humored.

Tomaso whirls around. He has not heard the man approach.

"Yes, Signore, I have come to look, although I have nothing against praying." The stranger smiles as Tomaso continues, "I think this painting is sublime. I only wish I could know the story." The wistful quality in his voice moves the stranger.

Tomaso studies the stocky man beside him who has appeared out of nowhere and begins to speak with such conviction. His curly black hair showing threads of gray forms a halo around his cap. His tunic is fashioned of a fine wool, but is somber in style. Tomaso is struck by the feeling of sadness in his eyes, a melancholy. Who could he be? This man has known unhappiness, he thinks, listening raptly as he begins to speak.

"The scene is taking place two hundred years after the death of Christ. On the eve of the Battle of Milvain Bridge, an angel appears to Constantine in a dream---see, there is the angel, he is above the upper left of the tent---and foretells that he will be victorious over Maxentius in the sign of the Cross. See, the light coming from the angel illumines the scene, the solidity of the pavilion where Constantine is sleeping, watched by a seated servant and two sentries, one seen from the rear, the other from the front. They are the *coulisses*, the lead-in figures if you will, to the depth of the painting." He pauses, reflecting.

"Two other tents cast dim outlines in the night sky. This is a scene of an army on the move, tents pitched for a night's rest before tomorrow's big battle. The supernatural light coming from the angel overhead who brings the message fills the space with the magical silence of the night."

"Yes, I see it! Truly I do." Tomaso's voice is enthusiastic. "Even though I have never before in all my years seen a scene of the night in a painting. It is a marvel.

"You see, Signore," he continues shyly, "I am a soldier. I *know* about soldiers, and battles too, for that matter. The fighting and dying men, the horses, the lances, I can tell you, the man who painted these things must have been a soldier. I am sure of it."

The stranger seems well pleased with his words. He nods approvingly.

"Take these two sentinels guarding the tent," Tomaso continues, his enthusiasm running ahead. "They could have come from my own company, they are so like soldiers I remember."

"So many years it has taken, to come to the finish of it. I wonder, has it been worth it?" The stranger's mood moves in another direction, he is speaking to himself, barely above a whisper.

"I beg your pardon, Signore?" Tomaso does not understand.

"The frescoes are almost finished now, but it has been hard, extremely hard, on the one who painted them. Every setback, every discouragement, a rambling, incoherent tale to tell..." The stranger lets his voice trail off.

"But surely Signore, great deeds are born of great struggles; in war, in painting, nothing achieved is easy." Tomaso gestures with upturned palms. The stranger sighs, satisfied.

"Some things one recovers from," he resumes, still speaking as though to himself. "Hard work one recovers from. Other hardships, hardships of the mind, are like a physical deformity. They remain forever." The stranger has become withdrawn, secretive. Suddenly his spine stiffens, a mask drops down over his face and he turns to leave, first looking behind him as though wondering if he has been overheard by anyone else during their conversation.

"I bid you good day, Signore," he says courteously, quickly turning his back on Tomaso and marching out of the chapel, out of the sanctuary, into the street.

"What can be the meaning of that?" Tomaso wonders aloud, somewhat confused by the stranger's behavior. An old woman wearing soft slippers and an apron over her dark skirts, shuffles into the Cappella Maggiore and begins scouring the marble floor with her bucket and brush. Tomaso approaches her.

"Do you know the man who just left here, Mother?" he asks respectfully.

"Si, Signore. Did you not know? It is the artist, Piero della Francesca. It is said that these frescoes by him will make Arezzo so famous that someday people will journey here from all over the world to praise them."

Tomaso is astounded. The artist himself! And Maddalena's former suitor! But I did not guess, he was not wearing a smock, holding his brushes! His eyes are filled with wonder, and sympathy for the man who seemed, in some strange way, to bear the burdens of the world on his wide shoulders. He can believe, can Tomaso, that the old woman is right. One day, people from all over the world may come to praise these works.

<p align="center">*</p>

Ah well, Piero thinks, leaving the Church of San Francesco. If I helped that soldier understand a bit of what I have tried to do, it is worthwhile. Especially as he had no idea of who I am.

The idea of anonymity appeals to Piero. Not that he could ever be accused of self-promotion of his work. Oh no, leave that to the hawksters like Domenico Veneziano, Ghirlandaio and the rest. He scowls darkly, walking toward his suite of rooms in the faded palazzo on the Piazza Grande.

I'll be leaving here soon. going to the little hamlet of Monterchi between Arezzo and San Sepolcro, where my sainted mother Romana was born. They want a painting of the Madonna as protector of all pregnant women. Well, they shall have one. And what a painting I have already in my mind. It will be shocking, but unforgettable, and a perfect devotional image.

Monterchi will be sought out because of it. And then? What will I do next in this lonely, gypsy existence I lead?

A brief time in San Sepolcro perhaps? Checking to see that Lucia is running the household right, then it is high time for me to return to Urbino. I have not yet painted the diptych of Federigo and Battista da Montefeltro as I promised. There is much work to be done on my treatise on perspective, *De Prospective Pingendi* which I have decided to dedicate to Federigo da Montefeltro. Still, should the Pontiff beckon from Rome? He gives a wry smile. Maybe that honor will one day be accorded to me. There is still time.

On this hopeful note, he turns into his lodgings. Could the soldier he met at the frescoes this day have been right? Do great deeds in painting as well as in war beget eternal fame? Perhaps these frescoes may survive as my enduring legacy after all.

In his heart of hearts, Piero keeps his thoughts of Maddalena under lock and key. On reflective, spontaneous moments, they are likely to escape. This is one of those moments.

Is she well? How does she fare? Does she ever give one tiny thought to me? Only one? The longing overwhelms him and he feels tears welling in his eyes. With a great will, he forces himself to think of Monterchi and the Pregnant Madonna, the *Madonna del Parto,* his next commission.

NINE

Donatella, her lips drawn into a thin line, informs Maddalena she has a visitor below. "A Signora Datini is calling," she announces, a look of displeasure spread over her homely face.

Maddalena frowns. Who can it be? The name is unfamiliar. Then, in a flash of recollection she knows. It is Tina! Guiltily she recalls the poorly scrawled note, the one that arrived just before Marta's birth. She has forgotten all about it.

"Oh dear." Her eyes roam the chamber, cluttered with bonnets, blankets, towels, the disarray created by babies. "Show her into the *salone* please, Donatella. I will be down as soon as I can." She looks at the sleeping child, snug in her cradle as she makes a hasty toilette, then hurries downstairs remembering what Luigi has always said: Servants are the most snobbish people in the world. But why should Donatella look so displeased? What could she know about Tina?

She enters the room, looking carefully at the woman sitting on the chair's edge, nervously twisting her fingers. Tina has changed. She is plumper, much better dressed, but her hair is streaked with gray. There is a frown over the dark eyes and brows. That frown, spoiling her pretty face, has not changed, Maddalena thinks, going up to Tina to take both of her hands.

"Tina, it is good to see you." She notes the simple, dark velvet dress, the handsome red leather *scarpetti*, delicate slippers, and the ivory combs holding back her hair. She is enveloped in a beautiful cape which covers her from the chill winds. She is still a very handsome woman.

"I simply had to see you, Maddalena." Tina gets to her feet quickly. The dark eyes are imploring.

"You see, Maddalena, I am so very lonely. These Pratese women," she glances at the closed door beyond which she is sure the old witch of a servant is listening. "They do not accept me.

203

It is as though I came here, stole one of their men. It has turned out that Guido and I, we are happy together. They do not like that." The dark eyes turn stony. Ah, Maddalena thinks, that look like a gathering storm on Tina's face, that I remember.

"But your husband," Maddalena murmurs, embarrassed, "Surely his influence..."

"Guido is a carpenter. He works long hours. Do you suppose he wants to hear me complaining when he arrives home, weary and hungry? No, Maddalena, all he wants is to be served plenty of pasta, several goblets of wine, then he is ready for bed. He is a kind man, and I love him, but there is no help there."

"I see," Maddalena says in a small voice. Now what can I do? Think, Maddalena. Remember your mother, Bianca. She would be prepared to be helpful. Oh how I wish I had talked this over with Luigi.

"Well, Tina, I am glad you are here. You see, I received your letter the day before my daughter was born. In all the confusion since then, I had forgotten."

"You have a new baby?" Tina's eyes shine. "Oh, Maddalena, may I see her?" And indeed at that moment Donatella, with hardly a tap at the door, sails into the room bearing a sweet-smelling Marta dressed in a fresh, lace trimmed gown and bonnet and clutching a silver and coral teething ring in her tiny fist, an early present from her proud father. Donatella holds the child firmly, as though she has every intention of remaining in the room.

But this will not do, Maddalena thinks. Tina and I must have privacy. She motions for Donatella to bring the child to her. "Perhaps you would see to Elizabetta and Gino, Donatella, while I visit with Signora Datini?" She smiles sweetly at Donatella as she takes her leave, Donatella wearing a sour look on her face, not in the least deceived that she is being banished.

"Old crone!" Valentina bristles after she has gone. "She only wanted to hear what we are saying. See how these Pratese women look down on me? If I lived here a hundred years I would still be an outsider." The frown returns to her brow.

"Oh, come now, Tina. It can't be that bad. Come here, see Marta. Look, she is waving to you."

Tina hurries to her side and indeed, Marta is wildly waving her free hand. The other is still curled around the ring. Tina touches the hand with her finger and Marta's fingers close around it in a vise-like grip.

"Maddalena, look! See how strong she is. And she took my finger straight off. She must want us to be friends." Tina's face is transformed. The hard look, the frown disappear. Maddalena senses her outpouring of love.

"Here," she says, holding up the baby. "Hold her, if you wish." And Tina enfolds the child lovingly in her arms. Maddalena asks softly, "Tina, do you not have children of your own?"

"No, Maddalena." She lowers her eyes "I have not borne a child. Guido is so disappointed, but I know now it will not happen. We shall never have a child. I am being punished for my misdeeds. I am sure of it."

"Nonsense, Tina. You must not think that way. There can be many reasons why couples do not have children. You must not blame yourself. And Tina, you are still young. Do not give up hope. Tina, her finger still held in an iron grip by the baby, looks unconvinced.

Maddalena compliments Tina on her beautiful dress, the red shoes, the cape. Tina's eyes light up and she is pleased.

"I earned every florin I spent for them myself," she says proudly. "I spin and weave, you know. Surely Luigi told you? I have been selling my work to Luigi's firm for many years. Before you arrived in Prato, I saw him one day when he passed my house. I was outside with the wheel, and he came up to me and we talked. Did he not mention it to you?"

Flustered, Maddalena murmurs something to the effect that she must have forgotten. But it weighs on her mind. Luigi did *not* tell her about seeing Tina. Why? She must ask him this very evening. But as she visits with Tina an idea is taking root in her mind, an idea that might erase some of the misery on Tina's face.

*

"I know you are not asleep, Luigi. Why will you not speak to me about Tina?"

Maddalena and Luigi are lying in the big bed in their chamber. The household is slumbering: Gino, Elizabetta, Donatella in her cubbyhole room under the stairs. Marta lies sleeping in the little cradle beside their bed. The *capoletto* or tester above the bed is hung with fine woolen cloth, the finest Luigi can obtain. The coverlet of velvet is richly embroidered. The walls of their chamber and the ceiling are painted blue with a pattern of gold stars. It is a beautiful room, suitable to display the most important piece of furniture in the villa, the bed.

"Do you hear me, Luigi?" Maddalena asks again. "Tina came to visit today. Do you not wish to hear what she said?" Patiently she awaits Luigi's reply.

"Maddalena, Tina left the employ of my father over ten years ago. She is settled, she has a husband who supports her. Why should I worry my mind with thoughts of Tina now?"

"I thought you would be interested in her well-being, for she once was close to you."

"We played together as children. That was many years ago."

"Luigi, I know the whole of it." Maddalena acts on impulse, girds up her courage, pulling the covers up close to her chin. "I know you and Tina are closer than playmates." The silence spreads over the room like the stillness of a snowfall in winter. Only a contented sigh from a sleeping Marta in her cradle floats on the air.

"And what do you know?" Luigi's voice is hard, not the loving voice she expects.

"I have known since before we were wed that Tina is your half-sister, Luigi. I have always wondered when you would tell me."

"All right, so you know. What is there to be said about it?" His voice is curt, biting.

"Luigi, Luigi, do you think I blame you for this? Do you think it makes one whit of difference about what I feel for you? Of course not. The oceans will dry up before I lose my love for you. I just thought you would want to know how Tina fares. Since she is your half- sister." Luigi sighs heavily and sits up in the bed.

"Cara, forgive me. I have dreaded this moment for years. I wanted to protect you from this, this stain. I had hoped Tina would use common sense and keep away. But she has not."

"But Luigi, surely she should feel free to come to us, when she has no other family to whom she can turn?" Maddalena's voice is soft in the darkened room.

"So what is it now?" Luigi asks wearily. "Why is she miserable?"

"She is not totally unhappy. She and her husband care for each other, she is grateful for her position, her house, the fact that she can earn a little money through her weaving. But she is miserable because the women of the town will not accept her. She feels they resent an outsider coming in and marrying one of the local men. And most importantly, Luigi, she and Guido have no children. They cannot conceive. This, I believe, is most painful of all to Tina."

"I see. And do you think having her call on you will win over the ladies in Prato? No! It will only give credence to the tales of our kinship which must already be seeping out of the mouths of the local gossips. All that I have worked for you and our children will be swept away on a flood of lies, innuendo and rumor. I cannot stomach it! Look at your very own father, Giovanni."

Shocked, Maddalena reflects on Luigi's burst of anger and how deeply he feels about this family disgrace. Is there nothing she can do to persuade him differently?

"Luigi, my father was not hated. It was the dei Medici who were hated, first Cosimo, because of the shoddy way he treated his own son, then Piero, Cosimo's son and heir, because of his jealousy and cruelty toward his blood brother. No one, not even the Pratese, will blame you

for Tina's misfortune. But I repeat, she has no one else to turn to for help. We are strong. Surely our family and our love can embrace a kinsman who is miserable. Surely we can give her love and understanding. I should think that would help your position in the town. After all, unexpected children are not unknown in *Toscana*. Both of our families have experienced this."

Another long silence. "Maddalena, you are right, of course, as you usually are right. I have been a fool. It will not be easy, but I will try not to resent Tina. Give her what comfort you can. Let her call when she wishes. In time, perhaps I can change. I am ashamed of my feelings, but I cannot help myself."

"Luigi, Luigi," Maddalena turns to embrace him. "Do not be sad. How much we have to be thankful for, it is a miracle. You are a good man, Luigi. You will not regret this, I promise you will not. And maybe, just maybe we can help Tina." Maddalena closes her eyes, content. "Go to sleep now, Luigi."

TEN

Bianca and Tomaso, newly wedded, have arrived at Villa Contenta to pay homage to their infant granddaughter, Marta, and to visit Maddalena and Luigi. Later, Maddalena and Luigi plan to travel with the children to San Sepolcro for a visit with Luigi's parents, who are growing old and infirm and fear such a journey would be too tiring for them.

Maddalena and her mother are sitting on the balcony with little Marta sleeping in her cradle in the chamber behind them. Bianca is thinking how happy her daughter looks, surrounded by her family. Luigi was the right choice, she admits, the right choice for Maddalena.

Maddalena steals an occasional glance at her mother. Why, she is looking years younger! To be loved and cherished by a good man like Tomaso is erasing years of hard work and loneliness from her mother's face. She begins telling Bianca of Tina's visit.

Bianca frowns. Surely bringing Tina into their lives will end in trouble, which seems to follow Tina wherever she goes. But as Maddalena continues telling her of the slights and snubs Tina has endured from the women of Prato, their jealousy of her good fortune, and Tina's sadness at her failure to bear a child, Bianca's face softens.

Povera ragazza," Poor girl, she murmurs.

"But Mother, I have an idea of how we might help." Maddalena's eyes sparkle. "Why could Tina and Guido not adopt one of the children from the Ospedale degli Innocenti in Florence? Like Luigi and I did."

At first Bianca is silent, thinking it over. "It might be possible, if the couple is willing. Even though there is a foundling hospital in Prato, and as you know they are all over Tuscany, it might be more desirable to obtain a child from another place. No strings would be attached that way, and gossips would have nothing to spread about."

Maddalena quickly agrees. Her mother's impartial, considered judgment is unfailing. "You might ask Giovanna Doni to intercede, of course," Bianca murmurs. "Since Sister Ursula has died, there is a new Reverend Mother. Giovanna will know her. She could smooth the way."

"What a splendid idea, Mother, but first we must seek the approval of Tina and Guido Datini. That may not be easy. Some men may feel threatened, giving their name to an abandoned child. But when all obstacles are removed, then I will ask Giovanna for help."

The women are joined on the balcony by Tomaso and talk turns to other topics. He begins telling Maddalena of his chance encounter with Piero at the Franciscan church in Arezzo, of his conversation with the unknown man in front of the frescoes, whom he later discovered had been the great artist, Piero della Francesca.

"I thought he was just another onlooker, like myself," Tomaso smiles, "especially as he was not wearing the paint-spattered clothes of the artist."

Maddalena laughs. "That must have pleased Piero. He loves the idea of being the invisible observer. Receiving information rather than imparting it. He relishes a role behind the scenes. Did he seem happy?"

Tomaso takes a minute to reflect. "Yes, he did. There was relief, because the work is nearly finished. Pride. Satisfaction, yes I could see all of that in his face, now that I think about it." He does not mention the sadness he noticed in Piero's eyes. Why upset his lovely new daughter-in-law?

*

Tina, when she is approached by Maddalena and Luigi with the idea of obtaining a foundling child from the Ospedale, explodes with one of her tantrums. The two let her rave on unchecked while they wait quietly. Finally she sputters to a stop.

"You know, Tina, our son Gino came from the Ospedale degli Innocenti in *Firenze*. He is one of *i gettatelli*, the castaways, in a sense, because the flood made him an orphan. There are many others like that." Luigi's voice is quiet, thoughtful. "All children need good homes, the love of two parents."

Tina, wiping her eyes, looks subdued. "Gino is a wonderful son, Luigi. Any parent would be proud of him. I, I meant no disrespect." Maddalena takes Tina's hand.

"My cousin, Giovanna Doni, is a frequent visitor to the Ospedale. She helps out there. She could assist us in finding a suitable child, that is if you and Guido approve." The only noise in the room is the loud ticking of the French clock, Luigi's pride, recently arrived in a shipment of luxury goods from Paris.

"Guido mentioned the possibility of taking a foundling child long ago. Some time back, he suggested this. I, I flew at him with harsh words, saying I was not interested. I was afraid of all the talk. The women here..." Tina's eyes implore as the tears run.

"There, Tina, do not cry. It is different now. You have Luigi and me to lean on. What the women say won't matter. Building your family is more important."

"I do want a child." Tina says. "More than anything in the world, and if the only way I can get one is by adopting one of *i gettatelli,* I would like your help."

Monterchi/ Prato/ Urbino/ Firenze

ONE

Spring arrives late in Tuscany and Valentina and Guido Datini are going on pilgrimage. Guido has heard of a devotional image, *The Madonna del Parto*, the pregnant Madonna, in the little hamlet of Monterchi, which is causing many barren women to conceive. It may be possible that his wife will be blessed. Guido, a quiet man, does not express himself often, but he is a firm believer in the miracles of Our Lord.

He sits solidly astride the horse, his great, muscular carpenter's hands firmly grasping the reins, his bald pate fringed in neat brown hair, his cloak drawn tight about him, giving him the appearance, at least on horseback, of a priest, except for his wife seated side-saddle behind him. Tina, frowning, hangs on, grasping his waist tightly

She suffers great guilt and shame because of her childless state, and is outwardly skeptical, but deep inside she is praying for a miracle as they jog along on the rented mare toward the little village of Monterchi.. The process of obtaining a foundling from the Ospedale in Florence is taking rather longer than they had hoped, since Guido is determined the child shall be a boy.

Because of Guido's work, the pilgrimage must be a quick one and when they finally arrive, Valentina feels weak with exhaustion. She grumbles to Guido that the little chapel in the cemetery where they find themselves seems an unlikely place for a venerated, miraculous shrine. Guido, although silent, has also expected something grander and more impressive.

"Are you sure, Guido, that we have come to the right place?" Valentina hisses, slowly slipping off the rump of the mare where she has ridden all the way behind her husband. A few pilgrims eye them suspiciously as they approach, half stumbling, because their legs feel numb and cramped from the long ride. Guido nods, looking at his wife with kindly hazel eyes.

"Yes, yes, I am certain," he says patiently, the voice of a man used to the sharp questions of his spouse. "The village is really only a hamlet." A handful of houses surrounded by large, well-tended wheat fields and neat, bare-looking vineyards. He sighs inwardly, a man of few words, but his voice is full of understanding as he answers Tina. He knows her barrenness has caused her great shame.

Once inside, they come face to face with the fresco, fitting perfectly into the little chapel's apse. Piero della Francesca has created a fresco of a circular damask tent, matching the architecture of the apse, side draperies pulled open by two powerful angel figures. The figures are identical: intelligent, thoughtful looking, their hair springing vigorously from smooth foreheads over heavy-lidded eyes. A tall Madonna of Hope, motionless, stands in perfect dignity between them. One hand rests on her hip, her right hand touches her womb, clearly visible under the unbuttoned gown. The ceremonious solemnity of the three figures renders this startling image one of deep veneration. In Mary's halo, shining reflections of the floor tiles, arranged in careful perspective, can be seen. The entire composition has been thought out with precision, logic and clarity. Even the Datini couple, lacking both a knowledge and an awareness of art, falls silent at the sight before them.

Time passes unremarked as they stand in hope before the image in the small chapel crowded with strangers. No one speaks. At last, Valentina and her husband slip quietly away. They will spend the night at Monterchi's only hostel, which will be crowded, ill-smelling, crawling with resident vermin, serving inedible food at exorbitant prices. But the memory of what they have seen and felt will cover them like an insulating nimbus, rendering discomfort and repugnance powerless to rub out that searing image of *The Madonna del Parto,* the pregnant Madonna.

If by chance Tina and Guido should overhear some of their fellow guests at the hostel that night mention the name of the man who painted the frescoes, it would mean nothing to Guido, and perhaps Valentina herself has forgotten the name of the artist Maddalena almost married, Piero della Francesca.

But in the middle of the night, lying on the filthy straw mattress as she recalls the powerful image of *The Madonna del Parto*, Tina reflects on how very much like Maddalena Castellani Mary looks. Her height, her statuesque, solemn beauty, her fair hair and blue eyes. Yes, the Madonna of Hope resembles Maddalena. Not a youthful Maddalena, but a woman of middle age, a woman who has lived long enough to know what it is like to long for a child and be denied.

The following morning, after a return visit to the little chapel in the cemetery, the couple begins the long journey back to Prato. Tina is silent, putting aside her customary sarcasm, her sharp words. She has been touched by what she has seen, and how it has made her feel.

That evening, bone weary as they stumble off the mare and go inside their house, Tina resists her inclination to collapse on the bed and instead goes into the kitchen and prepares a hot

meal for her husband rather than the bread and cheese she had earlier planned to give him. She sits opposite him as they eat, and her eyes take on a gentle, more loving light, as she realizes she is indeed fortunate to be married to such a good man. It was kind of him to take me there, she thinks, and who knows what blessing may come of it?

TWO

1472

The world of Maddalena comes crashing to an end on the third of November.

Earlier in that year, Elizabetta, now happily married, settles in Florence; Marta begins her novitiate at a church in Cortona; Gino is working in Florence, learning the cloth business at the Doni trading offices. Maddalena, who tries to hasten him toward matrimony at every opportunity, has as yet been unsuccessful in her efforts. Gino has not yet taken a wife. Luigi is far away on business.

Maddalena, on the fateful day, is alone except for Donatella at the Villa Contenta where she is hard at work readying the house for the celebrations of Advent. Luigi sailed from Genoa in the autumn with Alfredo Doni, visiting their agents in Lisbon, Arles, Tunis, Barcelona and London.

The storms that year, since Luigi's departure, have been frequent and violent. Sailors making port tell of floating debris on the roiling waters, wrecked cargoes washing ashore on remote points, circling vultures ready to devour whatever survives from vessels torn apart by the storms, rich caskets of jewels and gold coins lying on the deep and seemingly bottomless ocean floor.

But Maddalena wills herself not to dwell on secondhand reports and rumors which may be false. She has bid goodbye to her husband and his partner Alfredo Doni, confident in the knowledge that they are sailing on the *Good Hope*, a sturdy English ship with a seasoned captain. She has little fear that Luigi will come to any harm, secure in the belief he is about his business, looking after his far-flung mercantile interests.

At the onset of autumn, she begins to suffer nightmares. At first she cannot understand, for they are populated with faceless individuals who bear no relation to anyone she knows.

She awakes shivering with cold, as though having a chill. Later the dreams take on a more sinister aspect when over and over she dreams she and her husband are being pulled apart by unseen forces, powerless to help themselves. She awakens, terrified at the shadows moving across her darkened room as the increasing winds howl and rattle the shuttered windows.

But she is unsuspecting when the letter arrives from the English Trading Company, written on good parchment in a flowing, unknown script, informing her with the greatest sorrow that the ship, the *Good Hope* has met with violent storms in the English Channel and has gone down, its masts toppled, the body of the vessel broken apart by the force of the storm. There are no survivors. All aboard are lost. All cargo is lost.

Maddalena looks at the strange words, written in a language she has never read or understood, yet she comprehends this message perfectly. Luigi is gone. Alfredo is gone. Her world crashes hopelessly around her. She grasps the meaning of the dreams. Weeks ago the *Good Hope* went down. Only now is she receiving word.

At Villa Contenta, the days drag by, colored an unremitting sepia. Bianca writes to Maddalena that Giovanna Doni has taken to her bed, stricken down in grief, and suggests Maddalena go to Florence to help her; indeed, they can comfort each other. Maddalena, hardly mobile herself, is not well enough to go.

Daily her mind rails against the listlessness, the inactivity, so unlike her, yet she is powerless to rouse herself. The efforts of Gino and Elizabetta to help are of no avail. In time, however, the sepia days regain traces of color, numb feelings change to a slow, dull ache, like an ulcer, a sore which will not heal.

Valentina is only one of a stream of friends and neighbors arriving to pay a call. Tina brings her two fine children: Carlo, the boy adopted as a baby from the foundling hospital in Florence, now a handsome young man, and Chiara, his sister, a smaller, pretty version of a young Tina, born soon after her brother's arrival in the Datini household. But on the day they arrive, Maddalena is too weak to greet them. She sends word by Donatella, thanking Valentina for the visit, promising to see them when she is stronger.

On better days, she roams the empty rooms of her once loved Villa Contenta, touching a drapery here, a table there. Even the framed charcoal drawing of Piero's cat Giotto, a treasured possession, fails to lift her from a state of apathy. The beautiful French clock Luigi prized has been stopped, its hands resting at the hour when Maddalena learned of his death. Her eyes avoid it as she makes her rounds. The house has become a prison from which she prays daily for her release by death.

But death does not release her. Release is provided rather by the death of Giovanna Doni in Florence. They say she died of grief, Bianca writes to her. Giovanna, who had no children of her own, bequeaths the Doni villa on Via Ghibellina to Maddalena.

Moving aimlessly around the rooms of the Prato house, Maddalena feels a glimmer of hope at the news. Sadness of course, because she will miss Giovanna terribly, just as she misses Luigi, but she realizes death is what Giovanna has most wanted. Is it possible a move to Florence might lift her out of the pit? She would be able to resume close contact with the Ospedale degli Innocenti. She would be closer to Gino. I must get away from this house filled with memories of Luigi, she cries inwardly. I must get away from Villa Contenta and all that it represents of our life together, mine and Luigi's.

She is amazed at how seamless the transition becomes. Elizabetta is happy to have the great bed with its *capoletto,* the French clock. Marta neither wishes for, nor can she use, any material possessions in the life she has chosen as a nun. Maddalena gives the remaining furnishings to Valentina, who is overjoyed, and the deed to the house is passed on to Gino, to dispose of or to keep as he wishes.

The door is bolted and at last, she and Donatella are in the cart rumbling toward Florence and the Via Ghibellina. Donatella, who declared years ago she was too old ever to leave Prato, will not permit her mistress go off to *Firenze* without her. As they leave Maddalena does not turn her head to look back. It is finished.

In the space of a season the villa begins to waken into life, shining from top to bottom. Walls and ceilings have received fresh whitewash. Tiles and marble floors washed and lovingly polished . Kitchen and pantries given a good scrubbing. The rapid transformation is due in part to the arrival on the doorstep one morning of Giuseppe from San Sepolcro, who presents himself carrying all his possessions tied in a clean square of linen. Maria, the cook at Palazzo Castellani, has dispatched her son to help Maddalena, remembering Giuseppe's childhood promise to remain her good friend. *And Maria is right. I can use Giuseppe's help.* The tall, long-legged man standing before her is no longer the boy she knew in San Sepolcro. But the shining dark eyes and ready smile remain the same. He slips into the routine of the house, charming Donatella as he earns her respect with hard work, winning over the few servants, including the maid Simonetta, who has stayed on. Maddalena is slowly experiencing the return of her natural optimism, and feeling of well-being. *At last I am beginning to live again.*

There are occasional visits from Elizabetta, busy with her large family. Marta writes to her as often as the rules of her order permit. Maddalena corresponds with Luigi's parents, whose health has become even more fragile after Luigi's death. Her letters to her mother, full of news of Florence and the occupants of the Doni Villa, signal to Bianca and her husband in Arezzo that Maddalena is finally emerging from the depths of her sorrow.

Maddalena's visits to the Ospedale bring her great joy. And Gino proves to be the rock on which she can lean. In the hours he is not working at the Doni warehouse, he can often be found on Via Ghibellina in the company of his mother.

The void in Maddalena's heart fills, at least partially, but she understands life will never be the same without her beloved Luigi. Along with this reality comes the surprising thought

that, in his final years, Luigi was more and more away from her and the Villa Contenta. His expanding mercantile business required it.

Did I demand too much of Piero all those years ago? She questions herself. Must men seek their destiny apart from marriage, when, for women, marriage and children equate with satisfaction in life? She now knows they must, but all those years ago she was too young to realize it.

THREE

Returning over the Mountains of the Moon toward Urbino, Piero della Francesca feels a heightened sense of well being. It will be good to return to the comfortable quarters where his every wish is anticipated by silent, efficient servants, to resume his friendly but distant relationship with Duke Federigo and his court. It is the sort of relationship he likes best. Cordial, but still somewhat remote. And he anticipates seeing the beautiful Duchess Battista again. As so many years have passed, he wonders if her beauty has faded.

In his first audience with Piero, the Duke tells him he is eager to begin the diptych of himself and his wife, the pair of paintings suggested so many years ago by Battista. Piero nods. He had thought as much, when he received word that his services were required.

"The Duchess is slightly indisposed at the moment," Federigo murmurs, "but you may begin with me whenever you are ready." Piero is aware that during one of his long absences from Urbino the birth of an heir, Guidobaldo da Montefeltro, occurred. But the child did not survive. Piero defers condolences to Federigo and Battista until he has heard more about the condition of the Duchess.

In the years Piero has been absent from Urbino, there have been many changes. The Ducal Palace, then a work in progress, is largely complete, reflecting the genius of Luciano Laurana, the architect, sparkling with paintings of many famous artists: Justus of Ghent, Pedro Berruguete, Mezzo da Forli, Antonello da Messina, the fabled Van Eyck brothers, to name a few.

Piero is especially taken by a small *studiolo* in one of the palace's circular turrets, walls fitted out in beautiful *intarsia* panels, picturing many familiar myths and legends. It is a perfect small, jewel-like space for a scholarly ruler like Federigo in which to read and study undisturbed. It is Laurana's concept, unique with its illusionistic panels and architectural embellishments.

Glad to be once again in residence, Piero gets down to work in the privacy of his rooms. Nightfall finds him still sitting at his desk sketching, the light of a single candle throwing phantasmal shadows on the walls behind him, but he is unaware, so busy is he at his notes and drawings. The palace is quiet. The hour grows late.

The diptych will be small, each portrait slightly under life size. They will be shoulder length portraits of the rulers, each with landscape backgrounds. And on the reverse of the freestanding diptych, allegories of the triumphs of Federigo and Battista. For those allegories, he has in mind placing the small figures on grand, triumphal, chariot-like carts with a continuous landscape background depicting ducal lands with powerful realism.

In the portrait of the Duchess he will show the exactitude of her jewels; in Federigo's likeness, Piero, in his realistic style, will show moles and other blemishes and the wiry hair of a strong, bravely courageous warrior turned benevolent monarch. They will become a pair of rulers to remember, he thinks, through the medium of his art. Satisfied, he takes his candle to his bedside and prepares himself for sleep.

Morning. He enters the quarters of the Duchess for a sitting. Under veiled lids he watches as she sweeps in, seating herself in a chair on the dais. The startling fair hair, the incredibly high forehead, the blue of her eyes, careful attention to details of her dress and jewels, all are as he has remembered.

But his discerning glance at once spots a difference: the skin, still unblemished, has taken on a pallor, a grayish tinge which was not there before. Surely he is not mistaken. The eyes, too are different. They are veiled, unrevealing, when once they sparkled with merriment, assured, teasing. What does it mean? Perhaps only someone probing, like a painter, would detect a change, he muses to himself.

"Signore Piero." Her smile is welcoming as he bends low in front of her. "At last you have returned to us." She does not offer her hand. Not waiting for his reply, she indicates the easel which stands ready.

"Pray begin. I know Federigo has spoken to you of his wish for haste. He had planned to be here this morning when some crisis arose. He will come later."

"I am ready, Duchess. Is the costume the one in which you wish to be painted? If not, I will concentrate on your face and fill in the proper gown at another sitting."

"Yes, yes, begin on the gown at once. Then I will be free of it and can wear something more comfortable at later sittings."

He takes up his brush and begins summarily blocking in the figure. Her voice too is changed, he muses to himself. The childish, sing-song shrillness is gone, along with the youthful exuberance he remembers at the time he first met her. Then she was all gaiety, acting on a

whim, confident of her power to attract. How he had been bewitched by her charms. It must be the loss of the child, he thinks, which has caused the change.

The sitting proceeds without incident. He has caught the softness of the black velvet dress with brocade sleeves of a rich, russet color, embroidered in a complicated pattern he knows he will labor over in his studio for countless hours. He next applies the brush to the jeweled collar on her neck, still long and slender like a tulip stem. Two rows of perfect pearls inset with richly worked golden squares set on edge and studded with precious rubies and sapphires, a loose loop of the pearls dipping down the bodice of black velvet. The position of the necklace on the dress and figure is what he must capture. Details of the jewels can be finished later.

He works as quickly as possible, not wishing to tire her. She is strangely silent, unlike the time when he first saw her. He remembers her peering over his shoulder as he painted *The Flagellation*, all those years ago. How she chattered, bursting with vitality, like a lovely nymph, distracting him. Again the thought nags at him, is she not well? Neither of them mentions the death of the child. Discretion keeps him silent, but he is concerned.

Battista is suddenly seized by a fit of coughing. Frantically she searches through the velvet pouch hanging from her waist and produces a small square of white linen, holding it to her mouth. She turns her head away, the coughing subsides. Piero is standing awkwardly at the easel, at a loss to see how he might help. As she takes the linen away and thrusts it into the purse, Piero glimpses the tell-tale stain of red on the handkerchief. He quickly lowers his eyes, horrified, hoping she has not seen his glance. Consumption. In others he has seen the tell-tale stain many times before.

During the next two years Piero is the sad witness to the ongoing decline of the Duchess of Urbino. He becomes a co-conspirator with Duke Federigo, ignoring the inevitable and keeping up a facade of normalcy, the fantasy that nothing is wrong. This is Battista's wish, and Federigo is powerless to deny her anything. On days when she is too weak, there are no sittings. On better days the sessions must be brief, but Piero keeps the mood cheerful with a continual discourse of interest to the Duchess as he guides the brush.

And the entire court at Urbino loyally plays its part in the pretense, painfully aware that they are losing their beloved Duchess. The effect on the Duke has been most alarming. He has aged dramatically since their last meeting, Piero realizes. It is as though he is weighted down by sorrow, first the death of his son, now the knowledge that he is losing the love of his life.

Piero's labor on the diptych becomes all-consuming. He paints, unconsciously paying tribute to the beautiful, witty, courageous woman he has come to know so well. He is determined to help Federigo through this tragedy, and at the same time, produce a dazzling masterpiece, a memorial to a beloved lady. There is a nuanced luminosity in the landscape backgrounds new even to Piero, who first represented sunlight in his painting, *The Baptism,* long ago.

*

A summer morning, and the Duchess has been moved to a window in her chambers overlooking the distant Mountains of the Moon. They rise blue and faintly mysterious, and she recalls their beauty when she saw them for the first time, riding with her bridegroom from her home in Milan. She knows she will pass through them no more.

She has summoned Piero to her quarters, and he quickly puts his brushes aside, wipes his hands on a clean linen cloth and hurries to her chambers in the Ducal apartments, somewhat puzzled because the sittings are finished. He has only a few minor alterations to apply and *Federigo da Montefeltro and His Wife Battista Sforza,* will be complete.

"And do you feel the work is satisfactory?" she asks him, after first determining that he is applying the final strokes. "Are you pleased with the outcome?" He bends close to hear her, for her voice has become painfully weak.

"I have poured all of my energies into its completion, Duchess," Piero answers in his calm voice. "I have tried to represent the power, the goodness, the fidelity of the rulers of Urbino. I believe I have achieved my goals."

Wearily she leans back on the pillow, exhausted by efforts to speak. She folds her hands over her breast. "You have been a good and faithful artist, and a friend to Federigo and me. I would like you to know I am grateful." So much the expression in the eyes does not reveal, Piero thinks, overcome with emotion.

Piero, realizing this is her goodbye, bows deeply. "Your grace," he whispers, then makes his way out of the chamber, unable to see but the dim outlines of walls and furnishings as his eyes fill with tears.

The following day the Duchess slips quietly away. Piero, alone in his quarters, contemplates the work, drying on an easel before him, which has become a tribute to her memory. He is overcome with grief. When Piero presents the work to the Duke, he cherishes it above all others in his collection as long as he lives.

FOUR

1492

\mathcal{M}addalena sits at the open window of the Doni Villa in Florence looking down at the courtyard. Water splashes in the dolphin fountain. The gentle summer air stirs, warming her. Looking down, she remembers the beauty of the courtyard on her first visit to Firenze, *molti anni fa*, many years ago. Then she looked at the world with the wide, innocent eyes of a girl, a girl just beginning to form her hopes, her dreams.

Splashing waters of the fountain remind her of the many years she has listened to its sweet music. She is old, but time has hurried by in a moment, so clearly she recalls that young Maddalena, eager to grasp life with both of her strong, supple hands. She looks at those hands now, lined and wrinkled, resting placidly in her lap, the brown spots of age dotting them like the speckled breast of the lark. She nods in the sunlight.

"When will I join Luigi?" she asks herself, dozing, for Luigi has been gone for so long and she is weary, so weary, waiting.

Suddenly she hears footsteps in the courtyard below and sees him, tall, slender, hurrying to the house. Her mind jerks to attention. Her frail body, slow to obey commands, tenses as she strains to see more clearly. Presently her dim eyes make out the black brows and dark eyes of Gino, her son, dark locks peeping from beneath his cap. Yes, it is Gino---not Luigi---their son in every way but birth.

Gino's coloring, so unlike Luigi's blond hair, blue eyes, but the height and the natural grace---that is like Luigi, she muses. And Luigi, the only father Gino remembers, since his birth father was lost in the great flood in Florence all those years ago. She recalls the fearful night when little Gino was brought into the Ospedale, half-dead and starving, after being rescued from the floodwaters by Luigi and his soldiers. Luigi carried him up the steps of the Ospedale

so gently that night, gave him to the blessed Sister Marta who coaxed him to eat...and to live. Then, after our marriage, we took him as our own, Maddalena recalls with pride.

Now Gino is a man, her thoughts run swiftly, unlike her own halting gait, but Luigi is gone and will never return. She sighs, knowing she must be patient, but why, oh why could we not have perished together in the storm that took Luigi, a storm so vicious it tossed his boat about in the waves like an onion in a bubbling cauldron? Alfredo also lost on the same journey. Soon after, Giovanna, dying of grief, they said. Look at who is gone now, she recollects sadly: Donatella, her faithful servant from Prato; Bianca, her mother, Tomaso, her stepfather, both of the elder Castellani, Father Bruno, Mother Scholastica, Giovanna, Alfredo, and most of all, Luigi.

Gino divides his time between Florence and San Sepolcro, where he is now master of Luigi's family home, Palazzo Castellani. And still Gino has not chosen a wife, Maddalena reflects. How I long to hold Gino's child in my arms, just once before I go. Elizabetta, her eldest daughter, is busy with her large family; Marta has found fulfillment within the cloistered walls of the Priory in Cortona. Gino is the one who is alone. It is Gino she frets over.

Gino sees his mother at the window and hurries up to tell her of his day. "You would not believe your eyes, *Mamina*, if you could see all the improvements I am making at Palazzo Castellani," he begins after embracing her, pride in his voice.

And he recounts the renovation of the rooms, the laying out of new gardens, the construction of new quarters for the servants who previously lived in the dark, dank basements. The old quarters, newly whitewashed, have been turned into clean storerooms. Maddalena listens to his achievements, proud as he rattles off the newest additions, a fireplace here, a frescoed ceiling there. But in her heart, the one thing she yearns for is that Gino will take a wife. *The years fly by! Will I go to my grave without seeing a new Castellani heir?*

"Now, my son, all of that is all very fine. But when will you choose a wife?"

"Soon, *Mamina*, soon. I promise, and my promise is as true as the truth of the Lord's Prayer. When I complete a few more improvements, I will marry. You will hold your grandchild one day, believe me." And Maddalena has to be content.

There are times when she seems to forget that Luigi has died, because she talks to him often when she is alone. She was enjoying a wonderful talk with him recently, when Gino suddenly came into the room and heard her speaking to Luigi. Alarmed, he took her by the hand and spoke, oh so firmly to her. "Now *Mamina*, you know my father, your husband, is gone. He died when his boat went down in 1470, all those years ago. Do you not remember?" He looked so sternly at her!

Of course she remembers, but living with that horrible memory is so painful, she sometimes pushes it far from her thoughts, trying to forget, pretending Luigi is there, beside her. Or she can make believe he is simply away on a trip, visiting his agents in Rome or Alexandria, and

soon he will hurry back, hold her close, whispering sweet love words in her ears. Pretending is such a comfort. But Gino will have none of it.

"You are too much alone here, Maddalena," Gino says, forgetting that she does not wish him to call her by her given name. She deems it disrespectful. "You must come more often to visit me in Palazzo Castellani, move about more. Then you will not live so much in the past."

Ah, the young, she muses to herself. They think all the problems in the world will be solved by getting out and about more often! She offers her cheek to Gino, who must be away on his many duties and responsibilities, promising she will think about a trip soon to Palazzo Castellani, to see the improvements. "I will come the minute you have chosen a wife," she says teasingly as they embrace. Then he is gone.

When it is time for her afternoon tea, Giuseppe arrives, punctual as always, and places the small pot, a cup and slices of lemon carefully arranged on a plate before her. Maddalena is dozing in her chair.

"Wake up, Maddalena," he says softly. "It is time for your tea."

"Maddalena here, Maddalena there! Will I never receive the respect which is my due? How old must I become before you and Gino address me properly?" But her rebuke is soft and Giuseppe grins widely. She blesses the day he arrived from San Sepolcro to begin serving her in the Doni Villa. Giuseppe and I go back a long way. Our ties are strong, she thinks, sipping the tea.

"You are always like a girl to me, Maddalena," he says, teasing her, and she is grateful for his ready humor, his willing hands. She lets the image of Giuseppe, his wife Simonetta and their two small sons, recede as she remembers Giuseppe as a boy in San Sepolcro. How she played catch ball with him in the garden, sat beside him through the long night when he was afire with a fever. *Those moments the heart does not forget.*

And so Maddalena passes her days, daydreaming, recalling the past, in surroundings she has loved and among people lavishing loyalty and trust upon her. In that way, she is able to face the day with hope, not despair, recounting the many blessings of her life.

FIVE

Gino returns in a few days to the villa on Via Ghibellina. He has been to Prato on business about the wool weavers. His dark eyes shine as he comes to Maddalena in the little *salotina*, the small room off the grand *salone*, the room where she and Luigi first met in *Firenze*. The room is unchanged, filled with tapestries of the nymphs and satyrs disporting themselves, furnished with the delicate, gilded French love seat and matching chairs.

"There is news today you will be happy to hear, *Mamina*," he says, taking both of her hands in his.

"How so, how so, my son? A new painting, a new bedcover perhaps?" She cannot keep track of Gino's many projects to improve the palazzo.

"You have been saying for years that I need a wife, *Mamina*. Well, I have made my choice, I have selected her, proposed to her and she has accepted."

Maddalena's eyes fill with tears. Heaven be praised. At last he has come to his senses. "Who, my son, who?" She is thinking of Alessandra Passarini, of Margherita Bacci, others whose names she cannot recall, girls who have clustered around Gino like so many large butterflies at receptions and ceremonies.

"Chiara Datini. From Prato. Remember her?"

Thoughts start exploding in her head. Chiara! Valentina's daughter, her own daughter, not adopted like the son, Matteo. Valentina, Luigi's half sister! Then she remembers, Gino does not have our blood. He was not born a Castellani. There is no lawful reason why Gino should not marry Chiara. The fluttering in her heart has barely subsided when she has another thought. But Chiara! Is she not already married? She must be in her thirties by now. I thought she married some years ago.

Alice Heard Williams

"I see you are taken aback, *Mamina,*" Gino says grinning impishly. "Have I not pleased you with my choice?"

"But Chiara..."

"Is a widow now and I have loved her secretly for years," Gino breaks in. "Please don't lecture me, Maddalena, about her mother Valentina being a servant long ago. I know all about that. To her credit, Chiara has told me. And as to the fact that her father is a carpenter, well, what is wrong with carpenters? He is a good, honest workman and I admire him. Chiara's husband has been dead for three years now, and she is still a young woman. And I want her to be my wife."

Maddalena quickly collects her thoughts. "Gino, you are my son and a grown man. What right would I have to lecture you? I applaud your choice. I have always believed in marriages of choice. Surely you understand I would never challenge your good judgment. Chiara is a lovely girl and her parents are respected, upstanding Pratese. When will the vows be exchanged?"

"Soon, as soon as I take you down to San Sepolcro for one more visit to Palazzo Castellani. I must have your opinion on several problems about the rooms. It is necessary, Maddalena. I beg you! Come with me. We will go tomorrow!"

Maddalena would do anything for Gino. She assents, even though she does not guess the real reason for the visit to San Sepolcro.

San Sepolcro

ONE

Maddalena finds herself jolting along with Gino to San Sepolcro in the cart, driven by Giuseppe, who serves as her groom on infrequent trips like this one. The day is warm, she hardly needs the long jacket, the *cioppa*, to cover her gown, but it is new, it suits her.

She feels coquettish in her new finery, almost like a girl again, as she fingers the thin, fine wool of the jacket, admires the gold embroidery of its leaves and flowers on the dark ground. From the front of the cart, Gino, with Giuseppe, keeps glancing back at her, surrounded by cushions, making sure she is as comfortable as possible.

The long drive enables Maddalena to do what she likes best---daydream to herself, and that morning her thoughts are on Gino. Not one to delve into philosophical or religious texts, no longer interested in scholarly pursuits, Gino has become a magician at business. Under him, the old Doni firm has prospered even more. Gino is a wealthy man. And now he is concentrating his abilities into turning the old Castellani estate into a model for all Tuscany. Best of all, he is taking a wife.

Chiara will be fortunate indeed to capture such a husband. Maddalena only hopes she appreciates him, she thinks somewhat waspishly, remembering her mother Valentina's uneven behavior when she was young. Did any mother ever think her son married a paragon? She sighs in resignation. Mothers set impossibly high standards for their sons' wives.

She knows in her heart that Gino and Chiara's must be a true love match. Is not that what she and Luigi had? She recalls the stormy scene between Luigi and herself in the little room of the nymphs and fauns, a storm ending with a stolen kiss. How could any lovers stay apart in such a magical room? Ah, Luigi, I miss you, she sighs.

The cart rumbles on and Maddalena looks at the fields of her beloved *Toscana* in springtime, alive with terraces of grapes, green vines sprouting from weathered branches severely pruned, the soft gray of the olive leaves making the trees look like the giant heads of old ladies, waving in the gentle breezes. How Luigi would have loved this journey, being brought to his family's home by a strong, fine son like Gino.

Gino's style as *Il Signore* of Palazzo Castellani is different, she muses, from that of his grandfather Castellani. He mingles freely with his servants, calling them by name, taking an interest in their lives as well as the hard work they give him. He knows all of their family members, gives them help in time of trouble, not that Giuliano Castellani was ever mean or stingy with them. It was simply in his makeup to be remote, somewhat cold. Gino is different, and the servants repay him handsomely in loyalty, devotion and excellent service.

At last she spies the town of San Sepolcro in the distance. The cart pulls up at the door of Palazzo Castellani. After refreshing herself, Maddalena joins her son in the huge kitchen which remains just as she remembers it, albeit fitted with many more conveniences. The old pine table in the center, well-scrubbed, is still there, and Gino beckons her to join him. A smiling Rosalba, similar in appearance to Maria, whom Maddalena envisions in a moment's recollection, works silently behind them at her pots.

"At last, what was denied me all those years ago as a girl is coming true."

"What is that, Maddalena?" Gino is puzzled.

"Now I am going to sit at this table and eat a meal," she answers. "Never would Maria, or Bianca my mother, for that matter, allow it when I was growing up. The lines were not crossed then, we kept to ourselves, neither at home with the servants nor with the Castellani, your grandparents. That is just how things were. Nobody thought to change it." Gino frowns.

"Strange," he answers. "But I like this way better, do you not?" They eat in silence a few minutes, spooning the *zuppa di vedura*, a vegetable soup, breaking off pieces of the crusty loaf of bread. "Yes, the people who serve me, they are all a part of my family," he reflects.

Finishing the meal, they linger at the table. "Maddalena," Gino looks earnestly at his mother, "A strange thing happened to me recently. I went to the Priory of San Giovanni Battista to have a word with the priest there about plans for my marriage vows. The priest is *not* Father Bruno whom you remember. He is dead now." He pauses, looking anxiously at his mother.

"Yes, Gino," Maddalena answers quickly, trying not to seem exasperated. " I *know* Father Bruno has been gone, over ten years now." Children can be a trial, she thinks, especially when they treat us as children.

"Well," Gino continues, "The priest told me that a famous artist was expected later that day to view one of his early paintings hanging in the church, an altarpiece, *The Baptism,* in one

of the side chapels. I remembered you had told me about the painting, how the artist, Piero della Francesca, placed you in it, as one of the angels. So, I decided to go by and have a look for myself." Gino pauses to take a sip of the wine produced by his vineyard, his grapes.

"As I was inspecting the work an old man shuffled up, announced he was the painter and demanded, *demanded* of me what I thought of the painting. He asked question after question. I was almost at the end of my patience, except for his frailties and the sad way he screwed up his face to peer at the painting, for I think he is almost blind." Maddalena sits silently, shaking her head, wondering if this ancient can be the man she once knew so well. She has guessed what her son's next words will be.

"It was the artist himself, Piero della Francesca, to whom you were speaking." Her voice is matter-of-fact.

"Yes, *Mamina.* The same." Slowly Gino nods.

"As we were standing in front of the painting he seemed to falter, lose his balance, and would have toppled over had I not grasped him firmly and escorted him to a seat. He was extremely embarrassed and apologized for his infirmity, saying he'd best be getting along home. I insisted on accompanying him to his house on the Via della Chiesa. He admitted to me that he did not usually venture out alone, but Marco, the small boy who usually accompanies him, leading him along by the hand, was sick that day." Poor Piero, Maddalena lowers her eyes to hide the appearance of a tear or two. She must not show such weakness in front of her son.

"Piero asked me my name and when I told him, he seemed to know our family and told me that you had posed for the figure of the angel in the front of the picture, on the left side. I had expected him to be more surprised, but he seemed to think it was perfectly natural that we should meet in front of the altarpiece." Gino is silent for a moment, lost in thought.

"Piero spoke of you with great warmth," Gino continues. "How at some fete or other long ago he played his lute for you and sang one of Dante's love songs. He began rambling on and on about how you had inhabited his dreams for many years. Frankly, Maddalena, I took these wanderings to be a sign of infirmity in the head."

Strange, Maddalena thinks, how our children always deny us lives of our own, except the years spent in coaxing them safely and surely into adulthood. *Yes, we are expected by our children to have no interests outside our family circle.*

"Well, we got to his house and I helped him inside. He had told me by this time that he never paints now. He cannot, because of his poor eyes. The house is comfortable, but the neighborhood is shabby. An old woman, looking to be about his age, came bustling in and took over rather fussily, but at this point the old man seemed exhausted and relieved to place himself in her charge." Gino pauses, reflecting.

"I remember there was an enormous orange cat walking around as though he owned the place. As soon as the housekeeper got Piero into a chair, the cat pounced on his lap and began purring, making a noise like a spinning wheel. It was an amazing scene, I can tell you." Gino looks unseeing at his wine, the lambent eyes lost in thought.

Maddalena closes her eyes for a moment, seeing that house and that cat, but no, surely a descendant of Giotto. So many years ago, her visits to that house. Her thoughts take wing and she is in the ballroom at the top of Palazzo Castellani. Piero is playing his lute, just for her, and she is wearing the rose-colored velvet dress. It is the fete of Epiphany, with singing and dancing and the giving of presents to all the children of the servants.

"Did Piero wish to know more about me?"

""Yes he did, and I told him your husband Luigi Castellani had died many years ago, in a storm at sea and that you still missed him sorely. I told him about my sisters, about where you live now, in the Doni villa in Florence."

"Ah yes, she always did love Florence," Gino recalls Piero's words. Suddenly Maddalena feels exhausted, both in mind and body. She must have rest.

"Please, Gino, let me rest now."

"But *Mamina,* there is more I must tell you," Gino protests.

"Later, my son, later. After I have slept." And with thoughts crowding into her head from the past, she slowly makes her way up the grand staircase to her chamber.

<p style="text-align:center">*</p>

In the old days, Maddalena muses the following morning, a journey from Florence to San Sepolcro was nothing. Now, after a long nap and a full night's rest, I am still tired from the journey. It is the way of the aged, she thinks. She is sitting with Luigi in the sunny kitchen while Rosalba prepares steaming cups of milk laced with honey and brings warm bread for their breakfast.

"Now Maddalena," Gino resumes, "You know I said there was more to the story of Piero?"

"Yes, Gino, I am waiting to hear it now."

"I was sitting quietly with him a few moments before I left his house," Gino continues, "When he suddenly sprang up from his chair and walked in a sprightly manner toward a chest against the wall. He opened the *cassone* and bent over it, rooting around like some animal, searching in its depths. Rising, he came toward me with a small box in his hands. He presented it to me carefully, explaining that I should give it to you, that it really belongs to you and he wanted you to have it. He sent it with his good wishes, *Mamina.*"

<p style="text-align:center">230</p>

Gino carefully hands the box to his mother. Of course, as she lifts the lid, Maddalena sees the amber ring. Sent to her after his departure to Urbino, just after they had become betrothed. *He wrote a poem to me, sent with the ring.*

Then, when his absences from her were long and unexplained, she began having fears and doubts. Luigi reappeared, determined to show his love for her. And in the end, she rejected Piero, sent back the ring, turned her back on him. How many years have now gone by? She closes the box and holds it out to her son.

"No, *Mamina*, he wants you to keep it. And he sends his condolences on the death of your husband. He had not realized he had died."

"Thank him for me, Gino. Tell him I will treasure it always as a token of our friendship."

No, Maddalena, I will not thank him." Gino's statement throws her into confusion. What can he mean? He is always such a loving and obedient son. Puzzled, she looks into his eyes.

"I want you to tell him yourself, *Mamina*. I want you to pay a visit to Piero," Gino whispers.

"Gino," she pleads. "Do not ask me. I, I simply cannot. I am too weak." Feeling guilty for using such an excuse, she knows she is not yet ready to confront Piero, not because she fears him, but because she is ashamed of the way she treated him long ago.

*

Gino goes alone to pay another call to Piero the following day. He takes him a present of a *panforte*, made by the nuns of Siena, a cake which Gino has discovered Piero relishes, made of dried fruit and nuts.

There, in the gloom of Piero's house, motes of dust filtering through ladders of light from the shutters, Gino and Piero talk. Gino brings him news of the town, news of Maddalena, but he is careful not to raise his hopes by telling him she is actually in San Sepolcro. Not yet. Piero talks to him of his paintings, giving him glimpses of his travels to Urbino, Rimini, Florence and Rome.

There are occasional interruptions, a *viene qua!*, come here!, command to Giotto the cat, who seems assured of his stature in Piero's affections, exploiting it to the fullest, marching around the room like a prince, orange tail confidently flicking in the air like a banner. All of these things Gino will tell his mother, when he returns home.

"I never had a son, of course," Piero admits surprisingly as they face each other and he peers intently at Gino. "But if I had been so fortunate, I would wish him to look like the male

angel in my painting, *The Madonna of Senigallia,* you know, the one on the left side of the painting."

Gino, in the dark as to this particular painting, makes an agreeable sound he hopes will suffice.

"It was almost like a vision, that male angel," Piero continues thoughtfully, settling back in the old armchair, the dimness of the room kind to his weakened eyes. "I saw him clearly in my mind. Young, strong. Hands graceful and supple. His robes blue, with his breast adorned by a single pearl, a magnificent pearl. Shining eyes, an open face, his hair standing out like a nimbus around him. Yes, I painted him that way, the son I never had." He nods, content.

Then quickly, with the stealth of an adder he asks sharply, "You, why do you come here? To take pity on me? Or is it your mother who sends you?" A scowl covers his face, he shifts in his chair, upsetting the cat who stalks away, offended.

"Oh no, honored Signore. She did not ask me to come. I wished to come. You see, I have lived many years without my father. It is pleasant talking to you about your paintings. In some ways it is like talking to my father, even though he was not a painter, of course. Tell me of the other figures in this painting, *The Madonna of Senigallia.*

"The Madonna is in the center, of course." Piero, calmed, continues his discourse as though addressing a group of students. "She is a large woman, tall like your mother. I always preferred to paint her type, statuesque, the bearing of a queen, wearing the clothing of classical antiquity. She always made lesser women with their frills, ruffles and curls look like overdressed shop girls. Yes, shop girls," he repeats, pleased with the comparison.

"Then the Child Jesus, a big boy, not a *bambino,* seated in the crook of his mother's arm, holding up his right hand in blessing, the pose of a little classical god in flesh and blood. He holds a rose in the other hand, wears a necklace of coral. Both symbolize the Crucifixion of course." Piero closes his eyes. In a matter of minutes, he nods off.

Suddenly he rouses himself and continues. "There is a female angel on the right, over the left shoulder of the Madonna. She is dressed in pale pink and wears a necklace of perfect pearls, the most lustrous pearls I ever painted, except of course, those of the Duchess of Urbino in the diptych I painted of the Duke and Duchess. You know she died?" Gino assents, knowing both of the Umbrian rulers were long dead.

"She was a beautiful woman, like your mother in some ways. Battista was her name. Beautiful dressed in her jewels. Painting jewels is the strength of the Fleming painters, you know. Their secret is to mix oil with their pigment and it creates a luminous effect. Pure oil. Such detail they can create! The hairs of a dog, fur, the mustache, a beard." He sighs.

" In that, the Fleming Jan Van Eyck had no peer. No peer. Duke Federigo possessed a painting by Van Eyck in his collection. When I was in residence there I studied it almost daily. Oil, not tempera, the egg we Southern artists use, that is their medium."

And he is nodding off again, exhausted by all the talk. This time Gino slips softly out of the room, urged out by the housekeeper, barely disguising her haste in seeing him on his way.

"She looks after him like a mother hen, Maddalena," Gino scoffs, at the same time touched by her loyalty. "She tries to keep him from becoming overtired."

Maddalena is intrigued by these glimpses into Piero's life, not having seen him for so many years. So he was charmed by the Duchess of Urbino. And he liked painting women like me. A little flush of pride flames inside her. Should she go to see him as Gino wishes? As a kind of penance, should she try to make peace between them? Before it is too late?

She recalls the strange revelation Gino told her about Piero, that he has decided to spend his remaining years preparing for death. As he grows older, there are few hours in the day when he does not pray for death, pray to be delivered from his earthly cares. Are you not aware, he asks Gino, that our whole life is merely a race toward death?

He also told Gino he asks for only one book to be read to him now, *The Revelations of Saint Brigid of Sweden*, because she writes that the only services Christ desired were those given in a free spirit and in the charity of love.

TWO

Happy days with Gino at Palazzo Castellani pile up like a stack of gold coins. Maddalena will have them to spend on cold, dark days when she is back in Florence, alone at the Doni Villa. She knows her life will change when Gino marries. His visits will be less frequent. How she loves him! And wishes to please him.

"Gino, I am ready to visit the house on Via della Chiesa. To see Piero," she announces at breakfast.

"Maddalena, I knew you would agree in the end. Shall we go tomorrow? First, I have a surprise planned for you today."

Maddalena finds herself being escorted to the *Palazzo Communale,* the city offices of the town of San Sepolcro. All Gino will tell her is that he has a special treat in store for her. Later, perhaps the following day, they will visit Piero.

They enter the building and proceed to a small area of connecting rooms housing a collection of art---paintings, a few sculptures---owned by the town. In the last room they come upon the obvious prize of the collection, a fresco, *The Risen Christ*, the most astounding painting Maddalena has ever seen in her life.

"Dio Mio!" she exclaims, looking at the image of a stark, hollow-eyed Christ, his foot planted on the edge of the grave, actually rising out of his sarcophagus, with four soldier- guards sprawled on the ground beneath him. Two seemingly overcome by the light surrounding the figure of Christ, the remaining two still asleep. Now she understands why Gino wished to show her this powerful image, perfectly housed in the building of a town named for the Holy Sepulcher.

"I have never seen this painting," she whispers, standing in awe before it.

"Nor did I until recently, but isn't it the most powerful icon of faith you have ever seen, Maddalena?"

"Oh yes, Gino, yes," she whispers reverently as her eyes drink in the sight. The impact of the image is as powerful as a blow striking her: the eyes, the blinding light, the drama.

The figure of the Risen Christ, gaunt after three days of his ordeal, climbs firmly, erect, one foot planted on the side of the deep tomb, his right hand grasping the staff and large white banner emblazoned with a red Cross. The eyes of the Son of God look out on Maddalena and Gino, as they do on everyone who stands in front of the image.

"Remarkable, this scene," Maddalena frowns. "It does not come from the Bible. Nowhere is such a scene as this described in Holy Scripture. The artist himself received this vision."

"And we know who the artist is, do we not, Maddalena?" Gino's voice is teasing as he looks at his mother.

"Gino, if there were a shred of doubt, it would be removed by looking closely at the young soldier in brown leaning against the tomb, the second figure on the left. That face is Piero's face as I knew him, many years ago. There is no mistaking it. The broad cheekbones, enormous eye sockets, a halo of dark hair surrounding the head. Oh yes, it is Piero."

"Piero told me he finished it during the time he was working on the frescoes at Arezzo," Gino says. "What an image of meditation. It would be prized in any church."

"But suitable here, in the way it is displayed," Maddalena murmurs. " Look at the landscape behind Christ, Gino. In the left-hand side the trees are barren, stripped of their leaves. On the right the leaves are painted in full growth, green and abundant."

"What does it mean, Maddalena?" Gino's voice is that of a child, filled with wonder.

"I believe, Gino, it is from a Biblical passage of Christ's journey to Calvary when he said 'If they do this to me in the green tree, what will they do in the dry?' meaning 'If they do this to me while I am still alive, what will they do to me when I am dead?' It is also a symbol of the world before, then after the Crucifixion, when all mankind received God's promise, 'Whoever believes in Him shall be saved.' At least I think that is the meaning of the symbolism."

"Piero is a wise man, *Mamina*," Gino says in a low voice. "He must have a very deep faith, to have composed such a painting as this." For some time, they have been standing silently in front of the fresco. "They say some people love this work so much, they make a pilgrimage here to look at it every day, on their way to work or to worship."

"I am not surprised, Gino. When I knew Piero, he never spoke of his piety. But it was self-evident, deep and sincere. Yes, I am sure Piero is a man committed to his Faith."

"Shall we make our way tomorrow to Piero's house, Maddalena? Now we will go home so you can rest." Gino takes her hand and gently leads her outside to the waiting cart.

Palazzo Castellani rises in the distance, and Maddalena is thankful, longing for a nap. The bumping of the cart over the cobbles tires her. After looking at such a powerful painting, her emotions are spent. But as they approach, they make out the small, wiry figure of a woman pulling vigorously on the bell at the doorway. Gino hurries up.

It is Piero's old housekeeper, Lucia. Maddalena recognizes her. Yes, it is the same Lucia who has served Piero all these years. Now completely gray, hair severely scraped back and fashioned into a bun. Whippet thin, Maddalena thinks, with lips and brows to match. And a face wrinkled like a prune.

"My master wishes you to wait upon him after midday," she says tersely, before Gino has had time to greet her. "Will you come?" Her manner is brusque. Maddalena hides a smile, imagining Piero in the clutches of this virago.

"Tell him I will be there," Gino answers courteously, preparing to present his mother. But Lucia turns away quickly and begins striding homeward toward her master.

"Do you wish to ride home in the cart?" Gino calls after her, but if she hears, she gives no sign, continuing her march out of sight. "Poor Piero, under her thumb." Gino laughs and Maddalena laughs with him.

After finishing the midday meal, Gino faces Maddalena. "I know you are tired, but he is old, weak and alone, and really not able to call on us here. Will you come with me *Mamina*?"

"Yes, Gino, I will," she answers, knowing she will not be able to rest, if she does not.

THREE

Stepping into Piero's house, memories fill the dusky air like thousands of piled leaves stirred by the wind, crowding into Maddalena's head... Father Bruno accompanying her on that first visit to Piero's studio, later with Bianca, all of them clustered around Piero... eating the thin almond cakes, sipping wine... Piero in command, expounding on painting techniques...her first start of surprise as she recognizes herself in *The Baptism* when Piero draws aside the curtain.

Led by a thin-lipped Lucia, Maddalena and Gino enter the gloom of the studio, hardly able to see in the semi-darkness. Maddalena recognizes paintings of the mythological figures she remembers. Again her eyes are drawn to the Hercules.

"Good day to you, Signore," Gino greets Piero heartily, walking up to him and taking his hand. I have brought you a surprise." Gino bows low then moves to the rear of the room, leaving Piero and Maddalena alone, except for the old housekeeper who stands her ground.

"It is I, Maddalena, Piero," Maddalena says quickly, taking his hand. "I am visiting my son Gino for a little while and he has brought me to see you." The room is silent but for the rustlings of the housekeeper as she busies herself about the room, straightening piles of papers on a table, adjusting the shutters to admit a bit more light.

"Enough, woman!" Piero lets out a roar. "You know how my eyes hate the burning light! Leave us!" Silently Lucia eases out of the room. "So you came, Maddalena," he says gently, with a feeling of relief. Then, "Your hand feels cool, Maddalena."

"An old, speckled hand now, Piero," Maddalena says with a sigh. "We have joined the ranks of the ancient ones, you and I."

Piero speaks hurriedly. "I asked Gino to come. I did not realize you were in San Sepolcro, Maddalena. It is as though it has been arranged...in time..." His voice trails off. Then, "Are you well, Maddalena?"

"Very well, thank you. You might say I am on a cloud, Piero, for this very morning Gino has taken me to the *Palazzo Communale* to see to see your fresco of *The Risen Christ*. What an inspiring work, unforgettable, a powerful work. Who was the model for the figure of Christ?"

"Oh, some artisan I picked up in town. I forget his name. It is of no importance." She remembers Piero's old habit, brushing off praise. But she can tell he is pleased by his tone of voice. His thoughts, however, are elsewhere. His voice rushes on.

"I must speak to you, Maddalena, about our meeting at the Ospedale in Florence. Alberti was with me, do you remember?" There is an urgency in his voice, an agitation in his manner.

"You mean at the time of the flood? Yes, Piero, I do remember. I held one of the nursery babies in my arms when you saw me."

"Yes, yes." He is impatient. "I want you to know, Maddalena, I was not myself that day. I was so ashamed I had not told Alberti of our betrothal, but I was too weak to admit it. My foolish pride. I could see that you were hurt by my coolness and indifference. A thousand times I have gone over that meeting, reproached myself, wished I had spoken, made amends. The curse of my life has always been the hiding of my feelings." He shakes his head, takes in breath, continues.

"Most of all, I could never tell you of my true feelings, of my love for you. I wanted to speak what I felt in my heart, but it would not come out. My stupid pride and fear." Here his breath leaves and he ceases talking. Presently the breathing becomes more normal and he tries to resume. But his voice sounds fainter. Maddalena feels a little stab of fear and looks over her shoulder. Gino is silent, watchful, standing in the shadows. She must try to calm Piero.

"Do not fret, Piero. It is of no matter now." She speaks in soothing tones, trying to ease his troubled thoughts..

"But I must tell you while I can! Tomorrow may be too late!"

"Tell me what, Piero?" The urgency in his voice makes her draw closer to him.

"Tell you I loved you completely, passionately, from the moment I first saw you in the Graziani chapel that day with Father Bruno. But ever cursed with a pride which fettered my words and gave me an arrogant air to hide behind. I, I could not give of myself."

"Please, Piero," she says taking his hand again, trying to still the anguish of his heart, "I understand. I know it was difficult for you to express your feelings."

"How could you, a girl of sixteen, pure, innocent, be expected to understand me, a mature man?" The agony in Piero's voice tears at her and again she is frightened because of the

intensity of his pain and regret. How can she reassure him? He continues, a new urgency in his voice.

"And you must know this, Maddalena, I never stopped loving you. I know now it was wrong to leave you so long without returning to visit you, wrong to go off to Rimini with Alberti without first going to you. And I *did* enjoy Alberti's company. We had much to talk about. I admired his intellect. Our beliefs on painting, on mathematics, perspective were so much alike. But I never, never considered him as one who would take your place. Will you believe me, Maddalena?"

"Of course, Piero. Of course. I have long forgotten any resentment I might have felt in the past. You have nothing of which to be ashamed. I was young. My expectations of you were unreasonable, given the importance of your work, the scope of your talents. Why Piero, you had a duty to the world to fulfill, to leave the legacy of your paintings, a noble, worthwhile legacy for which mankind will always be grateful." Again Piero brushes aside her words, returning to his theme.

"And you must know, Maddalena, of how many times your face has inspired me as a subject for my painting. Time after time your face has come before my eyes in visions. Maddalena, do you realize you are the Madonna in my final painting, *The Nativity*, a Madonna of Humility, kneeling on the ground in front of The Child, with five, beautiful music making angels behind her, celebrating the arrival of the Savior? You never knew this painting. It was so precious to me, because of you, that I kept it and would never part with it.

"All these dimming, dark years, when my sight was leaving me, when I could no longer paint, your face in that painting was like a beacon. I felt close to you, even though at the end, when I could no longer see your face, I could imagine it, and it gave me the courage to go on in this dark world I inhabit." His breathing becomes labored.

"In the final painting I created for Duke Federigo, *The Madonna and Child with Saints*, another Nativity, you are the Madonna in that painting as well. Federigo, whose beloved wife Battista had died by this time, is shown alone, kneeling before the Virgin and Child for comfort and solace. I felt by painting you, I too could receive comfort and solace, and I did, Maddalena, many times. I wanted so much to tell you, Maddalena, that while there was a time when you were young and I wronged you, I tried all my life to make amends, by placing you in my paintings. It was the only thing I could do, since you were married by then."

"Shhh, Piero," Maddalena whispers, her eyes swimming with tears. "Do not upset yourself. Truly I understand. Do not torture yourself any longer. If you feel there is need for forgiveness, rest assured, you are forgiven. I have always been proud you painted me in your paintings. I only pray I am worthy of such an honor." Piero sighs and closes his eyes and sinks slowly into a restless breathing. He seems exhausted, but somehow calmed.

As she sits beside the dozing Piero, Maddalena looks at the large painting on the easel across the studio. Now that her eyes are more accustomed to the dim light coming through the

blinds, she can make out the Madonna kneeling on the ground before the Child, just as Piero described.

But this woman is no longer a young girl, she realizes. She is a matron, mature, her hair ever golden, but now tightly bound to her head in decorous, dignified style. Her hands are folded in prayer as she looks down on her sleeping Child. Her blue robes fall in graceful folds as she kneels, small touches of red at the neck and hem.

Maddalena can see that when she rises, this Madonna will tower over the chorus of five young angels, singing and playing their lutes. Did Piero imagine how she would look, even though he had not seen her for many years? It must be so, He has just told her she was in his mind as he painted this Madonna.

Next she studies the singing angels. Their gowns are similar, of slightly varying hues in a style of classical antiquity. But the heads are individualized, each one certainly a portrait head. Maddalena studies their fresh, unlined faces. Here is the embodiment of hope, she thinks, painted by an aging man, knowing he is losing his sight and soon will be unable to paint anymore. She can almost hear the clear, firm voices, sounding out their message in song to the world. In this small, helpless Child lies salvation for all mankind.

For some time, Maddalena sits quietly beside Piero holding his hand. She remembers so well the light from the open windows which flooded the studio back then, Piero's pent-up energies which could be released only through his painting. Now the studio has become an airless, cavernous tomb, windows covered to accommodate an aging, sightless man, still in bondage to his past.

Slowly she releases her hand from Piero's, stands. He seems to be sleeping peacefully now, his breathing shallow but even. She tiptoes to the door where Gino is waiting patiently, the housekeeper standing guard like a wizened soldier.

"I remember you, Signora," Lucia rasps suddenly in a whisper. "You were a girl when you came long ago with Father Bruno. *Molti anni fa*," she murmurs.

"You are right, Lucia. So many years ago. Watch over him carefully, he should sleep for some time, now."

"Yes, Signora. He will sleep in his chair. He says lying down, he cannot get enough breath anymore."

"Bless you, Lucia, for taking care of him." Maddalena takes the wrinkled, roughened hands in hers and for a moment their lives touch, bound up in the fervent prayer for this ill, aging man sleeping fitfully in the chair behind them.

FOUR

"*Mamina!* Surely you do not wish to climb all those stairs! The room has been shut up for years. The walls need fresh whitewash. There is dust everywhere. Giuliano and Margherita Castellani had kept it closed so long." Dismay sounds in Gino's voice as they return to Palazzo Castellani.

"Is the furniture as it was in my old room? Is the bed with the flower-painted headboard still there?" Maddalena briskly cuts into Gino's recital.

"Well, yes, it is there, the bed, that is. I cannot be sure of what else." Gino frowns, thinking, what can his mother be up to? Is she losing her mind? A caprice, to sleep in the room she inhabited as a girl? It is very worrying. Better humor her, however. The meeting with Piero must have unsettled her.

"I am asking you, Gino, to let me stay there tonight. One night. That is all I ask." Clearly he thinks I am mad she realizes, looking at her tall, handsome son standing before her.

"Of course, Maddalena," he says quickly. "I will have it freshened for you." Seeing her tired face, he remembers it has been a long day for her, with the unexpected visit to Piero after journeying to see the fresco of *The Risen Christ*. Who knows why she has this whim? Maybe it is something the old man said to her.

"Give me an hour. We can have some soup for our supper. The room will be clean and ready by the time we finish." Gino leads her toward a comfortable chair.

She watches from her chair in the great hall. Presently she sees two young maids emerging from the back corridor of the house, mounting the stairs, armed with mops, brooms, buckets of water.

They will think Julietta with all her demands has come for a visit, Maddalena muses. But no, these girls will never have heard of Julietta, Luigi's willful cousin of so many years ago. These girls would not even have been born!

After supper, Gino leads her upstairs to the room she once knew so well. It is clean and fresh smelling, with spotless bed linens and her own things brought up from her chamber below. Thankfully she embraces Gino and bids him goodnight. Now she can rest while remembering her past, snug in the old bed with the painted garlands of flowers on the head board.

Before falling asleep, recounting in her mind all of the occasions in her life when Piero was a part of it, she experiences a desire to see herself in the altarpiece of *The Baptism*, one more time. I will rise very early and go to the Priory of San Giovanni Battista in the morning, she whispers. Then I will not disturb Gino. Let him sleep late. I would not disrupt his habits. But the real reason, she admits, is that she wishes to stand alone in front of the work one last time.

Looking at the painting, drinking in her figure as one of the three angels witnessing the Baptism of Christ, a feeling of peace slips over her. This painting will bring comfort to mankind for centuries to come, she realizes, and is content. She turns and walks out of the church. The sun is shining brightly when, breathless, she reaches the big door of Palazzo Castellani and lets herself inside, only to find Gino in the hall, impatiently pacing the floor.

"Where have you been, Maddalena? I was worried about you." Gino's voice is tinged with relief and concern.

"Oh, Gino. I am sorry. I had hoped to return before you awoke. I walked to the Priory. I wished to look at Piero's altarpiece one more time. I, I planned to return before you awakened. But I walked slower than I had hoped, on the return journey." She sits down on the chair, exhausted.

"It is of no matter, Maddalena. But maybe you should rest a little, before you have breakfast," Gino says briskly. "Here, let us go into the *salone*. It will be much easier to tuck up your feet on the little sofa, rather than climbing all those stairs." Gratefully she follows him into the room and sinks onto the small sofa. In a matter of a few moments she is asleep.

It seems she has hardly rested her head when she suddenly opens her eyes and there is Gino, looking anxiously down at her. It takes her a moment to remember where she is. Yes, downstairs in the small *salone*, tired after her morning journey to look at the painting. But see it she did, and she will go and tell Piero this very day.

"What is it, Gino? Have I been sleeping long?"

"Not long, *Mamina*. Only an hour. Here, let me put this pillow under your head. Then you will be more comfortable." She is struck by the solemn note of his voice. How long has he been standing there?

"No, I will sit up. I feel fine now. Rested. What is it, Gino? You seem worried."

"*Mamina*," Gino speaks softly. "The old serving woman from Piero's house has just left. She came to tell us. Piero died in his sleep last night."

A cry of anguish escapes her lips. "No! Surely not! You are mistaken." This is a bad dream she thinks, remembering Piero's shortness of breath, his weakness. She tries to recall his exact words the day before when he saw that she had finally come. Was it something like 'I must speak to you while I can. Tomorrow may be too late'? Did Piero realize that his life was coming to an end? Did Lucia? And Gino? Frantic, her eyes search Gino's face.

"No, *Mamina*, I did not realize he was weakening so quickly." Gino takes her hand, trying to reassure her. "He has been more or less in the same state since I have known him. I do not think even Lucia, the housekeeper realized it. Her eyes were red from crying, her face blotched this morning. She was quite unprepared for his passing."

Thoughts race furiously through Maddalena's brain. Maybe it is true, Gino did not know. Lucia did not know. I certainly did not. *But Piero knew.* That is why he began pouring out his heart to me. Oh Piero, poor, lonely sufferer.

The torment in Piero's voice comes back to her. It encompassed the tremendous sorrows he had known in his life. Piero carried the burdens of his guilt on his shoulders. Most would say the burdens were undeserved. All of us carry with us guilt of some degree as we journey through life. Maddalena reasons out her feelings, unaware of Gino who is still sitting beside her, holding her hands.

"Piero's wonderful paintings, this is what he has left us, Maddalena, his legacy to the world. We are all richer because of Piero's work. It can never be taken from us, the inspiration received from all those wonderful paintings, whenever we see them or visit them in our thoughts. Piero left them, like so many children, to gladden us, to make us better for knowing them."

Suddenly the sun breaks from behind a cloud and streams into the *salone*, filling it with light, warm and golden, like the sunlight Piero created in his painting, *The Baptism*. She feels Piero's presence strongly at this moment, as though he were in the room, saying, "Do not mourn for me, Maddalena. I have found peace at last."

Appendix

PAINTINGS AND FRESCOES BY PIERO DELLA FRANCESCA MENTIONED IN THIS BOOK

The Baptism, The Nativity, National Gallery, London

Madonna of the Misericordia, The Resurrection, Museo Civico, San Sepolcro

The Flagellation, The Madonna of Senigallia, Galleria Nazionale, Urbino

Sigismondo Malatesta and St. Sigismond, Tempio Malatesta, Rimini

The Legend of the True Cross, Church of San Francesco, Arezzo

Hercules, Isabella Stewart Gardner Museum, Boston

Duke Federigo da Montefeltro and Battista Sforza, His Wife, Uffizi, Florence

Madonna and Saints with Federigo da Montefeltro, Galleria Brera, Milan

The Madonna del Parto, Capella Cimitero, Monterchi

Acknowledgments

Historical and artistic material on the works of Piero della Francesca which I found most useful include: *The Piero della Francesca Trail* by John Pope-Hennessy; Roberto Longhi's *Piero della Francesca;* Kenneth Clark's *Piero della Francesca;* Carlo Ginsberg's *The Enigma of Piero. Summer's Lease* by John Mortimer provided a delightful contemporary journey along the Piero Trail. No one has written with more clarity and verve of Piero and his world than the late Frederick Hartt in his *Italian Renaissance Art.* Many books provided insight into everyday life in Tuscany of the *quattrocento*, but my favorite remains *The Merchant of Prato* by Iris Origo, cover to cover jammed with precious, intriguing detail.

I am indebted, as always, to my husband James, to my daughters, Daisy and Holly; to Sylvia Wilcox, Sheila and Jerry Modjeska, Gay and Bill Tucker, Nancy and Jim Hunter, Joy Frost, Jacqueline Moffatt, Agatha Clemente, Priscilla Tolkien, Annela Twitchin, Pat Wilson; to Adam and Michael Warnalis for photography. Mary Faracci, Florida Atlantic University; Kathleen Fort of the Maier Museum, Randolph-Macon Woman's College; Candice Michalik, Lynchburg, Virginia, Public Library and the librarians of the Lipscomb Library, Randolph-Macon Woman's College, deserve special thanks. I am grateful to the Virginia Center for Creative Arts for granting a fellowship which enabled me to bring the book to its conclusion.. Finally, I thank all of my readers who, after approving *Seeking the High Yellow Note, Vincent van Gogh in Provence,* supported me in writing Piero's story.

About The Author

ALICE HEARD WILLIAMS, an Art Historian, whose novel, *Seeking the High Yellow Note, Vincent van Gogh in Provence*, was published in 2002, has written three books of poetry, the most recent, *Hey, Madame Matisse!*, winning a national award. *Seeking the High Yellow Note* is listed as one of the twenty best books on Provence by Amazon.com. Mrs. Williams lives with her husband in Florida and Virginia.

Printed in the United States
24429LVS00002B/25

9 781420 805963